PHOTOGRAPHY FOR EVERYONE

Kerry Ross

PHOTOGRAPHY
FOR EVERYONE

The Cultural Lives of

Cameras and Consumers

in Early Twentieth-Century Japan

Stanford University Press
Stanford, California

Stanford University Press
Stanford, California

Printed in the United States of America on acid-free, archival-quality paper

Library of Congress Cataloging-in-Publication Data

Ross, Kerry, author.
 Photography for everyone : the cultural lives of cameras and consumers in early twentieth-century Japan / Kerry Ross.
 pages cm
 Includes bibliographical references and index.
 ISBN 978-0-8047-9423-7 (cloth : alk. paper) -- ISBN 978-0-8047-9564-7 (pbk. : alk. paper)
 1. Photography--Social aspects--Japan--History--20th century. 2. Japan--Social life and customs--1912-1945. I. Title.
 TR105.R67 2015
 770.952--dc23

 2015007262

ISBN 978-0-8047-9563-0 (electronic)

Typeset by Bruce Lundquist in 10/14.5 Sabon

For Carol,
who, though she didn't make it to see this book in print,
was my most enthusiastic cheerleader from the beginning

And for Asher,
who everyday inspires me to be inquisitive
and reminds me to play

TABLE OF CONTENTS

ILLUSTRATIONS

PREFACE

The idea for this book began when I started research on the history of modernist photography in Japan. Once in the archives, contrary to my expectations based on all earnest, and I thought, thorough, preparations, I found that most materials concerning photography during the early twentieth century were directed toward amateur photographers. Instructional writing, amateur photographs, and advertisements fill page after page of how-to books and photography magazines from the time. Indeed, postwar scholars have made modernist photography stand in for nearly all photographic activity of that time. To date, most scholarly work on the subject has focused on the origins and development of a single strand of art photography, with particular attention to the creative efforts of a select few individual artists and theorists. Rarely have historians paid attention to the role of the typical middle-class consumer in photographic practices, yet it was these ordinary photographers to whom the majority of products, publications, and ideals of photography were marketed. This inattention to the wider photographic archive has created a skewed historical understanding of the social and cultural meaning of photography. What I show in the following pages is that photographic practice can be more accurately understood as the product of a complex relationship between middle-class consumer behavior, profit-driven camera companies, and movements to popularize photographic art. The aim of this study is to resituate the historical discussion of photography in Japan, one that has been dominated by concerns with aesthetic representation, in order to reveal the everyday meaning of photography for ordinary Japanese people in the early twentieth century.

At Columbia University, Henry Smith, Carol Cluck, and Andreas Huyssen

were instrumental to my thinking about the project and, in particular, about how to use images as sources for historical analysis. Kim Brandt and Eugenia Lean entered the fold a bit later but have continued to support the project with much-appreciated enthusiasm. My cohort at Columbia, especially Leila Wice, Sarah Kovner, Lori Watt, Ken Oshima, and Jonathon Zwicker, always challenged me to push my ideas further.

Later, a Fulbright IIE Dissertation Research Fellowship provided the opportunity to conduct the bulk of the research for this project in Tokyo from 1999 to 2001. Columbia generously funded the writing of this project by the Junior Japan Fellowship, the Department of East Asian Languages and Cultures, and the Committee on Asia and the Middle East. At DePaul, the University Research Council Paid Leave program generously supported me as I finished some crucial revisions to the book in 2011–2012. The University Research Council also helped fund publication of the images found in this book. DePaul's College of Liberal Arts and Social Sciences supported me in 2012 with a Summer Research Grant. The Japan Foundation Short-Term Research Grant made it possible for me to return to Japan (and to live in Nihonbashi!) for two months to complete the research.

So many young scholars starting out in the archives in Japan, myself included, have been patiently and unstintingly supported by Yoshimi Shun'ya of the Graduate School of Interdisciplinary Studies at the University of Tokyo. Likewise, Satō Kenji in the Department of Sociology at the University of Tokyo cheerfully advised me at an early stage in the project. Kaneko Ryūichi kindly made time for me and thoughtfully answered every question that I had about the history of Japanese photography. Okatsuka Akiko and the staff at the Research Library of the Tokyo Metropolitan Museum of Photography gave me open access to their wonderful archives. The staff at JCII Library connected to the Japan Camera and Optical Instruments Inspection and Testing Institute helped me locate some very rare copies of key sources.

Many people have taken time to read parts of the manuscript, and their criticism along the way has helped make this a better book. I am particularly grateful to Paize Keulemans, Greg Pflugfelder, and Chuck Woolridge for their thoughtful comments at an early stage. Paul Barclay, Julia Thomas, and Gennifer Weisenfeld, all of whose work has been inspirational to me, generously answered many of my questions along the way.

The History Department at DePaul University has been a wonderful place for me to grow as a teacher and historian. I am particularly indebted to Tom Foster, whose wise, unadulterated advice on all matters intellectual

and professional helps me stay sane. Gene Beiriger, Brian Boeck, Lisa Sigel, and Amy Tyson have been nothing but supportive and have helped me at various stages in the final preparation of the book. I am also grateful for the intellectual and social camaraderie of Scott Bucking, Tom Krainz, Rajit Mazumder, Brent Nunn, Otunnu, Ana Schaposchnik, Margaret Storey, Roshanna Sylvester, Valentina Tikoff, Julia Woesthoff, and everyone else in the History Department. Ian Petchenik assisted me with the images found in this book and entertained me with his wry sense of humor. Nobuko Chikamatsu in the Department of Modern Languages, Yuki Miyamoto in the Department of Religious Studies, and Elizabeth Lillehoj in the Department of the History of Art and Architecture are wonderful colleagues in the Japanese Studies Program, my second home at DePaul.

The editors at Stanford University Press, Kate Wahl, Jenny Gavacs, James Holt, Eric Brandt, and Friederike Sundaram, have enthusiastically supported this project from the beginning. I thank them for their crucial role in making this book possible. Emily Smith, production editor, and Cynthia Lindlof, copyeditor, were extremely helpful and graciously patient during the production stage. I am also grateful to the two anonymous readers for their invaluable comments on the manuscript.

My deepest gratitude goes to my family in Minneapolis, the Thacher-Rosses, who have taken such good care of me—feeding, sustaining, and loving me, even at some of my worst moments. Marta Drew's encouragement, friendship, and wisdom have been vital during some of the most trying moments in the past couple of years. This book is dedicated to Carol Thacher (1939–2014), stepmother extraordinaire, who would have loved to celebrate the completion of this book but, unfortunately, did not quite make it to see that happen. Aviva Rohde, in every way my surrogate mother, has never stopped believing in me and in this project. In L.A., Tokyo, New York, and Chicago, Jason Cremerius has carefully read every draft. His steadfast friendship, support, and editorial acumen have made it possible for me to finish this book. I especially wish to thank Asher Cremerius, who was born just as I was finishing the dissertation. He is the best thing that has ever happened to me, and I lovingly dedicate this book to him.

Throughout this book, Japanese names follow Japanese naming practice: family name first. Unless otherwise noted, all translations from Japanese are mine.

PHOTOGRAPHY FOR EVERYONE

INTRODUCTION

During a three-week visit to Japan in 1920, George Eastman, the founder of Eastman Kodak, remarked that the Japanese people were "almost as addicted to the Kodak habit as ourselves."[1] Eastman's visit to Japan was planned and paid for by some of Japan's leading economic experts and proponents of international cooperation, including Shibusawa Eiichi and Megata Tanetomo. It was an unofficial trip to help secure more friendly ties between the two countries. Along with Eastman, ten other men were invited, including bankers, journalists, and Lyman Gage, former secretary of the Treasury.[2] Eastman was a guest of Baron Mitsui, who hosted Eastman at his Takanawa estate,[3] and treated Eastman to a ride through the imperial palace gardens in a Cunningham car, coincidentally produced in Rochester, New York, for the Japanese emperor, "with the imperial chrysanthemum symbol having been woven into the upholstery."[4] According to his biographer, Elizabeth Brayer, George Eastman Honorary Scholar, Eastman was impressed with the Japanese people because they, like him, "had the ability to assimilate the ideas of others 'to the point of genius' and wondered if that was what 'has made her the powerful nation she is today.'"[5]

During his trip, Eastman paid special attention to the thriving commercial world of photography. His handlers, most notably Shibusawa, had planned

a packed itinerary, but as often as he could, Eastman wandered about the commercial districts of Tokyo visiting photographers' studios and dealers' shops, which one reporter noted numbered between six hundred and seven hundred in the city.[6] Among the shops that he visited formally was Konishi Roku, today's Konica Minolta, located in Tokyo's bustling financial district of Nihonbashi. On 26 April 1920, Eastman toured Konishi Roku's department store for photography; was greeted by the company's founder, Konishi Rokuzaemon; and was photographed once alone and once alongside Rokuzaemon in the store's state-of-the-art portrait studio.[7] Although Konishi Roku had been selling Kodak products for decades, this was the founder's first visit to the shop.

What astonished Eastman during his visit to Japan was the sheer quantity of photographic goods available to ordinary consumers. While he certainly had access to sales reports from the various distributors of Kodak products, it is unlikely that he would have had detailed prior knowledge of the enormous variety of retail options for photographic products available throughout Japan and its colonies, including Taiwan and Korea. By 1920, Tokyo's map was dotted with a great number of shops selling new products, but the city also was home to a vast used-camera market, which certainly made up a good percentage of the "hundreds of shops" that Eastman did not have time to see. In fact, by the time of Eastman's visit, the business of selling photographic products in Japan was already five decades old.

This book recounts the untold story of how ordinary Japanese people in the early twentieth century made photography a part of everyday life, using products produced by Kodak or, even more likely, by Japan's then thriving domestic photography industry. Such an endeavor necessitates looking at the quotidian activities that went into the entire picture-making process, activities not typically understood as photographic in nature, such as shopping for a camera, reading photography magazines and how-to books, participating in camera clubs and contests, and even preserving one's pictures in albums. These very activities, promoted and sponsored by the industry, embedded the camera in everyday life as both consumer object and documentation device, linking photographic technology to the practical understanding of modernity and making it the irresistible enterprise that Eastman encountered in 1920.

Historiography of Early Twentieth-Century
Japanese Photography

The overwhelming focus of historical scholarship on early twentieth-century Japanese photography has concerned the development of art photography. Artistic photography in Japan took off at the turn of the twentieth century, in part spurred by a vigorous debate among photographers over the best uses of photography. On one side were those who advocated photography's utilitarian and practical potential, while on the other were those who promoted its aesthetic possibilities.[8] Those looking to establish photography as an artistic practice struggled to "divorce photography from the realm of technology and establish it as a legitimate art form equal in status to painting."[9] Writers took up the theme of the aesthetic potential of photography in a growing number of journals dedicated to the art and technique of photography. These journals also published the artistic work of amateur photographers, making concrete examples of art photography available to a wider audience and thus legitimating the techniques.[10] But, as Mikiko Hirayama reminds us, proponents of the artistic relevance of photography also had to struggle against the predominant aesthetic norms of staged and staid studio photography, which "was still considered as a form of business, and photographers as artisans."[11]

Pictorialism, the first major aesthetic movement in Japanese photography, was adopted by the leading practitioners of art photography. Classic pictorialism in photography used techniques such as painting on the negative or positive, soft-focus lenses, and textured papers to create a romantic image.[12] In pictorialist photography, artists used the medium to experiment with new aesthetic forms, much like writers were beginning to experiment with expressionism in literature and painting: "This [photographic] work no longer imitated paintings, rather it demonstrated that photography could address the same kinds of themes as paintings yet retain an individual expression that reflected the inner dimensions of the artist."[13]

The artistic exploration of new photographic aesthetics, especially forms that could speak to the experience of disjuncture and alienation of urban life following the Great Kantō Earthquake of 1 September 1923, marked the turn toward modernism in art photography. For many photographers, the romanticism of pictorialism could no longer appropriately capture the kinetic and sometimes destructive force of the metropolis. From this perspective, pictorialism possessed an "old-fashioned aesthetic consciousness" that could

not keep pace with contemporary changes in everyday life.[14] Modernist photography of this period was heavily influenced by the work of Bauhaus and European avant-garde photographers like Lazslo Moholy-Nagy and Man Ray and new forms of photography like the photogram and photo-montage. The images of Japan's leading modernist photographers, such as those by Nakayama Iwata (1895–1949) and Koishi Kiyoshi (1908–1957), appeared in new photojournals like *Asahi kamera* and *Fuototaimusu*. Kimura Sen'ichi, editor of the monthly *Fuototaimusu*, was committed to introducing readers to *shinkō shashin*, or "new photography," the term used to differentiate modernist photography from pictorialism.[15]

Perhaps the most influential publication of the period, and one of the most important contributions to modernism in Japanese photography, was *Kōga*.[16] In May 1932, Nakayama Iwata, Nojima Yasuzō, and Kimura Ihei (1901–1974) produced the first issue of the small-circulation journal that published arguably some of Japan's most canonical images and essays of the 1930s.[17] Ina Nobuo's oft-cited article "Return to Photography" was the lead essay in the first issue. This article, in which Ina presses photographers to embrace the aesthetics of the machine and break free from pictorialism— the "humble slave of painting [*kaiga no 'kensonnaru' dorei*]"—became the manifesto of new photographic aesthetics in the 1930s.[18]

The late 1920s and early 1930s also marked the emergence of mass consumerism and the rise of a middle class made up of salaried employees who had unprecedented time and money to spend on new products and pastimes. In this context, photography influenced how products were marketed and consumed. The new professional field of commercial photography helped bring the modernist aesthetic beyond small-circulation magazines and galleries and into the homes of middle-class consumers through new packaging designs and advertising campaigns.[19] The modernist aesthetics that informed art and commercial advertising photography also set the tone for propaganda photography, which had become the essential means of communicating Japan's wartime activities to audiences on the home front. From the mid-1930s, commercial photography studios like Nihon Kōbō (Japan Atelier, known as Kokusai Hōdō Kōgei from 1939) were increasingly subject to government control. The large-format magazine *Nippon* was inaugurated in the autumn of 1934 by Natori Yōnosuke (1910–1961) as a "cultural propaganda organ aimed at foreign audiences in order to strengthen diplomatic policy."[20] Perhaps the most stunning use of modernist aesthetics for the purpose of propaganda culminated in the large-format

graphic magazine *FRONT* launched in 1942 soon after the beginning of the Pacific War. Among the magazine's staff were photographer Kimura Ihei and graphic designer Hara Hiromu (1903–1986), who, like many of the cohorts from the commercial photography studios, "quickly revealed the conservative uses to which the 'modern' or 'avant-garde' could be put."[21]

In the immediate postwar period, photographic realism was taken up by the prewar veterans and a new generation of photographers. Certainly for photographers who had participated in prewar propaganda projects like *Nippon* and *FRONT*, realism in the form of unadulterated, objective images was seen as a necessary aesthetic antidote to combat the understanding of photography as an instrument of war: "In essence, the goal was to grasp the subject directly without subjective interpretation, a concept that can be considered a reconfirmation of the function of the photograph as documentation."[22] Debates on the exact nature of photographic realism, however, appeared in the photographic press, which reemerged rapidly with prewar magazines such as *Kamera* and *Asahi kamera* relaunching in the immediate postwar years.[23]

While the development of Japanese artistic photography has received an enormous amount of scholarly and critical attention, that body of work represents a mere fraction of the photographic archive. It takes only one visit to a used bookstore, the library shelves of a major university, or the collections of a camera-related organization to see that the majority of photographic products and publications in the first half of the twentieth century were marketed to the ordinary photographer as essential possessions of modern everyday life. In fact, "photography" as it was understood by most Japanese people was an amalgamation of disparate practices shaped as profoundly by retailing and consumption as by aesthetic movements and gallery exhibitions. Yet historians of photography rarely pay attention to the role of the typical middle-class consumer in photographic practice, and scholars accounting for the history of the camera industry have routinely ignored the significant role companies such as Konishi Roku and Asanuma Shōkai played as arbiters of middle-class taste.[24] But it is the interaction between these very parties—ordinary photographers and the leading camera brands—that is critical to an understanding of the popularization of photography in the early twentieth century, necessitating that we take into account

the broader field of photographic activities, including the production and sales of cameras and film, the circulation of knowledge and information about photography, and the use of those products in everyday life.

Retailing, Consumption, and Gender

Another key aim of this study is to write retailing back into modern Japanese history from a social-cultural perspective and to consider the activities that took place "beyond the shop counter" as integral to understanding the consumer revolution of early twentieth-century Japan.[25] By focusing on retailing as well as consumption in photographic practice, this book seeks to reveal the various social and cultural factors that contributed to the rapid rise and success of Japan's camera industry. Camera companies like Konishi Roku deployed state-of-the-art marketing, management, and retailing strategies that, alongside leading department stores like Mitsukoshi and Shirokiya, revolutionized the twentieth-century shopping experience for Japanese consumers. By looking at the "processes and spaces connected to consumption before and after purchase," this study explores the space in which purchasing took place, the camera shop floor.[26]

The focus of scholarship on twentieth-century Japanese retail practices has been on the rise of the department store as the nexus of public consumer activity.[27] Some of these studies have taken into account the material setting of the store, but very few have looked beyond the department store to address the variety of contexts in which purchasing took place, including small shops, secondhand stores, outdoor flea markets, traveling sales, temporary stalls, festival booths, and subscription sales—many of which were remnants of earlier forms of retail activity. One way to get at this diversity of practices is to follow the path of a single product from its production in factories to its sale in shops and use by consumers. By looking closely at the movement of cameras through society, this book documents in detail the social, cultural, and material aspects of the distribution of products and knowledge related to one consumer item and, in the process, expands our understanding of everyday economic exchange in this period.

While historical studies of Japanese retailing tend to be narrowly confined to a business-historical approach,[28] scholars have made important contributions to our understanding of the role of the consumer in the Japanese consumer revolution. One strain of this scholarship focuses on the new public space that modern consumer society opened for women in the early twenti-

eth century. In particular, scholars have looked at the nature of the consumptive behavior, real or imagined, of the modern girl.[29] Studies of the emergence of the department store have also contributed to our understanding of consumption and gender in this period.[30] Unintentionally, these studies in the aggregate have naturalized a construction of gender that associates women with shopping and the impulsive, acquisitive desires related to modern consumption.[31] However, men's consuming habits are often neglected altogether or assumed to be defined by a rational, practical motivation. Few have yet to explore the origins of these myths about men's shopping behaviors. Indeed, as Christopher Breward has pointed out, historians of Western European and American consumption until recently have tried to "explain the social roles taken by men and women during the nineteenth century through recourse to the idea of 'separate spheres,' defining the broad process of production and consumption as respectively masculine and feminine."[32] In accepting this binary myth, many scholars have consequently ignored looking at men's consuming behaviors.

Because the consumers of photography as a serious pastime were primarily men, this study engages critically with men's shopping habits as well as the gendered divide that retailers constructed in marketing their products. To effectively sell their products to different kinds of photographic consumers, companies deployed overtly gendered marketing strategies. Men were targeted as dedicated amateurs and hobbyists who saw the entire picture-making process through from beginning to end. Advertisements for cameras addressed women (and sometimes children) as casual photographers, those who took photographs only occasionally and had their film and plates developed for them by a camera shop. For men, the entire productive enterprise of photography was marketed as a serious pastime, one intended to match middle-class masculine aspirations of technical mastery and productive use of free time away from work.[33] How-to literature, which was inherently geared toward male photographers, typically began with a detailed description of how to shop for a camera, an activity characterized as essential to proper photographic technique. Shopping is afforded the same methodical treatment as is developing a negative or using an enlarger, perhaps betraying the fact that men, too, needed to curb their acquisitive impulses before heading out to shop. Showing how men participated in the economy as shoppers as well as producers and users of products, this study seeks to expand our understanding of how the camera and photography were popularized in the context of the rise of modern consumer culture in Japan.

Middlebrow Photography and Middle-Class Photographers

Another goal of this book is to explore the ways that photographic practice defined middle-class masculine identity. In addressing the consumer and leisure-time activities of middle-class men, this study complements the growing body of scholarship on the emergence of middle-class culture in early twentieth-century Japan.[34] The popularization of photography was fueled in many concrete ways, but among the most important was the domestic production of affordable cameras and light-sensitive materials. Japanese camera companies like Asanuma Shōkai and Konishi Roku's production company, Rokuōsha, made great strides in producing dependable, inexpensive photographic products, including cameras. Production of affordable cameras made photography economically accessible to a wide range of consumers, but the majority of photographic consumers were men who came from the new middle classes—typically urban, white-collar workers with the requisite income and leisure time to engage in the serious pastime of photography. However, it was not only the economic accessibility of photographic commodities that helped popularize photography among middle-class men. The spread of photographic practice, especially as a serious leisure-time and club activity, was also fueled by the popularization of fine arts.

The increased public visibility of fine arts in museums, galleries, expositions, and, perhaps most important in terms of access, art exhibits in department stores, as well as the incorporation of art education into the school system from the Meiji period (1868–1912), brought fine arts into the lives of an increasing number of ordinary Japanese people.[35] Such institutional and commercial support helped disseminate the idea that being an educated member of society also meant that one needed to have at least some basic familiarity with the fine arts. In this environment, the photographic medium uniquely gave users access to a means of artistic self-expression and a set of tools to represent the world as they saw it. By helping spread the idioms and practices of artistic expression among a wider audience, photography was a critical force in popularizing fine arts and disseminating the vocabulary of aesthetic value in modern Japan.

This book is one of the first serious studies of the aesthetics employed by amateur artists of any kind in twentieth-century Japan. Just as the bulk of the photographic archive far outweighs the canon of Japanese art photography, the bulk of photographs published in photographic journals and books were those made by ordinary photographers. The term "middlebrow" refers

to the aesthetic practices of ordinary photographers, and while the term often carries a pejorative tone, I am following Joan Rubin's usage in her work on middle-class reading habits in early twentieth-century America.[36] Rubin applies "middlebrow" to the role of critics and publishers in helping create literary standards that influenced what middle-class consumers chose to read. In the case of photography in Japan, I use "middlebrow" to refer to the standards of amateur photographic aesthetics as they were established by the arbiters of photographic taste—the editors of photographic journals, contest judges, and exhibition organizers. It was this group of experts who selected exemplary images for publication and exhibition and to whom amateurs looked for advice in making their photographs. My intention is to take seriously the aesthetic practices of middle-class (would-be) artists, not only because they influenced such a large part of the photographic archive but also because these practices help us understand the neglected art and aesthetics of ordinary people living at the time.

Middlebrow aesthetics, in some senses, can be seen as derivative versions of elite, modernist understandings of artistic value or, conversely, as slightly elevated versions of mass-cultural notions of beauty. But to judge the pictures that amateur photographers made according to the standards of high- and/or lowbrow aesthetics is misguided. In fact, amateur images not only interpreted the highbrow aesthetics promoted in modernist journals and exclusive gallery shows but also, critically, advanced a distinctive way of making photographs. Photographic aesthetics were produced in the darkroom, using specific technologies, products, and skills. Like the literary critics in Rubin's work, popular photographic experts, critics, columnists, how-to writers, and contest judges functioned as cultural mediators who collectively helped create a common definition of aesthetically superior photographic images.[37] Companies fostered artistic photographic production by publishing how-to books and sponsoring contests that rewarded exemplary photographic aesthetics. In addition, camera clubs, a primary avenue for amateurs to participate in photography, served as a kind of classroom for the people where the world of fine arts was introduced through the photographic medium. In the context of the club, members learned not only how to make artistic photographs but also how to evaluate those images in light of prevailing aesthetic standards. High-art exhibitions often included select work of amateur and club photographers, granting these humble practitioners, at least temporarily, the status of an "exhibited artist." What the experts and judges saw as superlative, however, was not necessarily the

sharp, gleaming angles of modernist images but rather the soft, romantic visions of pictorialism, an aesthetic achieved most commonly through manipulation of the image in darkroom procedures.

Structure of the Book

The narrative of this book follows a thematic organization to explore in depth parallel developments that contributed to the popularization of photography in the first half of the twentieth century. Chapter 1 argues that the camera industry was at the forefront of a retail revolution from the turn of the twentieth century and places camera selling in a cultural history of urban retail practices. By focusing on retailing and consumption in photographic practice, the first chapter seeks to unearth the various social and cultural factors that contributed to the rapid rise and success of Japan's prewar camera industry. Camera companies like Konishi Roku deployed the latest marketing and retailing strategies as well as created a multitude of innovative ways for consumers to participate in photography, including product-based clubs and remote consumer networks. And camera emporiums like Konishi Roku and Asanuma Shōkai, Japan's leading camera companies in the early twentieth century, contributed to the transformation of the urban shopping experience associated most commonly with the rise of the modern department store. In 1916, Konishi Roku opened its department store for photography, a four-story edifice in Nihonbashi, Tokyo, that welcomed shoppers with huge plateglass windows, glass display cases filled with attractively arranged products, and an escalator, all of which spoke to new retail methods aimed at democratizing the shopping experience.[38]

Chapter 2 follows the retail revolution in photographic products to explore how the camera market was segmented into two distinctly gendered consumer markets—the casual photography market and the amateur photography market—and the innovative ways that the camera industry marketed its products to these two very different consumer groups. Companies promoted the idea that photography was for everyone; yet not all cameras were meant to be used by just anyone. In marketing their products, companies deployed overtly gendered marketing strategies to sell their products to different kinds of photographic consumers.[39] These marketing campaigns drew on very specific assumptions about how women and men participated differently in leisure activities. Companies advanced the view of women as passive consumers, whose leisure time was filled with such activities as

Ginbura (window shopping in Ginza) and marketed the camera as the perfect accessory for the stylish woman. For men, photography was marketed as a serious pastime, one that encompassed the educational and workplace aspirations of middle-class masculinity.

In Chapter 3, I follow the male consumer to investigate the role of how-to books in democratizing photography, in terms of both their explicit, stated purpose to teach photographers how to take and make photographs and the ways in which they suggested to readers the appropriate place of photography in their leisure time and in their homes. During the period from 1912 until 1940, publishing houses and camera companies produced more than five hundred books and nearly thirty monthly journals aimed at the amateur photographer. An overwhelming number of these publications were how-to books geared to various levels of photographers, from rank beginners to skilled hobbyists. How-to literature on photography in this period can be placed more generally into the overall trend in the commercialization and distribution of knowledge whereby information about commodities, just like products themselves in advertisements, was marketed to consumers. How-to books on such diverse topics as home cooking, tennis, and model airplane building not only taught consumers how to cook, play, and build but also how to construct a middle-class lifestyle that incorporated certain products and activities. How-to books on photography provided technical knowledge on all aspects of photographic activity—from buying and getting to know your camera to proper storage of plates and chemicals to outfitting a darkroom, making negatives, and printing out photographs. From one perspective, how-to literature privatized the learning process, offering readers a way to continue their education and use their time productively outside the realm of work. In the case of photography, however, it also taught readers what were the appropriate kinds of photographs to take and how photography fit best into a middle-class lifestyle.

Among the most important venues for the spread of photographic literacy was the amateur camera club, the subject of Chapter 4. The availability of cheaper, domestically produced cameras and developing materials fueled the popularization of photography. Along with affordable products, the rapid growth in popular camera clubs from the turn of the century helped spread photographic know-how. Camera clubs were shared social spaces where members, primarily men, explored photographic art and technique. By spreading the idioms and practices of artistic expression among a wider audience, camera clubs, along with museums, galleries, and exhibitions,

were the primary institutional setting for the democratization of the fine arts in modern Japan. At the same time, clubs were voluntary associations and operated in accordance with democratic procedural principles that provided members with the opportunity to participate in democratically run organizations where they could exercise individual rights not granted to them in the wider political system.

Chapter 5 considers the actual pictures that amateurs took with the aim of understanding the popular aesthetics and related techniques of the period. Most amateurs worked within the aesthetic standards and vocabulary of pictorialism, which, when properly executed, yielded painterly images suffused with moody, nostalgic, even romantic imagery. Such photographs relied heavily on manipulation and handwork in the image-making process—the part of photography that takes place in the darkroom where the image is actually made. Techniques such as bromoil transfers and enlargement allowed hobbyists not only to express themselves creatively but, more important, to display technical mastery over a complex apparatus. The focus on process—sometimes to the neglect of the resultant image—became a central component of the aesthetics of pictorialism. In the face of an increasingly mechanized middle-class lifestyle, the creation of pictorial photographs allowed the exercise of handwork and a craftsman's sensibility. And because such processes typically involved the use of expensive chemicals, equipment, and papers, the camera industry actively promoted these techniques in ads for their products and through the contests they sponsored. Pictorial photography, as both a final product and a total process, provided hobbyists with an aesthetic language that matched their middle-class ideals: an active place in the world of consumerism befitting their newfound incomes and an absorbing activity that placed value on craftsmanship.

The Epilogue briefly takes up the fate of popular photographic consumption during and immediately following the Pacific War. While ordinary consumers were diverted from photography as a pastime in the early 1940s, several Japanese camera companies continued to produce strategically significant photographic products for the military, setting the stage for their rapid recovery in the postwar period. From the late 1930s, cameras were deemed luxuries that were objects of anticonsumption campaigns. Imported cameras were burdened with extraordinary taxes, much to the dismay of camera sellers all over Japan. Light-sensitive materials, because of the chemicals used to make them, became almost impossible to acquire. All of these restrictions on consumption brought popular photography to a near stand-

still from 1940 to the end of 1945. Despite this wartime gap in the ordinary photographic market, camera companies rebounded quickly to prewar levels of production and sales by resurrecting the highly effective strategies and tactics that had marked the popularization of photography during the preceding decades.

A RETAIL REVOLUTION

Male Shoppers and the Creation of the Modern Shop

Sources from the first half of the twentieth century related to the consumption of photography reveal that men were avid consumers of photographic commodities and that they actively participated in the world of shopping, though they often were positioned as needing guidance in their shopping. Photography monthlies and how-to literature offered men extensive advice on procuring all manner of photographic commodities. Shopping as a masculine activity, however, had to be a rational practice, grounded in a dispassionate attitude and based on research. Thus, consumption for men did not happen willy-nilly but was defined within particular parameters of masculine identity—rationality, knowledge, and disassociation.

On the other side of the shop counter, camera sellers like Konishi Roku created a retail environment, what retail strategists today might call the "in-store customer experience," that matched male shoppers' expectations. Everything from the material experience of the shop, its architecture and layout, to its management style, drew on rational, dispassionate retail strategies. Glass display cases created visual access to goods, which a consumer could now compare side by side in an unbiased manner. A salaried workforce, wearing Western suits, provided knowledgeable and reliable service. For the high-end camera shopper, this retailing experience dove-

tailed seamlessly with the way marketers and commentators positioned photography and the camera as the most modern and rational of consumer technologies.

The Male Consumer Shops for a Camera

Even though scholars have often seen shopping as an activity in which the act of "acquiring the goods for consumption . . . was socially perceived as a feminine task," at least according to shop owners, men did indeed shop.[1] In fact, it was the male office worker, so often represented in literature and film of the time as a symbol of Japan's modernization of the metropolis, who uniquely had sufficient expendable income and free time to frequent Tokyo's numerous camera shops.[2] The upper levels of salaried workers were the very men who shopped at the camera counter at Mitsukoshi or at Konishi Roku's main shop in Nihonbashi. Office clerks and shop hands, also salarymen but existing on the periphery of middle-class prosperity, window-shopped at Mitsukoshi but probably bought their cameras at one of the many used-camera shops dotting Tokyo's east side.

If men had the time and money to shop, they still required much guidance in the proper approach to consumption. Suzuki Hachirō offered one of the most extensive and detailed guides to shopping for a camera in his how-to book, *Knowledge of the Camera and How to Choose One* (1937), the first volume in his series The Arusu Course in Popular Photography.[3] Foremost among the "Five Principles for Choosing a Camera" is "money," especially for the first-time buyer.[4] In Suzuki's account, men are just as susceptible to the buying impulse as women, but the risk in the case of a camera is especially high and requires a rational and reasonable approach:

> You head out to buy a necktie on sale for a yen, but even though you end up splurging because there are none less than six yen, and even though you will have to refrain from getting anything new for two or three months, still it's done. But in the case of a camera, this kind of recklessness would be a serious matter. Therefore, it is necessary to clearly decide on a budget.[5]

Second, the consumer should choose a camera that suits his purposes. Suzuki reminds readers that the camera is a tool and an appropriate camera exists for every approach to photography—just as different kinds of vehicles function as tools for different forms of transport. For example, a truck transports goods while a bus transports people, and so on.[6] Accordingly, Suzuki advises that consideration be given to the uses the camera will be put—travel, work,

or leisure—before making any decisions. Once the buyer is clear about the way he will use the camera, the choice will become that much easier. Suzuki then goes on to describe how different camera models fulfill different photographic objectives: the single-lens reflex camera works well for artistic photography; the Leica is best to capture motion and mechanistic beauty; and for the nostalgic look, nothing is better than the vest pocket camera.[7] Suzuki's third piece of advice to his readers is to choose a camera from as reputable a company as possible: "This is not limited to cameras but applies to all routine shopping." The best way for a novice to judge a product, according to Suzuki, is by its *māku* (brand). If you need light bulbs, then you can't go wrong with the Matsuda brand; for small motors, trust Shibaura.[8] It is exactly the same when shopping for a camera. One must look beyond what the ads say and see which brands have been trusted by the most people over the years. The fourth step is to pick a camera that is easy to use rather than one that is overly complicated. Finally, Suzuki recommends that, just as when deciding on an automobile, it is important to consider quality over decoration.[9]

Together these five factors are meant to help a consumer new to the world of camera shopping choose his "one and only camera."[10] Once the consumer settles on a camera brand and type, the next step is to prepare for the shop experience. In "Instructions for Buying a Camera," Suzuki advises, "First, you must do research."[11] After deciding on a budget, the knowledgeable shopper uses catalogues to decide on the proper model of camera and necessary equipment and accessories. Photographs and descriptions of "absolutely necessary accessories" fill two pages and include the following: a *sokusha* case (a camera case with a strap worn over the shoulder that allows easy access to the camera for quick or even impulsive photographing), a tripod, a lens cover, a light meter, and a range finder.[12] The next step is to "consult with a more experienced colleague."[13] And if you have no colleagues who can help you, go to a camera shop and speak to a knowledgeable clerk. "Once you've made a decision, don't turn back."[14] And by all means, do not let an eager clerk try to change your mind or sell you the display model. "Inspect the camera" to make sure that you are getting your money's worth.[15] Suzuki recommends a cursory check before leaving the shop to be sure that the body is intact and that all the accessories are included. Still, a fuller examination at home is necessary, and he offers detailed tips on how to go about a thorough check of the camera and all its parts. Finally, "take a test [roll]."[16] Using all the equipment, the owner of a

new camera should keep one roll of film, or several plates depending on the model, to test the inner mechanics. With these practical tips in mind, buying a camera can be a relatively painless process, though perhaps not as painless as buying a necktie.

Suzuki's tips are typical of how-to books aimed at the newcomer to hobby photography.[17] Most authors, in fact, list buying a camera as the first step in the process of taking and making pictures.[18] By taking seriously the buying process, how-to writers transformed the act of shopping, which was commonly associated in the popular imagination with the irrational impulses of female consumers, into a disciplined, even scientific, practice.[19] In the case of a camera, the recommended customer journey requires research, consultation, and determination to make the proper purchase, the one that enables the amateur to practice photography according to his well-thought-out plans. As Suzuki describes it, purchasing a new camera can be an overwhelming experience, especially for the first-time camera owner. Even though he describes at length the five basic models of cameras, Suzuki readily admits that there are hundreds of kinds of cameras and for every camera there are even more accessories. Choosing the perfect camera and accessories is so confounding that "really, you can't laugh at women buying clothes in a department store."[20]

Yomiuri Newspaper's Guide to Merchandise

Guides to shopping for products were not unique to the camera market. Throughout the mid-1930s, the *Yomiuri Newspaper* published "Handy News," a regular column with consumer tips on shopping for everyday products. Articles that ran throughout 1936 were collected and published in a single volume in 1937 under the title *A Guide to Merchandise*. The book jacket promotes this volume as a necessary home reference work: "Every household needs one copy! Before you go shopping, take a look at this book first!" In the preface, the editors offer the following reasons for the publication:

> As we were publishing the articles [we heard that] department stores and shops were using them as materials to include as part of a clerk's education and that girls' schools and finishing schools were clipping the articles in order to make a single reference book on everyday products.
>
> Also, we wanted to help increase the proper awareness of everyday products among the general populace [*ippan no hitobito*], and we thought it could be used as a reference when buying and choosing the products that we have included in this volume.[21]

A Guide to Merchandise is filled with small articles on over 280 different products arranged according to several categories. Under "Foodstuffs" are such topics as rice, noodles, canned goods, eel, beef, biscuits, fish cakes, soba, butter, beans, konbu, bonito flakes, sake, tofu, peaches, edamame, and tomatoes. The editors offer details on fountain pens, ink, watercolors, and school bags in the "Stationery" section. Dress shirts, shoes, umbrellas, neckties, sweaters, raincoats, and socks are some of the products treated in "Accessories and Men's Furnishings." In "Miscellaneous," we find tips on everything from tents, irons, and cut glass to shoji paper, charcoal, and Buddhist altars.

The individual articles, ranging from one to three pages, typically describe the product in detail and then advise shoppers what to look for when choosing that product in the store. When buying sesame oil, for example, you should choose oil that is amber in color and clear.[22] Did you know that originally mosquito-repellent incense (*katori senkō*) was made from the petals of the Dalmatian pyrethrum, a vermifuge chrysanthemum? Because it is too expensive and difficult to make into its typical coil shape, these days producers make the incense using a mixture of chrysanthemum petals (50 percent), chrysanthemum stalks (30 percent), and a paste (20 percent).[23] And when buying a necktie, do not be tempted by the pattern of individual ties; rather, you must keep in mind the kind of clothing that you already own.[24]

Tucked between a rather full treatise on fishing gut and a piece on reading lamps is an article on cameras: "A camera is the one thing you want to commemorate scenes and people that will make up your memories of the fun times."[25] According to the editors, you can find a good domestically produced camera for about twenty-five yen or a decent import for around sixty to seventy yen. They advise potential consumers on what to look for when buying a new camera, recommending that shoppers be especially careful about inspecting the lens and shutter before making a purchase. An amateur is not really qualified to judge the quality of a lens, but if he buys one for at least fifty yen, he can be certain that it has passed a rigorous inspection.[26] Just as Suzuki suggests, the editors recommend going to a trustworthy shop and taking a test roll of film before making a final purchase.

The Konishi Roku Brand

When George Eastman visited Japan in the spring of 1920, he accepted only two invitations to receptions in his honor among the many that he was offered.[27] One of them was hosted by Konishi Rokuzaemon, the

founder of Konishi Roku, who hosted a banquet at a hall in Ryōgoku on the evening of 28 April.[28] Konishi Roku was Japan's leading producer and retailer of camera and light-sensitive materials in the first half of the twentieth century. Rokuzaemon invited more than 120 people—photographic industry leaders, famous photographers, and most important, the press—to welcome Eastman to Japan. The guests hailed Eastman, who was most pleased, with the enthusiastic ring of three shouts of "Banzai."[29] As mentioned in the Introduction, despite his very busy schedule, Eastman visited as many camera shops and photo studios as time would allow.[30] One of those visits was to the headquarters and main retail outlet of Konishi Roku on 26 April. There, Eastman is said to have closely inspected and praised Konishi's products, especially a projection printer and a Lily camera.[31] He also had a portrait taken by Ōno Takatarō in Konishi Roku's newly outfitted photography studio that was published as the first gravure in the May 1920 issue of *Shashin geppō*.[32] Eastman's visit to Japan was highly publicized in the photographic press. And his brand, Kodak, was well known among even casual photographers. While it may not have sparked the same level of public excitement that Charlie Chaplin's visit did several years later in 1932,[33] Eastman's tour gave the top camera makers, especially Konishi Roku, the opportunity to publicize their names alongside Eastman's and to garner some of that international acclaim and reputation for their own cause.

Long before Eastman's visit in 1920, however, Konishi Roku was already held in high regard, at least within Japan and the Japanese colonies, and was well known for its success at producing cameras and photographic materials that were both reliable and relatively affordable. In addition, Konishi Roku was one of the earliest examples of a Japanese company embracing modern marketing and retailing strategies to promote not only its own products but also a more general awareness of its brand and to actively promote a strong association of a brand with an entire product category and field of consumption.[34] Rokuzaemon had seized early upon an easily recognizable, iconic trademark—the cherry blossom (Figure 1.1). Later the design was simplified into an elegant flower pattern with the character for the number 6 (*roku*) in the middle of the petals.[35] The cherry blossom was also the inspiration behind the name of Konishi's production company, Rokuōsha, established in 1898. The name "Rokuōsha" was a combination of the "Roku" of "Rokuzaemon," the adopted trade name of Konishi Roku's founder, Konishi Rokuzaemon (né Sugiura Rokusaburō), and a play on the Chinese

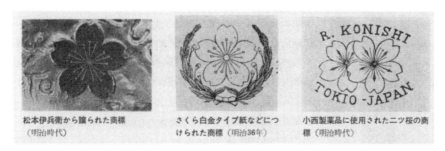

松本伊兵衛から譲られた商標
（明治時代）

さくら白金タイプ紙などにつ
けられた商標 （明治36年）

小西製薬品に使用された二ツ桜の商
標 （明治時代）

FIGURE 1.1 Meiji period Sakura trademarks. Konishi Rokuzaemon had seized early upon an easily recognizable, iconic trademark—the cherry blossom. Reprinted with the permission of Konica Minolta, Inc. Source: Konishi Roku, *Shashin to tomo ni hyakunen*, 39.

reading of the character for cherry tree (*sakura*). The new production facility was located in Yodobashi-chō, in suburban Tokyo, where it is said that Rokuzaemon had seen many lovely cherry trees in full bloom at the time he purchased the land.[36] Sakura was also the brand-name for Konishi Roku's line of film products and developing materials. An advertisement for Sakura Film and Paper Products from 1936, shown in Figure 1.2, shows the way that Konishi Roku's designers incorporated both the company trademark and the theme of cherry blossoms into product packaging.[37]

A Modern Department Store for Photography

Konishi Roku's efforts to promote its name and reputation extended well beyond trademarks and packaging. The brand's Nihonbashi shop and headquarters transformed a typical Meiji-era shop (Figure 1.3) into a glass and granite goliath in 1916 and stood as a monument both to photography and to the modern shopping experience, replete with huge plate glass windows and dressed with an escalator, welcoming staff, and mahogany waiting area (Figure 1.4).[38] The scale of Konishi Roku's new shop and its connecting annex, its incredible diversity of goods related to photography and lithography, and the attention to attractive display contributed to the image of the newly built shop as a "photography department store."[39] It is worth noting that this particular department store experience was created for male consumers. Despite the attention that scholars have given to the department store as *the* sphere for women's public participation in the economy, retailers like Konishi Roku were acutely aware that the majority

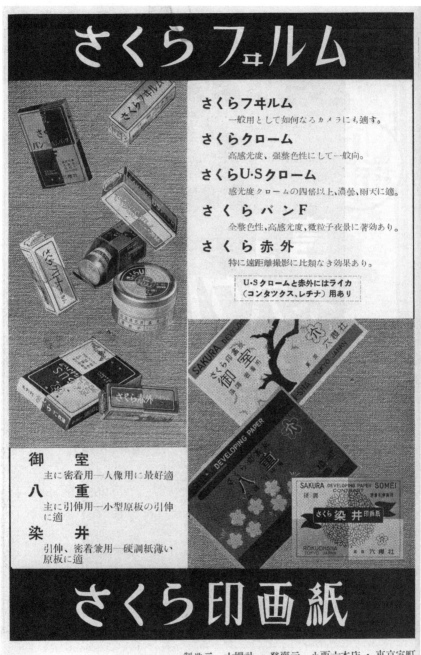

FIGURE 1.2 Advertisement for Sakura products. Konishi Roku's designers incorporated both the company trademark and the theme of cherry blossoms into product packaging. Source: *Asahi kamera* 21, no. 4 (April 1936): n.p.

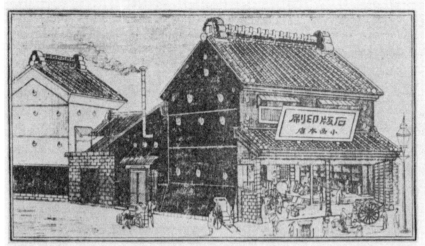

明治10年代の小西本店（店は昔ながらの土蔵造りで石版材料を求める人々が賑やかに出入りしていた。看板でもわか
るようにこのころは石版関係の商品が主であった）

FIGURE 1.3　Konishi Roku's shop in the 1880s. Meiji-era *dōzō-zukuri*-style shop. Reprinted with the permission of Konica Minolta, Inc. Source: Konishi Roku, *Shashin to tomo ni hyakunen*, 23.

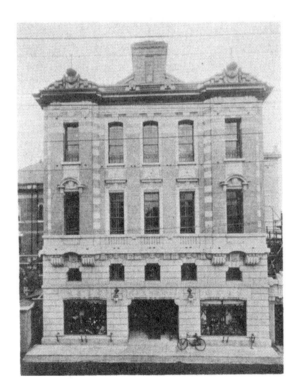

FIGURE 1.4　Konishi Roku's shop and headquarters, Nihonbashi, 1916. The glass and granite goliath built in 1916 stood as a monument both to photography and to the modern shopping experience. Reprinted with the permission of Konica Minolta, Inc. Source: *Shashin geppō* 21, no. 6 (June 1916): n.p.

of their customers were men and created a suitably masculine atmosphere for their clientele, befitting, in this case, the store's location in the bustling commercial and office district of Nihonbashi.

Two large plate glass show windows framed the central entrance to the store. The window on the right displayed goods for photographic printing, and the window on the left displayed cameras (Figure 1.5).[40] Though glass had been used at the entrance of some shops from the mid-Meiji period, plate glass show windows were part and parcel of the retail revolution taking place in urban Japan from the late nineteenth century. Guides to new retail practices highlighted the importance of well-appointed show windows in attracting passersby: "Artfully decorating the inside of a show window is

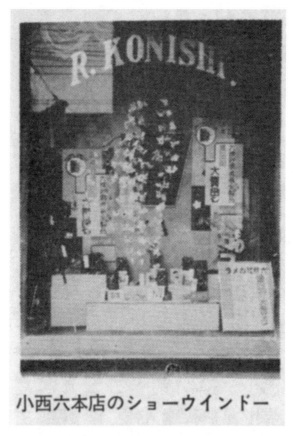

小西六本店のショーウインドー

FIGURE 1.5 Konishi Roku's shop window display, 1924. Plate glass show windows attractively displayed goods for sale in the shop. Reprinted with the permission of Konica Minolta, Inc. Source: Konishi Roku, *Shashin to tomo ni hyakunen*, 313.

one method to make passersby stop and draw customers in both indirectly and directly."[41] The first retail establishment to incorporate the plate glass show window was the venerable Mitsukoshi Department Store in 1903.[42] That same year, an Osaka manufacturer had successfully produced thin plate glass suitable for show windows. Prior to that, all plate glass was imported.[43]

Upon entering Konishi Roku, customers could see an escalator to their left that beckoned them to the second and third floors. Though the escalator had been introduced to Tokyo commuters as early as 1902 at the Mansei-bashi railway station, Mitsukoshi again was the first retail establishment to include one in its newly rebuilt shop in Nihonbashi in 1914.[44] While escalators "possessed the same magnetic appeal and drew crowds to the department store for the chance to ride up and down the moving stairs," the motivation behind incorporating them had as much, if not more, to do with managing crowd flow.[45] Though it is a bit difficult to imagine that the designers of the new Konishi Roku headquarters included an escalator for the purpose of crowd management, they certainly saw the draw such a device could have for shoppers or the simply curious.

The show windows were not the only area of the shop devoted to display. Throughout the shop, merchandise was arranged attractively in glass cases (Figure 1.6). All kinds of products were on display, including a variety of Eastman Kodak cameras and magic lanterns, lenses, tripods, albums, enlargers, and numerous other photography-related commodities.[46] Example photographs exhibited expertly filled all of the wall space of the shop's interior.[47] Innovation in product display was integrally tied to emerging retail sales methods.[48] Soon after the original shop opened its doors in 1873, it had adopted a new kind of "free-entry" system of shopping in which products were displayed in cases and customers could enter the store to look at products at their own leisure.[49] The incorporation of glass showcases, a radical change in merchandise display, had begun in the late Meiji period when the top retail operations like Mitsukoshi began to replace the traditional "sitting-sales" style of retail with the "display-sales" method.[50] Takahashi Yoshio of Mitsui Gofuku (what became Mitsukoshi Department Store), the man who is credited with bringing modern retail practices to Japan, described the system of sitting sales in the following way:

> Around [the shop] hang deep blue *noren* with the character *etsu* in a circle.[51] There are eleven departments with head clerks [*bantō ukemochi*]. The customer looks for the familiar *bantō*, and when he places an order, with the customer standing there, the *bantō* calls out in a booming voice, "Boy,

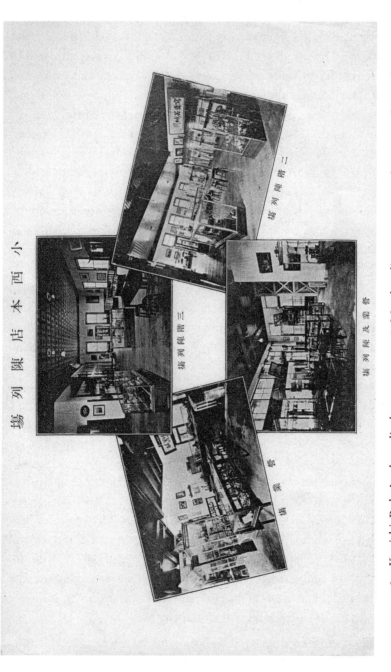

FIGURE 1.6 Konishi Roku's glass display cases, 1916. Merchandise was arranged attractively in glass cases throughout the shop. Reprinted with the permission of Konica Minolta, Inc. Source: *Shashin geppō* 21, no. 6 (June 1916): n.p.

bring me the such-and-such." Upon hearing this voice, the shop boy brings the merchandise from the warehouse and places it on a flat square board. The *bantō* takes the merchandise and shows it to the customer. Because the inside of the shop is veiled in a thin layer of darkness due to the deep blue *noren*, [it is important] to display the goods well. Furthermore, it is best to bring as few goods out as possible in order to satisfy the customer.[52]

Glass showcases and well-organized shelving, the heart of display sales and the free-entry system, allowed the presentation of many items at once and cut out the need for shop boys running to and from the warehouse, optimizing floor space, and saving time and employment costs.

A stairway located to the right of the Konishi Roku entrance took customers to the second floor and deposited them in front of a hanging ink scroll by Tokugawa Keiki (1837–1913), the final shogun of the Tokugawa reign.[53] The second floor was the main display and sales area for cameras. On that same floor was an elegant waiting area with a large Chinese table surrounded by twenty-three color prints and carbon portraits as well as the painting *The Bath* by Victorian painter and sculptor Lord Frederic Leighton (1830–1896). The third floor was devoted to Konishi Roku's lithographic machines business, binoculars, and various kinds of lenses. It also housed a small office space for *Shashin geppō*, the monthly photography magazine published by Konishi Roku. A small observation tower on the roof was accessible from the third floor and allowed guests to look over the eastern part of Tokyo. Viewers could see as far as Yasukuni Shrine, Nikolai Cathedral, and Ueno Park. The tower also afforded customers a place to test out telescopes and binoculars on sale in the shop. The annex, a three-story wooden structure that connected to the main shop via a passageway on the second floor, was the display area for larger products such as lithography presses and studio furniture. The annex also boasted a fully equipped darkroom on the third floor. In both buildings, all the available wall space was covered with more than two hundred example photographs using Konishi Roku's most popular products. Finally, the third floor of the annex was made into a photography studio, with a large darkroom and sloped ceiling windows to allow for natural light, where such luminaries as George Eastman and the Taishō emperor had their portraits taken.

This department store for photography did not survive the Great Kantō Earthquake of 1 September 1923. Like most Nihonbashi retailers, Konishi Roku lost all of its merchandise in the subsequent fires. One month later, Rokuzaemon opened a small temporary shop on the grounds of his produc-

tion facility, Rokuōsha, on the outskirts of Tokyo (Figure 1.7).[54] The flagship shop was reopened in its original Nihonbashi location on 26 March of the following year. Although the shop and offices operated out of a much smaller barrack-style building for nine years, planning had already begun by early 1928, in conjunction with the reconstruction of Tokyo, for building a more permanent presence. One thousand people were invited to the grand opening of Konishi Roku's new five-story shop on 15 March 1932, but the new structure looked more like an office building than a palace to shopping (Figure 1.8). It had none of the grandeur that the Taishō building offered its customers. In the new shop, white-collar employees who worked in the neighborhood could leave their staid office buildings to browse in Konishi Roku's rather lackluster, if efficient shop.

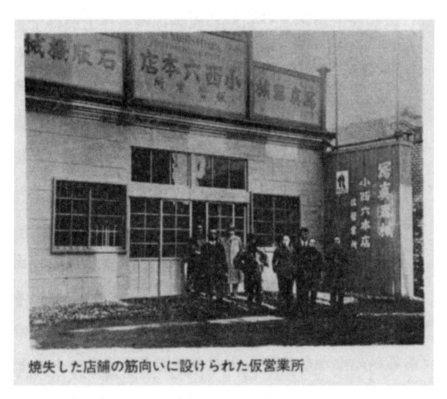

焼失した店舗の筋向いに設けられた仮営業所

FIGURE 1.7　Konishi Roku's barrack-style temporary shop, late 1923. Konishi Roku's small temporary shop on the grounds of its production facility, Rokuōsha, on the outskirts of Tokyo, opened after the Great Kantō Earthquake in 1923. Reprinted with the permission of Konica Minolta, Inc. Source: Konishi Roku, *Shashin to tomo ni hyakunen*, 311.

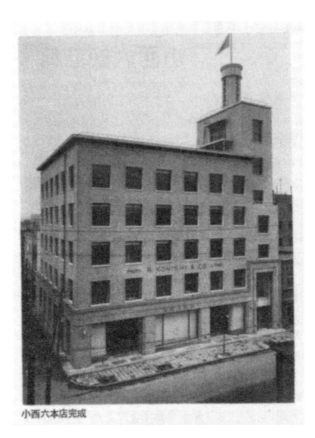

小西六本店完成

FIGURE 1.8 Konishi Roku's new headquarters and shop, 1932. Opened on 15 March 1932, the new shop looked less like a department store for photography and more like an office building. Reprinted with the permission of Konica Minolta, Inc. Source: Konishi Roku, *Shashin to tomo ni hyakunen*, 374.

Rationalizing Retail

In 1911, an advertisement on the first page of the April issue of *Shashin geppō* announced the addition of several new telephone numbers by which to reach Konishi Roku: "We apologize for the fact that we have had only three telephone lines up until this point and that it has continually been an inconvenience for our customers," especially when arranging for the "delivery of carefully selected merchandise."[55] To supplement the three existing telephone lines, Konishi Roku added seven more: four to the main shop, one to the Printing Materials Section, and two to Rokuōsha's offices. Though perhaps an incremental change, increased telephone access to the shop was entirely

consistent with Konishi Roku's larger mission to bring photography to an ever-greater number of consumers by catering to customer expectations of high-quality goods and services. Indeed, all of the early twentieth-century transformations of the shop—its architecture, sales techniques, and display methods—were aimed at achieving that goal. Increased accessibility and efficiency—and the resultant increased profit margin—were driving forces behind Konishi Roku's efforts to modernize its day-to-day business operations, and the company adopted one after another forward-looking administrative strategies and new management techniques. The restructuring of the headquarters on the outside paralleled efforts to reorganize its management style and workforce on the inside.

Among the many administrative changes, double-entry bookkeeping rationalized Konishi Roku's fiscal record keeping, an increasingly complex procedure as the company evolved from an importer to a major producer and retailer. Konishi Roku abandoned traditional methods of bookkeeping in favor of Western-style double-entry bookkeeping in the late Meiji period.[56] Though major merchant houses of the Tokugawa period used a "quite sophisticated 'double-classification' system of accounting,"[57] there was no uniform practice of bookkeeping and the management of accounts differed depending on the type of business.[58] Generally speaking, pre-Meiji forms of accounting were idiosyncratic and complicated. Most businesses maintained several separate account books—general accounts, stock, sales, earnings, receipts, orders, goods/freight—into which day-to-day pecuniary matters were recorded.[59] Double-entry bookkeeping, however, rationalized accounting and simplified financial record keeping even for complicated businesses.[60] This same rigor characterized Konishi Roku's analysis of sales statistics to place overseas orders more efficiently:

> During those years [the late Meiji and early Taishō periods], I worked in the imports office at Konishi Roku for Sugiura Sennosuke, who instituted modern statistical record-keeping practices. Though it was difficult to make orders with Ilford and Eastman, by making detailed statistics on the volume of imports and sales over the years and by taking into consideration the expected arrival time of goods on order and the market at that time, as well as by carefully investigating what sorts of changes might occur in the market, we determined when the ordered goods would arrive and what quantities to order. It's quite a difficult thing for anyone to predict the business conditions of three months from now or to understand those from half a year ago, so by having years of experience and detailed statistics, you can have a good indication how to handle orders.[61]

In 1902, Konishi Roku completely restructured the main shop's work-force, adding to the growing list of major administrative modifications. Abandoning the "feudal employee naming system that was out of place" for a company of its kind, Konishi Roku adopted more suitable appellations for the employees of a modern enterprise.[62] There were no more *kozō* (shop boys), *tedai* (shop assistants), or *bantō* (head clerks)—all terms connoting a bygone era. Now there were *torishimari-yaku* (directors), *jūshokunin* (managers), *hokuin* (staff), and *minarai* (apprentices).[63] The renaming of Konishi Roku's employees was a small but highly symbolic part of an overall restructuring of the business.[64] Prior to this time, Konishi Rokuzaemon, the founder and still very active president of the company, looked upon his workers as family. But by the turn of the century the main shop had more than fifty workers (not including branch shops or production facilities), and his "family members" were fast becoming "employees." In 1908, the shop revised its "Shop Rules," and much of the new document projected a rationalized, impersonal stance toward employees and their role in the company. In addition to defining the business lines, the rules explained salaries, job titles, and descriptions, as well as working hours, vacations, and benefits.[65] Interestingly, the president of the company was still officially referred to as *tenshu* (head of the shop). *Tenshu* suggests a more paternalistic appellation, harkening back to the nineteenth century, when Rokuzaemon set up shop in 1873.

In the 1908 rules, several articles describe job titles and responsibilities within each division and the relationships between different levels of staff and among the divisions.[66] The main shop had three divisions—Inventory, Sales, and General Affairs—and each division had several operating sections. Each division had a *buchō* (chief), who worked closely with the president. All sections were directed by the *kachō* (section head). Straightforward and impersonal, these articles take on a managerial tone, one that connoted a modern corporate institution. In addition to the regular posts just described, the company had several committees that oversaw different aspects of company operations.[67] Each committee was mandated to hold regular meetings and to share any pertinent information with the relevant divisions and sections. These articles evoke the tenor of a corporation and mark the transition of a successful business into a major corporation.

One article in the section on wages states, "Commuters [*tsūkinsha*, as opposed to apprentices, or *naikinsha*] receive their salaries once a month on the last day of the month. However, if the employee so desires, he can be paid twice a month, once on the fourteenth and once on the last day of

the month."[68] Receipt of a monthly pay envelope, no matter how much or little that envelope contained, was the defining characteristic of modern white-collar work.[69] Though no information remains on the specific salaries of Konishi Roku's employees over the years, articles throughout the document indicate that working hours were long, 7:00 a.m. to 6:00 p.m. from 1 April until 30 September and 8:00 a.m. to 6:00 p.m. from 1 October until 31 March.[70] These hours presumably did not include preparation time before opening and cleanup time after closing. According to Inoue Sadatoshi, a civil servant who conducted surveys of white-collar workers during the early Shōwa period for the government, "The actual working time for department-store workers is about one hour longer than the hours of operation because it takes a good deal of time before the shop opens and after the shop closes to clean the sales floors and to arrange the merchandise."[71] In fact, among all white-collar workers in the early twentieth century, surveys revealed that shop clerks worked the longest hours and were among the lowest-paid salarymen. According to Inoue's analysis, unlike upper-level white-collar workers—civil servants, bank and company executives, professors, lawyers, and judges—who were found to work eight-hour days, clerks at retail establishments, depending on their status and the type of shop, worked anywhere from eight to fourteen hours per day.[72]

Konishi Roku workers, like most other retail workers, had only two successive days off each month.[73] Again, these stipulations correspond to the results of surveys that show retail workers, among all white-collar workers, had the fewest days off each month.[74] While the government bureaucracy and large private-sector companies offered half days off on Saturdays and Sundays, retailers kept longer hours of operation on weekdays, weekends, and national holidays to cater to higher-level salaried employees during their time off. In 1932, participating members of the Association of Department Stores (Hyakkaten Kyōkai), mostly large urban department stores, closed down their operations on each day in a month that had the number 8 in the date (for example, the 8th, 18th, and 28th of each month), in addition to their regular two days off per month.[75]

At the same time Konishi Roku workers were becoming "employees" and "salarymen," remnants of a more paternalistic working environment lived on well into the twentieth century.[76] This is well illustrated in the enumeration of articles under the "Wages" section that pertain to employee welfare and to apprentices, young boys who lived on the premises of the shop and received training to become regular employees upon turning twenty years

of age. The treatment of apprentices[77]—the provision of accommodations, clothing, allowances, and emergency funds—was a holdover from older forms of apprenticed labor.[78] Once apprentices reached the age of twenty, they received a salary. Prior to that, their salary was called an "allowance," and they received only one-third of it for expenses; the remainder was put into a reserve fund.[79] Despite the continuation of these earlier forms of apprenticeship, by 1925 the staff had been cut in half and all clerks and office workers at Konishi's headquarters, except the *tenshu*, were required to wear Western suits and shoes to "renew the atmosphere" (*kibun wa isshin shi*) in the aftermath of the Kantō earthquake (Figure 1.9).[80] With this policy of rejuvenation by Western suit, Konishi Roku workers became true "suited paupers" (*yōfuku saimin*).

Where to Shop for a Camera

Konishi Roku's flagship shop in Nihonbashi was, of course, not the only place where men shopped for cameras and photographic commodities, though it was certainly touted in how-to books and photography magazines as the most reputable. There were so many options, in fact, that first-

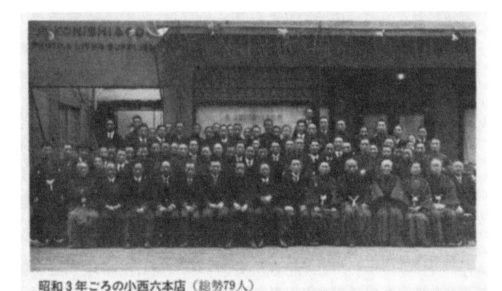

昭和3年ごろの小西六本店（総勢79人）

FIGURE 1.9 Konishi Roku's shop employees wearing Western suits, 1928. Reprinted with the permission of Konica Minolta, Inc. Source: Konishi Roku, *Shashin to tomo ni hyakunen*, 313.

time camera buyers were urged to go to a "trustworthy shop, [because] you will be able to test the camera" before making the final purchase.[81] In the eighth edition of his best-selling how-to book, *Techniques of Hobby Photography* (1919), Miyake Kokki supplements the detailed instructional text with a highly selective list of "Tokyo's Most Respected Camera and Photographic Supplies Shops," including the names, addresses, features, and phone numbers of twenty-seven camera shops in Tokyo. Similar but much slimmer lists follow for Osaka (thirteen shops), Nagoya (one), Kobe (three), and Kyoto (three).[82] According to the *Arusu Photography Annual* for 1926, there were 113 camera shops in the relatively small, but extremely dense area northeast of the Imperial Palace, from Asakusa, Nihonbashi, Kanda, Kyōbashi, to Ginza and then finally wrapping around the palace to the southwest through Hibiya Park into Kōjimachi.[83] Well over half of all of Tokyo's numerous camera shops were located in this area. Nihonbashi and Kanda were home to over forty-five shops (and this figure does not include the photography studios and used-camera shops that also pervaded these areas). This will come as no surprise to students of the business districts of Edo (Tokyo) during the Tokugawa period (1600–1868). Nihonbashi was the principal area for Edo's pharmaceutical businesses and licensed wholesale dealers. These pharmaceutical merchants were the most obvious dealers to take up the new business of the photographic trade in the nineteenth century since the photographic process of the times required not only optical instruments but also chemical products.[84] Early Meiji photography suppliers, such as Konishi Rokuzaemon himself, were often trained as apprentices in merchant houses connected to the licensed pharmaceutical dealers.

THE CAMERA COUNTER AT MITSUKOSHI DEPARTMENT STORE

Department stores, especially upscale emporia like Nihonbashi's Mitsukoshi, also dealt in the camera trade.[85] Mitsukoshi's commitment to the modern culture of retail has been well documented.[86] In that regard, the department store embraced photography as one of the key elements of a fashionable middle-class lifestyle. Mitsukoshi's middle-class and highbrow customers were invited not only to have their photographs taken in Mitsukoshi's photography studio but also to buy their cameras at Mitsukoshi's camera counter and have their film developed there as well. Indeed, Mitsukoshi was home to one of the most exclusive camera shops in Japan. In his selective list of Tokyo camera shops, Miyake states definitively that Mitsukoshi's camera counter "has all the supplies and an abundance of superior cameras and

lenses."[87] Mitsukoshi presented photography as an essential accompaniment to what were touted as the ideal middle-class leisure-time activities, such as travel, bird-watching, and Sunday picnics. The April 1920 issue of *Mitsukoshi*, the department store's publicity magazine-cum-catalogue, featured five high-end Kodak cameras along with a lunch basket filled with canned fruits and ham, chocolate bars, and taffy. The copy reads, "A camera is your best friend to take on a spring walk in the suburbs."[88] Following the discussion of cameras is a description of the lunch basket: "Imagine you are out on a small trip"—say, for a walk in the suburbs with your camera— "[how about] a small, snack-filled basket valued for its convenience and quality?"[89] In the May 1922 issue, cameras were grouped along with portable silverware sets, cosmetic cases, travel guides, and binoculars under the heading "Travel Goods."[90] An eight-page spread later that summer in the August 1922 issue advertised two German cameras as part of a sales campaign, "Preparing for Vacation and Travel."[91] Other fashionable imported goods were offered to ease the burdens of travel—compact parasols, folding chairs, backpacks—as well as to make the journey more pleasurable—a portable record player, sunglasses, a banjo, watercolors, and a folding easel. Together these products made up the essential summertime ensemble for the tasteful traveler. The cameras were the latest models from Germany and were ideal for commemorating one's journeys.[92] While most issues featured cameras as an auxiliary to leisure-time activities, as the tool that would capture these memorable leisure moments, another layout presented cameras in the context of hobby photography, a worthy leisure-time activity in itself. Several expensive Kodak cameras (ranging from 90 to 545 yen) appear with developing chemicals, photographic paper, and darkroom bulbs.[93]

In addition to the camera sales counter, beginning in August 1911, Mitsukoshi launched its one-hour photography service as part of its Photography Studio, which first opened for business in 1907.[94] An advertisement for the one-hour service in *Mitsukoshi* magazine explained:

> With our instant photo service, if you get your portrait taken at 9:00 a.m., it will be ready at 10:00 a.m. Using the latest developing methods currently popular in the West, you have your picture taken in one second; then you can shop for fifty minutes and spend ten minutes in the cafeteria and then return to the Photography Studio to pick up your portrait. One set includes three postcard-sized photographs so that you can send them to faraway relatives as a memento. Buy the stamps in our store; we even have a post box [for your convenience]. You can write a short message on the back.[95]

The price of the service in 1911 was one yen fifty sen. A promotional article detailing the service praises its convenience: "It's practically as if you were having an automatic commemorative photograph taken."[96] Beginning in December 1922, Mitsukoshi's camera counter offered a drop-off developing service that processed prints in twenty-four hours.[97] Through these integrated consumer services, Mitsukoshi and other department stores helped bring photography into the fold of everyday middle-class life.

USED-CAMERA SHOPS

Not listed in how-to books or enumerated in photographic annuals were the numerous used-camera shops dotting Tokyo's commercial districts, most of which offered trade-ins and special exchange programs.[98] Based on the number of ads appearing in photography magazines beginning in the mid-1920s, the used-camera trade was robust and constituted an important retail setting in which cameras were bought and sold. How-to writers, however, were especially wary of recommending these shops. Suzuki Hachirō's warning was particularly strong. In his how-to book concentrating on choosing and purchasing a camera, *Knowledge of the Camera and How to Choose One*, Suzuki clearly warns first-time camera buyers against entering the used-camera market. For experienced photographers, used products made a great deal of sense. But for the uninitiated, the utter plethora of goods available made choosing the right product almost impossible: "If you look at how the models are mixed in with one another [at a used-camera shop], you will understand why I cannot recommend [a used camera] to a first-timer who has no knowledge to distinguish among the differences."[99] Suzuki counsels his readers against the dangers of excess when shopping for either a new or a used camera. In the case of secondhand-camera shops, in particular, getting lost in the allure of abundance can easily lead to an ill-considered purchase. Used-camera shops fill their show windows and cases with so many and so many different kinds of goods that an inexperienced shopper might easily get confused (Figure 1.10). To avoid such a fate, planning and determination are the best defense even for the camera aficionado.

Ads for secondhand-camera shops from the time were similarly chockfull of a mesmerizing amount of data. Minuscule text fills the page for an ad for Kōeidō (Figure 1.11). The legend on the lower right-hand corner explains the marking system used throughout the list of products: "'S' indicates the camera is the same as a new product, 'A' indicates good condi-

FIGURE I.IO San'eidō used-camera shop show window, 1936. Source: *Kamera kurabu* 2, no. 5 (May 1936): n.p.

tion, and 'B' indicates a product used to the normal degree."[100] Almost as if responding to Suzuki's warnings, the ad states repeatedly that Kōeidō is a trustworthy business: "Selling or buying a camera? Head to Shinbashi's trustworthy Kōeidō!" "Kōeidō, the camera shop that you can trust!" "The most trustworthy secondhand-camera shop in Japan!" And the ad takes one more step to convince skeptical readers by offering a "Guarantee of Responsibility" on all cameras whether new or used. In yet another double full-page ad, Osaka's Kawahara Shashinki-Ten promises that customers will not have to haggle, since the real price of each product is clearly marked.[101]

Most secondhand shops sold both new and used cameras, and they also took trade-ins and bought secondhand products. In a full page of ads for used-camera shops that appeared in the 1933 issue of *Kamera* magazine, Kanda's Maruyama claims that it will buy secondhand cameras for the absolute highest prices and especially welcomes trade-ins. On the same page of ads, Nihonbashi's Katō Shashinki-Ten deals in the used-camera trade but also serves as a studio, develops and prints film, and does touch-ups. And Yotsuya's Kamera Tenchindō has a warehouse filled with new and used cameras. Osaka's Kawahara, mentioned previously, opened its shop weekly on

FIGURE 1.11 Ad for Kōeidō used-camera shop, 1937. Source: *Kamera kurabu* 2, no. 7 (July 1937): n.p.

Sundays and holidays especially for the "Amateur Camera Exchange Club. "We welcome the exhibition of ordinary people's used products. Display your goods with the actual price for on-the-spot sales (we take a 10 percent sales commission) or just come to shop."[102]

Given that the price of a new low-end camera equipped with a lens in 1926 was 25 yen (or 34.5 percent of the average white-collar worker's monthly salary of approximately 138 yen), the vibrancy of the used-camera trade in this period is hardly surprising. In this context, secondhand shops marketed themselves liberally to readers of photography magazines. Of the eighteen advertisements for camera shops published in the June 1925 issue of *Kamera* magazine, for example, twelve were for secondhand shops. A little over a decade later, the *only* ads for camera shops in the March 1938 issue of *Asahi kamera* were for secondhand shops.

The proliferation of used-camera shops and ads for those shops indicates both the rapid popularization of photography and the emergence of a hierarchy in camera selling in which amateur practice constituted a niche market and casual photography drove camera and film sales.

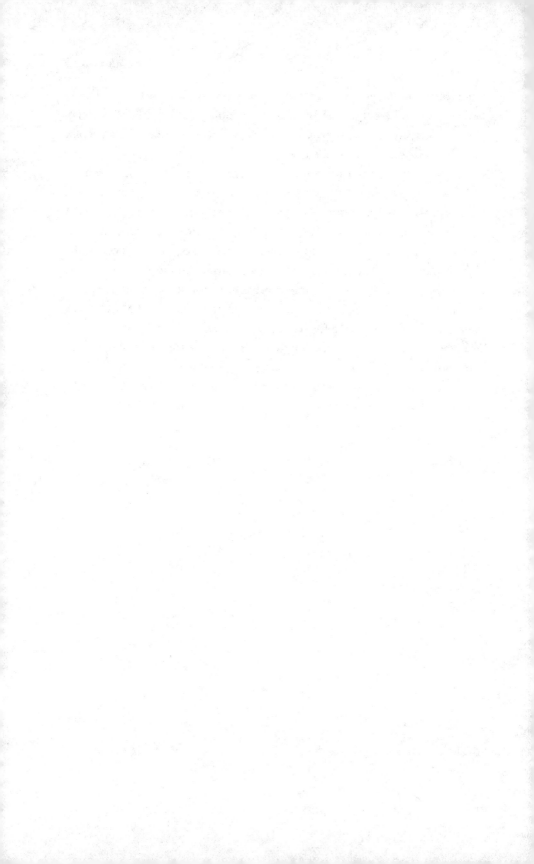

PHOTOGRAPHY FOR EVERYONE

Women, Hobbyists, and Marketing Photography

The popularization of photography significantly expanded when companies were able to produce affordable consumer products that they marketed specifically to casual photographers. From the mid-1920s, companies fostered a division in the camera market between two different kinds of photography consumers. Hobbyists and amateurs, mostly men, would-be expert photographers, constituted one side of this division: a lucrative but relatively stable market. Casual photographers, understood by the industry as mostly women and children, who took pictures but did not develop film on their own, constituted the mass photography market that had enormous potential for growth, especially in sales of film and accessories. Hobbyists and commentators were quick to dismiss consumers in the mass market for photography as unskilled and unknowledgeable, traits taken as virtues by the industry who marketed photography's simplicity. However, the industry understood hobbyists as men and as serious and knowledgeable practitioners. Who these male and female consumers were and how commentators and the industry addressed them in marketing their products are discussed in this chapter.

Celebrating the Invention of Photography

The year 1925 marked a watershed moment in the popularization of photography. Not only did Konishi Roku release the Pearlette camera, the first

Japanese product to be able to compete with the Vest Pocket Kodak camera, but it also marked the one hundredth anniversary of invention of photography in 1825. Though the "discovery" of photography is conventionally attributed to Louis-Jacques-Mandé Daguerre in 1839, the Asahi Newspaper Company, as well as Japan's leading camera and light-sensitive materials makers and other interested parties, planned the Photographic Centenary Commemoration (Shashin Hyakunen-sai Kinen) of the birth of modern photography,[1] which commemorated the year French chemist Joseph Nicéphore Niepce had successfully "obtained light impressions on bitumen spread upon plates of metal" in 1825.[2] Organized by *Asahi gurafu* magazine, the Photographic Research Society of Japan, the Photographic Research Society of Tokyo, the Photographic Goods' Suppliers Association of Tokyo, and the Tokyo Professional Photographer's Association of Tokyo, the centenary celebrations spanned a week of events from 8 to 14 November 1925, including a radio program, photography exhibitions, photo contests, and lectures. The opening-day ceremonies, which included speeches by the mayor of Tokyo and the French ambassador to Japan and various musical performances, were held in Hibiya Park with an audience of more than ten thousand people. Branches of the photographic societies and the Asahi Newspaper Company in Osaka and Nagoya similarly organized a week of events to commemorate Niepce's discovery.

Among the events was a radio lecture, "A Talk on the Discovery of Photography," by Narusawa Reisen for Tokyo Broadcasting Company in which the future founding editor of *Asahi kamera* discussed the details of the invention of photography from the camera obscura to the wet-plate collodion process of the late nineteenth century.[3] The lecture described in narrative form the exhibition of materials related to the history of photography being held at the Hibiya Library for the duration of the celebration. Other talks included a lecture, "Regarding Art Photography," by Fukuhara Shinzō, well-known art photographer and heir to the Shiseidō cosmetics fortune, at the Commemoration Lecture Series, an event that brought over nine hundred audience members together for two evenings of lectures on photography.[4] Exhibitions of photographic works were held throughout Tokyo, including one on art and portrait photography at Mitsukoshi Department Store and another on applied photography—x-ray photography, microscopic and astronomical photography, aerial and survey photography, and so on—held at the Takashimaya Department Store in Kyōbashi. The Outdoor Photography Competition, also held on the first day of the celebration, was per-

haps the most spectacular of the planned events. The competition required contestants to take pictures within four preset themes: the Saigō estate, the centenary opening ceremony, scenes of Marunouchi, or sketches of Ginza. Competitors could submit one photograph per theme. From five o'clock in the morning, over three thousand photographers converged on the 330,000 square-meter Saigō estate in Meguro. The gates opened at nine o'clock, and photographers spent the day snapping their shutters of the various scenes (Figure 2.1). The winning photographs were published in a special edition of the *Asahi gurafu* magazine.

In addition to the organization of the events themselves, enormous energy and resources were spent advertising the celebration and then publishing special editions, articles, and photographs featured in the events. *Asahi gurafu*, *Asahi Shinbun*, and *Shashin geppō* were among the publications that covered the events. Asahi Newspaper Company published two separate volumes in commemoration of the event: *"Asahi gurafu," Special Issue: The Photographic Centenary Commemoration* included all of the exhibition photographs and descriptions of the events; *The Collected Lectures from the Photographic Centenary Commemoration* included transcriptions of all of the lectures, including Narusawa's radio address.

While the events were certainly newsworthy, especially within the photographic world, the sponsors—media outlets, camera companies, and professional photographers—deployed creative marketing techniques to sell not only photographic products but also the pastime of photography, whether that pastime was taking and making photographs or simply looking at them. The results of their efforts, at least as portrayed by the media, were stunning. Participation in contests and attendance at the exhibitions and lectures were by all accounts remarkably high. Event organizers saturated all media outlets, including radio and newspapers, with news and advertisements of the proceedings.

Even a Three-Year-Old Girl Can Do It: Gender and the Division of the Camera Market

The year 1925 was also noteworthy in the history of Japanese photography because it was the year when Konishi Roku produced the first all-pressed metal camera manufactured entirely within Japan.[5] Released in June of that year, the Pearlette was available for purchase at all Konishi Roku outlets in conjunction with the Photographic Centenary Commemoration.[6] Marketed

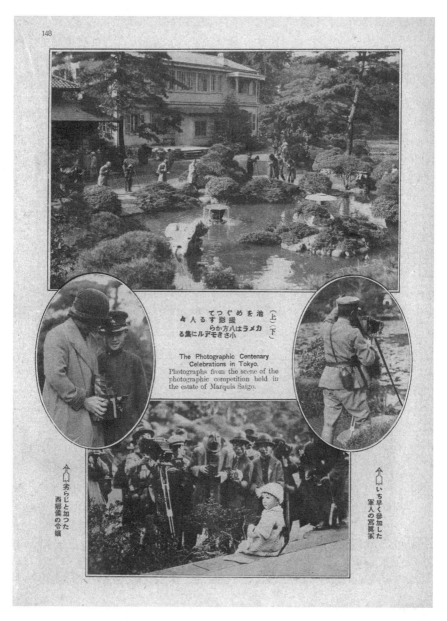

FIGURE 2.1 Outdoor Photography Competition, 11 November 1925. This
competition was held as part of the opening day of the Photographic Centenary
Commemoration. Here photographers converge on the Saigō estate in Meguro,
Tokyo, to snap their shutters. Reprinted with the permission of Asahi Shinbunsha.
Source: Narusawa, *"Asahi gurafu" shashin hyakunen-sai kinen-gō*, 148.

as the perfect camera for beginners, this vest-style camera was represented in advertisements in the hands of young women and described as "easy to use for anyone."[7] In another ad (Figure 2.2), a young woman presses the shutter, and the copy proclaims that the quality and price of the Pearlette cannot be beaten by imports.[8] Here, the use of a specifically female photographer as the model assures the viewer that the camera is simple to use. Simplicity and a reasonable price—these had become the industry's lures for an emerging group of camera consumers. At twenty-five yen, about twice the cost of a tennis racket (between eleven and fifteen yen in 1925) and quite a bit less than that of a bicycle (between forty-five and seventy-five yen in 1925), almost any white-collar worker, even a lowly clerk, could afford the Pearlette.[9] But could just anyone use it? According to the camera companies, not just anyone but everyone could use their new products, even women and children. Konishi Roku places the Sakura camera, a "new, streamlined, handheld camera" made of "beautiful Bakelite," in the hands of a young boy (Figure 2.3). Simplicity and affordability were buzzwords for "made in Japan," and from 1925 Japanese camera makers vigorously competed for consumers who wanted to take, but not make, photographs. In a 1937 ad for the Minolta Vest and Baby Minolta cameras (Figure 2.4), a young child points her camera toward the viewer. Other advertisements proclaimed a simple press of the button was all that was needed; and some cameras were indeed that simple, especially if processing was left to a photo shop.[10]

Though their motives were entirely different, photography critics were in agreement with the companies. For example, Itō Hidetoshi, a frequent contributor to *Shashin geppō*, argued in a short piece about the democratization of photography (*shashin minshūka*) that "a photograph comes to life with the smallest of mechanical actions and just a bit of scientific knowledge."[11] Itō argued, however, that the ease with which one could take a picture threatened to degrade the quality of art photography. As Fukuhara Shinzō, heir to the Shiseidō cosmetics' company and passionate photographer and critic, put it in 1926, photography was so simple that even a three-year old girl could do it (just like the girl in the Minolta ad shown in Figure 2.4).[12] A three-year-old girl clearly represented the lowest common denominator. Though technology for Fukuhara was an essential element and the very characteristic that distinguished photography from the other fine arts, it was ultimately only a tool to achieve the more important work of artistic expression, to project one's inner psyche. Takakuwa Katsuo, a how-to writer, editor, and ardent promoter of hobby photography, heralded this

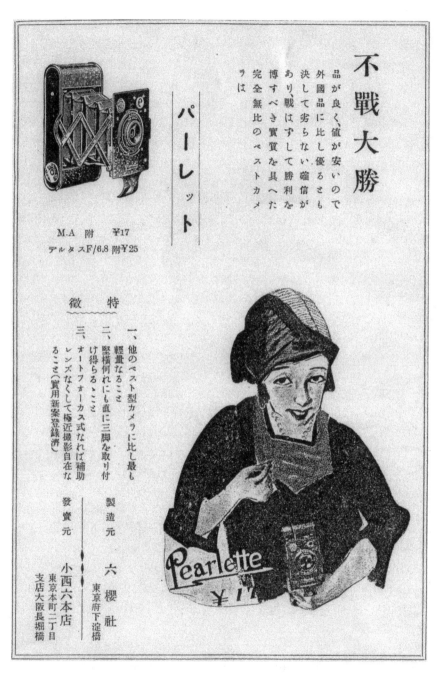

FIGURE 2.2 Advertisement for the Pearlette camera, 1925. Reprinted with the permission of Konica Minolta, Inc. Source: *Shashin geppō* 30, no. 6 (June 1925): n.p.

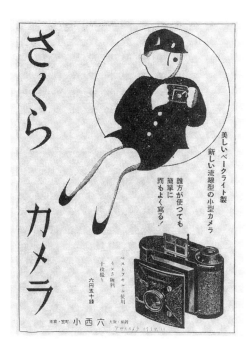

FIGURE 2.3 Advertisement for the Sakura Kamera, 1937. "It's easy to use and takes great pictures no matter who uses it!" Source: Sakai, *Kōkoku ni miru kokusan kamera no rekishi*, 73.

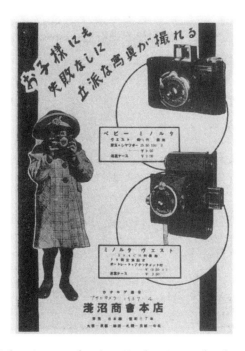

FIGURE 2.4 Advertisement for the Minolta Vest and Baby Minolta cameras, 1937. "Even a child can take magnificent pictures without mistakes." Source: Sakai, *Kōkoku ni miru kokusan kamera no rekishi*, 73.

simplicity as the gateway to a people's art form (*minshū geijutsu*): "Hobby photography is quick, and anyone can do it, and everyone can enjoy looking at the pictures."[13] Both promoters and detractors of popular photography, then, agreed with the industry's claims about the simplicity of new products and techniques.

Yet it is precisely during the mid-1920s that the easiest of mechanical operations (specifically photography) became a favored subject of how-to writing, which by its very nature is meant to demystify a *complicated* set of practices. On the one hand, photographic artists saw simplicity as a threat to the status of their work as art and, thus, quickly dismissed it as unimportant to the creation of a good picture. On the other hand, camera companies touted simplicity in advertisements for their products. These same companies, along with publishers, also positioned photography as a form of complicated knowledge that could be marketed, and mastered, along with cameras and film. Thus, photography in the 1920s and 1930s had not only reached new practitioners via more affordable goods—cameras, film, lenses, cases, chemicals, and papers—but was increasingly commodified as knowledge itself, most prolifically in the form of how-to books targeted at middle-class men.[14] How-to literature glorified complex technique and new technologies while establishing the legitimate technical boundaries of hobby practice.

In literature aimed at the hobbyist, photography was positioned as anything but simple. Part of the appeal of hobby photography was its association with rationality, modern industry, and advanced technological systems. Indeed, intellectuals writing on photographic technologies often figured photography as the child of machine civilization (*kikai bunmei*).[15] How-to writers also claimed a unique status for photography in modern, rational societies. Yasukōchi Ji'ichirō asserted, "Civilized people [*bunmeijin*] and the camera can no longer be separated."[16] Yoshioka Kenkichi maintained that being a modern person (*kindaijin*) is tantamount to understanding the photographic process.[17] Writers and publishers of how-to books promised to demystify photography without taking the mystery out of it and thereby cultivated a sense of distinction from casual photographers, such as the women and children in the ads for the Pearlette. This distinction of hobbyists from casual photographers, whom Pierre Bourdieu refers to as "dedicated" and "occasional" photographers, respectively,[18] undergirded sales to consumers in a niche market eager to participate in the consumption of modern technological products. Writers positioned the process of

taking and making pictures as a highly ordered, rational set of steps that, if carefully followed, would yield positive results. Above all else, hobby photography required attention to order and detail, a good deal of effort and training, and sufficient time and money. Volume after volume detailed each step of the photographic process: purchasing an appropriate camera, setting up the shot, snapping the shutter, exposing the film or plate, processing the negative, and finally printing out the positive. How-to writers unanimously agreed that every one of these steps demanded significant concentration and skill.

What seems to be a contradiction—specifically the positioning of photography as both simplicity itself *and* as a complex set of procedures—is actually a by-product of the split in the camera market and photographic practices. Photography positioned as simplicity was a draw for the first-time photographer, who was likely to pick up a camera to take occasional photographs. By promoting photography as both fashionable and effortless, industry appealed to potential new consumers of photography, such as the young men and women who were fast becoming key consumers of and participants in the ever-expanding world of photography. Though the Kodak system of "just press the button and we do the rest" was not repeated by Japan's domestic camera industry at that time,[19] shops offered developing services so that all a camera owner needed to do was load her plates or film, take the pictures, and bring them to the camera shop for development, leaving the messy, technical aspects to the experts. It was not until the 1910s that camera shops offered customers standardized developing services like those at Mitsukoshi's camera counter. Iizawa Kōtarō, the leading historian of Japanese photography, describes the expansion of the photography market immediately following World War I as growth founded on offering developing services, as well as selling cameras and related goods, to typical users from the "new middle classes," not only to advanced amateurs and professionals. "The majority of these photographers did not have a darkroom at home but rather entrusted development and printing of their film and plates to retailers of the photographic materials industry. . . . By 1920, there were over fifty such establishments in Tokyo alone."[20] Shops sold cameras, cases, and even tripods (photography's hardware) to meet the needs of middle-class customers, Pierre Bourdieu's occasional photographers, who used photography almost solely to document important moments in their families' lives and leisure-time activities. But most important, shops sold film and developing services to those occasional photographers

whose engagement with the camera and the photographic process could now be limited to taking pictures due to innovations in film and camera technologies. The major camera companies peddled their wares to a group of inexpert users who opted to take rather than make pictures. Here, profitability relied on a dependent consumer who looked to shops to process exposed films and plates.

While the industry profited from consumers uneducated about the product they owned and used, camera companies were honing in on an equally lucrative enclave market of would-be photographic experts, Bourdieu's dedicated photographers. These companies marketed the equipment, chemicals, and technical know-how necessary for the entire photographic process to individual hobbyists as well as club and art photographers, who embraced the end-to-end, "do-it-yourself" nature of dedicated practice.[21] And by situating photography as a complex technological procedure, as anything but effortless, how-to books lured the more dedicated breed of hobbyist, but perhaps not yet skillful expert, with appeals to making art with a rational attitude, hands-on production using advanced technology, and laboratory-like workspaces filled with chemicals, vials, and basins.[22]

What Made Her Do What She Did?
The Female Consumer in the Camera Market

Sometimes even the simplest of actions were depicted as too difficult to be left in the hands of a woman, as in the cartoon in Figure 2.5. A group of young, fashionable people are out for a day of fun at the beach. What better occasion to photograph? The young lady with her curly locks takes out a camera; her friends pose for the shot. She's done a fine job setting up the pose. But when she sees the photo she took, lo and behold—a mass of curly locks! Some of us have taken pictures of our fingers, so we understand her embarrassment. She holds her head in disbelief. Never put a woman behind a camera.[23] Though it may strike today's viewer as a minor detail, the fact that the final picture surprises our femme photographer indicates that she herself probably did not develop the picture. By looking at this cartoon in the broader context in which it was published, in a popular photography magazine, a not-so-subtle commentary surfaces regarding the diversification of the amateur photography market. That is, for club and hobby photographers, who were the predominant readers of *Asahi kamera*, the humor of the cartoon derives from the way that the female photographer

FIGURE 2.5 Typical female photographer, 1930. Not only can she not *make* a picture; she cannot even *take* a picture. Source: *Asahi kamera* 10, no. 2 (August 1930): 216.

is portrayed as an ignorant consumer. And what better way to portray a passive consumer than as a young, frivolous female, who can neither make nor take a picture.

"TALKING ABOUT AMATEURS": RETAILERS AND FEMALE SHOPPERS

The 1936 roundtable discussion "Talking about Amateurs" provides a rare glimpse into the emic perspective of the camera retailer. The rather candid conversation, published in the April 1936 issue of *Asahi kamera*, convened a select group of owners and managers of Tokyo's best-known new- and used-camera shops to discuss all sides of their business, from the amateur market and best-selling products to the customers themselves. Most revealing here, however, is the way that the retailers characterized the female and

male shoppers who frequented their establishments. The following, rather lengthy, quoted material provides a unique and intimate view into retailers' attitudes toward their customers. In response to the interviewer's opening question regarding the customers who shop at their stores, the respondents discuss that the kinds of customers they see most often are (male) students and salarymen:

> *Kagata Kōichi (Kaneshiro Shōkai representative)*: Comparatively speaking, we get a lot of white-collar workers and students.
> *Interviewer*: About what percentage?
> *Kagata*: White-collar workers are about seventy percent and students are about thirty percent.
> *Interviewer*: How is it in Nihonbashi?
> *Hosonoya Rikichi (Konishi Roku representative)*: By far, most of our customers are white-collar workers, but of those, most are older [*nenpai no kata*]. Recently we have seen quite a few younger people, but they are not what you would really call regular customers. They mostly come for entertainment.[24] Most of our customers are the comparatively older set.
> *Interviewer*: It's the same for you over at Asanuma, isn't it?
> *Yagi Katsunosuke (Asanuma Shōkai representative)*: For our part, we don't deal much in retail. So I think that most customers head to a retail shop. We do have many retail products on display, but we don't hear the voices of many real customers.
> *Interviewer*: Are the customers over in Kanda mostly students?
> *Ida Shigeru (Miedō representative)*: That's right. About thirty percent of our customers are students. Seventy percent are white-collar workers. And of those, the most common, about half, are shopkeepers.
> *Interviewer*: Of the white-collar workers who shop at Kaneshiro Shōkai, which group is the most common? Bankers? Company employees?
> *Kagata*: Mostly it's people who stop by on their way out for lunch in Ginza or those who stop by on their way home from work.
> *Interviewer*: I guess for Marubiru's Asanuma most of your customers are people who work in Marubiru?
> *Ishii Yūzō (Marubiru Asanuma representative)*: That's the situation. People from the immediate neighborhood are the most typical.[25]

The owners of these camera shops attest to the fact that most of their customers were men, either office workers or students who stopped by on their way home from work or during a lunch break. Prime camera shop locations like Nihonbashi, Marunouchi, and Kanda were centrally located in the capital and served as hubs for business, government offices, and elite universities and secondary schools.

Particularly revealing for our purposes here, however, is how retailers characterized their female and male shoppers. Just as commentators did not take female photographers seriously, neither did the retailers participating in the roundtable discussion. When the discussion moves into the specific terrain of female shoppers for cameras, the retailers' conversation reveals, if only anecdotally, the relatively small number of female customers who actually shopped at Tokyo's leading camera shops. The tone of this particular exchange betrays the lack of seriousness with which the participants thought of female photographers:

Interviewer: Which of you [camera shop owners] see a lot of female customers?

Miyoshi Yūzō (Tamura Nishindō representative): [We do] in Ginza, of course.

Ida: We hardly get any [female customers], but we're in Kanda. . . ."

Kagata: When we do get female customers, most often they are female students.

Interviewer: Well, girls really aren't out-and-out students, are they?

Kagata: That's right. In fact, my daughter is just about to graduate from a women's school. She's a real young lady [*o-jōsan*].[26]

Later, the discussants return to the topic of female consumers of photographic commodities, and in response to a question about the relationship between women and cameras, the patronizing tone is amplified:

Interviewer: What do you think of women who possess cameras?

Hosonoya: Well, if it's for the sake of vanity, I cannot understand how it could be a good thing.

Interviewer: But what if Konishi did some research on the kinds of cameras female students or ladies would possess, such as on the style or color?

Hosonoya: Until recently, we had released cameras in special colors, but they didn't sell at all.

Interviewer: At the risk of being tedious, is there nothing that can be done?

Hosonoya: Well, most of our products are on the plain side—dark browns and greens.

Interviewer: If you think about handbags, many have no color at all; instead, they do something like put a little mark or something on it.

Murakami Tadao (Murakami Shōkai representative): It's best when the color is stylish [*sumāto*].

Yagi: It seems that the color should also have a bit of national character [*kokuminsei*]. But it is an extremely vexing problem. In America, Kodaks are what sell well for [the sake of] vanity.

Interviewer: Over there, isn't it true that there are many very pretty and
 showy cameras?
Murakami: Those models haven't received very favorable reviews in Japan.
Yagi: In the end, Japanese women just don't take photographs.[27]

Apparently, Japanese women were not interested in cameras either for their
expressed purpose of taking photographs or even as fashion accessories.
Even when pressed, rather ardently by the interviewer, the retailers cannot
seem to imagine women behind cameras actually taking pictures. Never-
theless, advertisements and illustrations from the time frequently display
women "wearing" cameras as an accoutrement to a fashionable wardrobe.
In Figure 2.6, the cover of a popular how-to guide, the voluptuous woman
handles the camera so awkwardly that the idea of her actually snapping a
photo is laughable. And, in the advertisement featured in Figure 2.7, the
young lady casually holds her camera almost as if it were a purse.

When asked why women are not interested in photography, however,
the participants' replies move beyond statements about the superficiality of
female consumers. "Let's face it; Japan is still feudal. Photography does not
fall into the realm of women's activities."[28] The interviewer continues to
press this panel of experts, asking them why they have not effectively mar-
keted photography to women. Though the respondents admit that there is
potential camera market for female consumers, the interviewer seems more
interested in this issue than the interviewees do:

Interviewer: Isn't there great room for expansion, say, among female stu-
 dents, especially with heavy advertising?
Murakami: Aren't female students ultimately going to be more or less
 Mrs. So-and-So?
Interviewer: What if you advertised inexpensive cameras to housewives
 as a way to take pictures of their children? Housewives haven't really
 entered the class of people who *take* photographs to the same degree as
 children have. . . .
Interviewer: That is to say, if women are going to take photographs, it
 would be good if they did so when they are on a trip with their hus-
 band, or of their friends and classmates, or if they are brought up in
 homes where photography is practiced. There are quite a few female
 golfers, so there should also be a promising future for amateur female
 photographers if they have some guidance.[29]

The retailers remain unconvinced. And it remains for the interviewer to
offer potential marketing ideas to sell photography to female consumers.

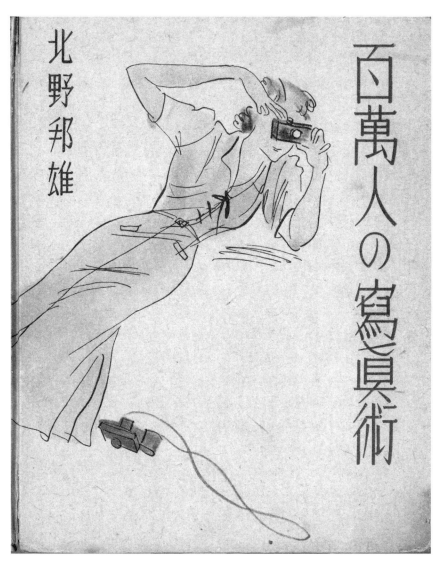

FIGURE 2.6 Cover of *Hyakuman nin no shashin jutsu* (Photographic Technique for One Million People). Source: Kitano, *Hyakuman nin no shashin jutsu*.

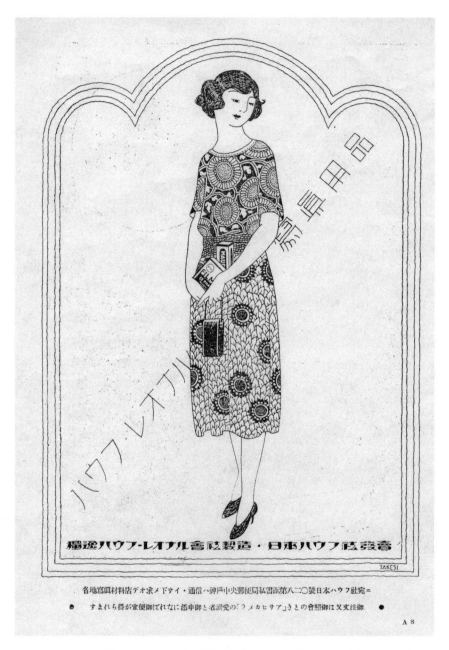

FIGURE 2.7 Advertisement for Haufu Reonaru photographic goods shop, 1930. A young woman sports her camera as a purse. Source: *Asahi kamera* 10, no. 6 (December 1930): A8.

Despite their overrepresentation as consumers of film and their underrepresentation as masters of the photographic process, however, amateur female photographers were, of course, productive and well informed even in the advanced techniques of photography. The extent of their activity is even less documented than for the male hobbyist, but there are references to and small clippings about camera clubs for women, female prize winners of major contests, and contributions by female writers on photography to the major journals. For example, a special article for *Asahi kamera* in 1935 on the state of women and photography, "The March of the Female Photographer," highlights the novelty of women behind the camera.[30] One of the more creative contributions, nine short verses called "A Poem about Photography" by Tsurudono Teruko, describes taking and making pictures—from focusing the lens to pressing the shutter, standing under the red lamp of the darkroom, and printing out her photo on gum paper:

> The lens connects with the black pupils shining
> from the midst of the soft silver fox
> From the nape of her neck to her shoulders
> the lines flow beautifully in a woman's pose
> She smiles just when you focus your lens
> and then you see a beautiful row of teeth
> Are those cosmos fluttering in the wind
> just as you release the shutter?
> The clouds floating above the mountains with wisps
> of purple haze are refracted through the penta-prism
> Looking into the sky, she puts down her camera
> and stretches her legs, tired after taking pictures
> She puts herself into the midst of the dark red light,
> all alone she quietly develops her pictures
> As the radiant sun sets, she chooses a half-plate
> negative, maybe she'll make a gum print?
> Light blue flowers reflect vividly from the negative
> she placed outside in the fair weather.[31]

Though the contributors discuss their experiences in the darkroom and refer to influential how-to books, they do not offer practical tips on photographic technique. Rather, these women write as pioneers, offering confessional accounts of their early encounters with photography, of their attempts to have a career in the studio, and, most commonly, of how

photography serves as an ideal family activity. Sugawara Kiyoko's piece, "Women and Photography," describes how she learned darkroom techniques from her father, a hobby photographer.[32] Yamada Yaeko mentions that her interest in photography was initially sparked after she had her first child. She wanted to be able to document his childhood years. She alludes to a nameless how-to book by Yoshikawa Hayao, one of the most prolific and popular how-to writers of the day, who claims that many amateurs first become interested in photography for the same reason.[33] One author mentions that these days you can even see women pulling out a camera, like the Pearlette, from their purses to take a picture.[34] Ultimately, this series of short, impressionistic essays depicts these women as exceptions. Most women defend their transgression into the masculine world of hobby photography by explaining that the days when the activity was only an option for men have finally ended.

Despite the actual existence of skilled and experienced female photographers, derisive images in the photographic press are evocative of prevailing sensibilities about the gender transgressions of the modern girl. In general, female photographers were the objects of a mixture of awe, as in the case of female tram drivers and pilots, and scorn, as in the case of café waitresses.[35] Images of femme photographers fit stereotypes of the modern girl that the medium of photography itself so readily exploited in popular magazines, picture postcards, and bromide shops.[36] Scorn usually wins out, as the cartoon of our curly-topped photographer shows. Let's return to that cartoon for a moment. When she sees the picture she took, the photographer laments in the caption, "Nani ga . . . sō saseta ka?," which translates as "What . . . made me do it this way?" This phrase, especially as is it written with the ellipsis between *ga* and *sō*, probably looked familiar to readers of *Asahi kamera* that year. On 6 February 1930, the hit movie *Nani ga kanojo wo sō saseta ka* [What Made Her Do What She Did?] opened at the Tokiwaza movie theater and ran for an astounding five weeks. The film depicts the tragic fall of a young woman, who in desperation sets fire to a church.[37] At the end of the film, superimposed onto the burning flames of the church was the subtitle, "Nani ga kanojo wo sō saseta ka." Whether *Asahi kamera* readers equated the bob-haired photographer with the orphan-cum-criminal heroine of "What Made Her Do What She Did?," the cartoon certainly conjured up the prevailing image of the modern girl—the decadent, short-haired consumer that feminist Yamakawa Kikue depicted as "a passive figure who lay supine on a beach and afterward strolled through the town, still

clad in her bathing suit"[38]—and depicts a typical reaction to women who take control of technology, a response not so surprising during a time when controversies raged over the role of women in society.[39]

Domesticating Photography:
Marketing Photography as Family Activity

Just as the pioneering female photographers discussed earlier indicate in their musings, photography was often portrayed as an enjoyable family activity. Indeed, in advertisements and how-to literature, photography was promoted as an ideal family pastime. Photography of the 1920s and 1930s in Japan was strongly associated with middle-class identity, in which the transition to a nuclear family structure was beginning to take hold. Photography was one of the terrains upon which to negotiate tensions accompanying this massive social shift. In his work on the modern home and discourses of domestication, Jordan Sand discusses the importance of the concept of the *ikka danraku*, or the "family circle," in which family gathering and shared pastimes became a central point in moral discourse on the middle-class home and family in late Meiji and Taishō texts.[40] The camera industry borrowed from this discourse, exploiting the emotive elements of photography both as representational lexicon and leisure-time activity. With respect to representation, photographing the family bolstered the concept of the nuclear family as an "autonomous emotional unit."[41] Even as late as the 1930s, companies continued to champion photography as one way to perform the rituals of the family circle. In an advertisement for a stereoscopic camera from 1934 (Figure 2.8), the pleasures of this product are promoted in three contexts: sending family photos to the folks back home, sending photos to your brother studying abroad, and taking pictures of the family circle. Photography brings together father and son through their shared enjoyment of taking pictures together with dueling cameras, as demonstrated in a 1938 advertisement for the Rolleicord and Rolleiflex cameras. In the ad shown in Figure 2.9, son mimics father, and both sport quiet smiles as they aim their cameras.

In the case of hobby photography, primarily the domain of the father-husband, photography could bring the family together. How-to writers offered various suggestions on ways to incorporate the family into this rather solitary pastime. In addition to taking pictures of the family, the hobby photographer could embrace the family circle by incorporating his family directly into pastime activities. How-to writers like Nagai Saburō plainly state, "It

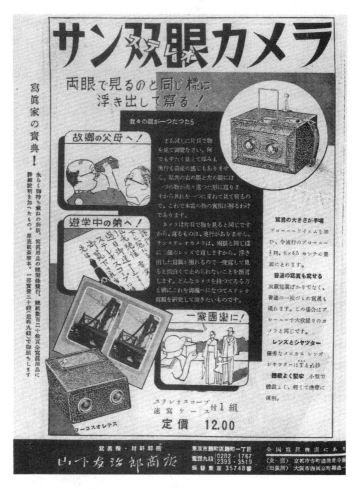

FIGURE 2.8A Advertisement for the Sun Stereo camera, 1937. Source: Sakai, *Kōkoku ni miru kokusan kamera no rekishi*, 74.

FIGURE 2.8B (Detail) "Photography Brings the Family Together!"

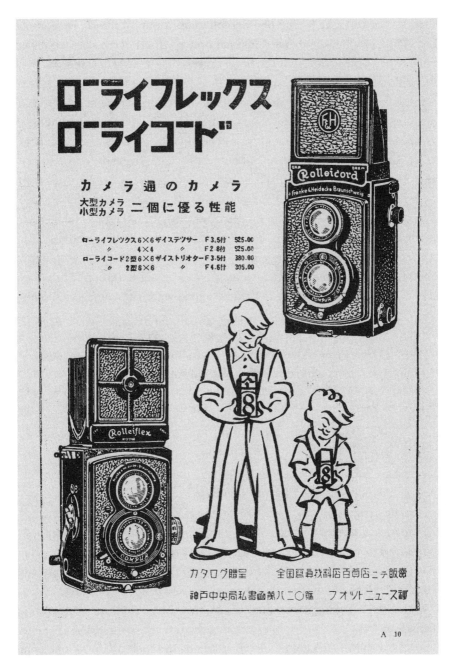

FIGURE 2.9　Advertisement for the Rolleicord and Rolleiflex cameras, 1938. "The camera for the camera expert. Both large and small models excel in their performance." Source: *Asahi kamera* 26, no. 3 (September 1938): A10.

is important to make hobby photography into a family affair." He continues, "Photography is not something that only the head of the household can enjoy. The popularization of the hobby is reaching even wives and children and is deepening their interest in more than just having their pictures taken, but also in taking pictures, and developing and enlarging them, too."[42] And encouraging this hobby among your children, he argues, will prove extremely beneficial from the standpoint of their education. Incorporating the family as active participants into the leisure of hobby photography served as a compromise between a father's familial obligations and his personal enjoyment. In the preface to *How to Take Photographs Easily* (1937), Yasukōchi Ji'ichirō shares an anecdote that illustrates the centrality of hobbies in middle-class family life. He mentions a letter he received from a friend's wife who says that her daughter wants to study at a girls' school where they teach photography. The mother complains that her daughter needs to study at a school where they teach tea and flower arranging to become a good wife. The daughter responds:

> Oh mother, no matter how good at tea and flower arranging you are, you can't please your husband with just these things! The times are moving on. There isn't a person today who hasn't taken a photograph. The foundation of an amicable household is that a husband and wife share the same hobbies throughout their lives. If my husband does photography as a hobby, I want to be together with him and share the same feelings.[43]

In one of the essays in "The March of the Female Photographer" series, wife and mother Yanagita Yoshiko describes how she "assimilates" (*dōka*) into her husband's hobby by becoming the critic of his photographic work.[44] In fact, all members of the Yanagita family participate in the husband's pastime: the youngest son takes the photos, the husband enlarges the print, and the oldest son fixes the images. Madame Yanagita's job is to criticize these joint projects. Once, she even urged her family to submit to a contest a print that she praised highly, and the photo won. Thus, she exclaims, "Isn't it wonderful when a family can participate in a single hobby together?"[45]

Ultimately, looking at the final product of the hobby, the photographs themselves, was yet another way to enjoy the father's pastime and a way to represent the new model of middle-class family, the nuclear family. Images in advertisements for cameras and how-to texts romanticize this understanding of family. Photography theorist Judith Williamson argues, as does Bourdieu with regard to occasional photography, that representations of this "autonomous emotional unit" are highly edited before appearing in the family album. Likewise, how-to writers chose only example photographs that affirmed a

particular view of family. Abandonments, bickering, housework—these equally real aspects of familial life hardly ever appear in family photos. Only the ideal is preserved. In upholding the ideal of the nuclear family, rarely do more than two generations of a single family occupy the same photograph. In Figure 2.10, the multigenerational family is posited as an institution of the past. The meeting becomes a photoworthy event due to its uniqueness, highlighting a distance among family members in an increasingly urbanized Japan. In an equally heartwarming shot of wife and child (Figure 2.11), the affective ties of the happy household are displayed in this splendid little scene of mother picking up after her naughty child and father capturing it all on film. Most images of the family are of mother and child. The father is absent from the picture because he is taking it.[46] Figure 2.12 shows yet another enactment of the nuclear family in hobby photography. This six-framed illustration portrays the wife as family photographer, a rare representation indeed.

久しぶりにあつたお爺さんと探

コンテックス F 5.6. 1/50秒

FIGURE 2.10 "Grandfather and Grandchild Meeting after a Long Time." In this example photograph in a how-to book, the multigenerational family is posited as an institution of the past. Source: Yasukōchi, *Yasashii shashin no utsushikata* (Arusu, 1937), 265.

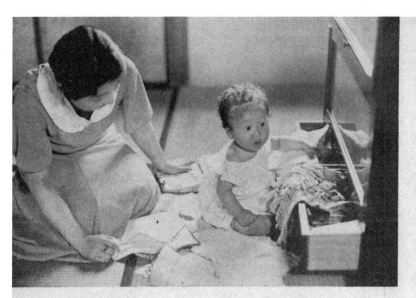

おいたをする赤ちやん

おいたなしてゐる赤ちやん。傍らでお母
さんは樂しさうに見てゐる。組立器、電
燈採光50ワット1球 F 4 5 露出1秒

すね。若し年老いて、自分の赤ん坊時代の寫
眞が、いろ〳〵に撮られて一々説明でもつけ
られて、一册のアルバムにでもなつてゐるも
のを見たら、どんな氣持になるでせう。しか
も兩親の手で、これが作られてゐたとしたら
ちよつと形容のしにくい氣持になるのぢやな
いかと思ひますね。實在を正確に傳へるもの
は何といつても寫眞ですよ。繪や文章である
とたゞ大體の輪廓だけしか知ることができな
いが・寫眞なら少しのいつはりもないのです
からね。

いや大分それ道をしました。これから本題
に入るとしませう。

子供ほど寫眞の題材にとつて面白いものは
ないと思ひます。子供の心は神様のやうなも

255

FIGURE 2.11　"Bad Baby." In this example photograph in a how-to book, the father is capturing the mundane family moment on film. Source: Yasukōchi, *Yasashii shashin no utsushikata*, 255.

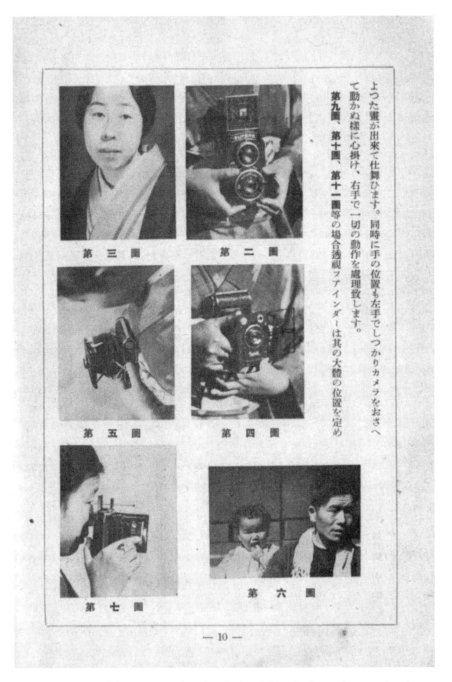

FIGURE 2.12 How to use the viewfinder. This six-framed example photo-graph portrays the wife as family photographer, a rare representation indeed. Source: Kanehara, "Fuaindā wa dō nozoku no ga tadashii ka," 10.

Hobby photography, however, was often practiced as a solitary activity. Despite the encouragement to bring the family into Daddy's pastime, developing film was usually executed in a small, dark space by an individual. And even a small space in the family home could be difficult to find. Jordan Sand has traced the discursive and material transformations of *ie* (hereditary-family temporality) to *katei* (affective space of the modern home) during the late nineteenth century.[47] In particular, Sand documents the feminization of the ideal middle-class home in which "good wives and wise mothers" became efficient household managers and knowledgeable consumers, not only running the home on a tight budget but also appointing the interior in an appropriate, tasteful manner. Along with feminization, the modern middle-class home underwent a significant architectural rearrangement in which a more intimate familial space was separated from the head of the family's work and social space. Thus, a "gender-specific cloister could be retained under the same roof as the family haven without contradiction."[48] Just when the middle-class home had become privatized and thoroughly feminized by physically separating work and social responsibilities from the everyday life of the family, hobby photography, an inherently solitary (masculine) pastime, threatened the new order of the feminized domestic sphere. In particular, the hobbyist's home darkroom recaptured for developing pictures those parts of the house—bathrooms, kitchens, closets, and tatami rooms—that now belonged to his wife. Finding the suitably sized and perfectly (un)lit space for a darkroom not only was a practical spatial issue but also potentially turned the pastime into a antagonistic family affair.

The role of the family in hobby practice was at best presented in an ambivalent way, and exhortations to involve the family in this seemingly solitary activity seem to be nothing more than justifications masking tensions that arose with the configuration of the middle-class nuclear family, the roles and expectations of family members, and the use of time and space in the home. While the context of the family and the family home was potentially fraught with obstacles to pursuing photography as a hobby, many amateurs explored their craft, individually, with the help the numerous instruction manuals on photography. By the 1920s, the publishing industry took up photography as a profitable theme for how-to books, which had exploded

into the marketplace. These books not only taught hobbyists how to take and make pictures; they also suggested to readers the appropriate place of the hobby in their lives. This popular form of literature became another important area where the knowledge about photography circulated and was consumed.

INSTRUCTIONS FOR LIFE

How-to Literature and Hobby Photography

How-to Writing in the Early Twentieth Century

Instructional writing about photography emerged almost as soon as photography arrived on Japan's shores in the mid-nineteenth century. By the 1920s, how-to books on photography were published at fever pitch, and sales were remarkably successful, as illustrated by the fact that Takakuwa Katsuo's iconic how-to book, *Techniques of Film Photography* (1920), sold over ten thousand copies in a single month.[1] Yet this literature has yet to be analyzed in any systematic way. Part of the challenge is that this work rarely appears today in the card catalogues of the major libraries and archives in Japan.[2] Researchers are much more likely to find these churned-out, inexpensive volumes in the corners of dusty, used-book stores and in the piles of unwanted titles at department store used-book festivals. Another reason for the neglect of these volumes is their association with hobby photography, photographic practice that has not received the scholarly attention that art photography has. Though some of the authors of this literature were well known, as either critics or photographers themselves, they remain at best a footnote to the history of Japanese photography.[3]

The hobby market took shape just when publishers and other companies were beginning their wholesale efforts at selling technical knowledge to

audiences in the form of how-to literature. Not only did the books outline the steps of the photo-taking and photo-making processes but they also offered readers, mostly men, a view of the appropriate place of photography in their leisure time and in their homes. How that literature configured that leisure time and those homes is the subject of this chapter. How-to literature provided more than suggestions on photoworthy occasions and technical information on lighting and proper equipment. What was photographable was not defined by technical considerations alone, and the unstated rules for how to use a camera were directly tied to middle-class masculine consumer practices.[4] These mundane materials reveal some of the values that shaped what it meant to be a middle-class man during the period. The camera was figured as a commodity of advanced technological progress, which, if carefully studied, could be manipulated to achieve the goals and intentions of the user. Yet the appeal of such literature to the camera enthusiast was that these texts promised, in a straightforward and no-nonsense manner, mastery of their subject. With the allure of expertise, how-to books offered middle-class men an avenue to ameliorate anxieties about nonproductive time away from work with the reward of productive "free time."[5]

HOW-TO LITERATURE AND MIDDLE-CLASS LIFE

How-to literature on photography from the 1920s and 1930s can be placed more generally into the overall trend in the distribution of knowledge in which information about commodities, just like products themselves in advertisements, was marketed to consumers. The audience for such writing was an educated, even overeducated, group of men and women.[6] Several government surveys from the period show the important place of hobbies in middle-class lives. For example, the Hiroshima Social Affairs Bureau conducted a survey on the living conditions of salaried workers in 1925. Unlike the broader income surveys conducted by the national government discussed previously, the stated purpose of the Hiroshima survey was to "thoroughly inform readers of the material conditions of the social life of Hiroshima's regular citizens."[7] In addition to information on income and expenditures, the survey requested information on the kinds of illnesses respondents experienced and their religious practices and beliefs. Most important for our purposes are the data gathered on hobbies (*shumi ni kansuru chōsa*). The survey asked respondents (heads of household and all members over the age of fifteen) to record their hobbies. In contrast to the national expenditure surveys, the Hiroshima survey asked not only about the

amount of money spent on hobbies (*goraku-hi*) but also about the specific hobbies that respondents participated in regularly. "According to [the survey results], the principal hobbies reported were reading, baseball, fishing, Go, Japanese chess [*shōgi*], music, gardening, exercise, etc. If we look at the data according to the sex of the respondent, for men, the information is the same as reported above; for women, the principal hobbies are ikebana, reading, music, needlework, shrine visitation, theater, etc."[8] Photography appears in both sets of collected data. For heads of household, 21 of 2,173 respondents participated in photography; for other members of the household above the age of fifteen, only 11 of 4,178 mentioned photography. No women reported photography as a hobby. For household heads, 106 different hobbies were listed, and photography ranks number 22.[9]

While social-scientific data reported expenditures for the new middle classes, how-to literature taught them *how* to spend their income. The limited pecuniary conditions of middle-class life increasingly demanded that its members economize, rationalize, and deploy time-saving techniques to their everyday lives.[10] Middle-class life necessitated practical instruction in order to function effectively based on these new principles of management—at least according to the publishing houses that churned out how-to book after how-to book during the 1920s and 1930s. Full-length treatments and magazine articles that doled out instructions for all manner of activity—from running a household on a strict budget to the rules of baseball and dodgeball—occupied a significant and growing percentage of the market for reading materials.[11] Indeed, as we saw in the case of the Hiroshima survey respondents, reading itself was one of the leading pastimes of the period. Much of this how-to writing was geared toward the urban middle classes, who increasingly formed the consumptive base for new products, ideas, and activities and looked to how-to writing for instruction on thinking about and using these new commodities. It is interesting in this regard that the expenditure surveys combined *shūyō* (cultivation) and *goraku* (leisure) in their itemization, a gesture that pointed to the close proximity between these two concepts. And how-to literature incorporated both.

How-to writing employed the voice of an experienced, usually self-appointed, authority who guided the reader through a series of steps in an activity—preparing fried pork cutlets, swimming the breast stroke, developing a photograph—in order to train readers how to do the activity themselves. On the surface, how-to literature privatized the learning process, offering readers a way to continue their education and use their time

productively outside the realm of work (or, for women, how to make better use of their time at work in the home). The popularity of how-to writing also suggests that middle-class consumers were taking up hobbies and self-improvement activities as part of their everyday lives. The breadth of topics covered and the sheer number of volumes produced are remarkable. How-to literature taught readers skills, but it also indicated which skills were necessary to participate in middle-class life. In a sense, this body of writing helped direct and affirm the tastes and leisure-time choices of readers. As they incorporated time-saving techniques into their daily food preparation, readers of books like *Everyday Cooking: Practical Home Cooking* (1925) also learned which foods made the *katei* a home.[12] When they read Kondo Yaichi's *New Golf Techniques* (1936), readers also gleaned what to wear, as well as when and with whom to play. Practical matters were covered overtly while taste and etiquette emerged from within the settings, illustrations, and descriptions of rules and recipes. The range of how-to literature can be seen in Table 3.1, a selected list of how-to titles that appeared in *Publishers' Annual* (*Shuppan nenkan*) from 1926 to 1933.

Examples of this literature have appeared in the fifth volume of Minami Hiroshi's influential collection of primary source materials documenting modern life, *Kindai shomin seikatsushi*, which includes reprints of magazine articles and manuals on Japanese and Western sewing, knitting, and embroidery.[13] These articles were written to assist women in managing their homes economically by illustrating techniques, teaching repairs, and offering tips on how to reuse old scraps of material. But these manuals also provided women with tasteful ways to incorporate products into their homes.[14] Countless how-to books on sports, art, music, and games also appeared in bookshops. Especially popular were guides to golf, social dancing, and baseball.[15] Activities such as bird-watching, hiking, and tennis also provided fertile ground for publishers and readers. Though volumes on Japanese games, arts and crafts, and music were regularly published, they are a minority in the world of how-to publications. Publications concerning middle-class pastimes were oriented to the new and fashionable.

THE COMMODIFICATION AND CIRCULATION
OF PHOTOGRAPHIC KNOWLEDGE

Just like other genres of the modern form of how-to writing, guides to photography had been published since the mid-nineteenth century.[16] Bibliographic data show a dramatic rise in the number of publications about

TABLE 3.1 Selected list of how-to book titles, 1926–1933

Atarashii oyogikata (New Ways to Swim)	Jūraisha, 1931
Atarashii sukii jutsu (New Skiing Techniques)	Meguro Shoten, 1930
Chanoyu dokushū zukai (An Illustrated Self-Study Guide to the Tea Ceremony)	Kinseisha, 1928
Dare ni mo dekiru: pen-ga no egakikata (Anyone Can Do It: How to Make Ink Drawings)	Fūbunkan Shoten, 1933
Inu no kaikata (How to Care for Dogs)	Keiyū-en, 1926
Kamishibai no jissai (A Practical Guide to Picture-Story Shows)	Kirisutokyō Shuppansha, 1933
Karuta no torikata to hisshō-hō (How to Play and Win at Japanese Cards)	Shōbunkan, 1929
Katei Kanri-hō (Methods of Household Management)	Seibundō, 1929
Kendō no tebiki (A Guide to Kendō)	Takeda Toshiyoshi, 1932
Mājan kyōgi-hō to sono hiketsu (How to Play Mahjong and Its Secrets)	Sanseidō, 1929
Ragubii no ABC (The ABCs of Rugby)	Kinseidō, 1930
Rajio no koshō to naoshikata (How to Repair Broken Radios)	Nihon Hōsō Kyōkai Chūgoku Shibu, 1932
Rekōdo no erabikata to kikikata (How to Choose and Listen to Records)	Arusu, 1933
Shakō hōru ni dansu ikeru made (Until You Can Dance in a Dance Hall)	Ōmori Shobō, 1927
Shinkō kyūgi dojjibōru shidō no jissai (A Practical Guide to Modern Dodgeball)	Kōbunkan, 1926
Shōgi shogaku no tehodoki (An Introduction to Elementary *Shogi*)	Osaka: Hattori Fumitaka Dō, 1927
Shoho no jidōsha chishiki to unten renshū-hō (Basic Automotive Knowledge and Methods of Driving Practice)	Kokusai Jidōsha Kyōkai, 1932
Tegaru ni dekiru: Wayō ryōri no shikata (Preparing Japanese and Western Dishes with Ease)	Shōbunkan, 1932

photography from the Bakumatsu period (1845–1867) until the end of the early Shōwa period in 1945.[17] Throughout the Meiji period, publications dealing with photographic technique included manuscripts, books, and papers that described photographic technology or an aspect of it (including x-ray photography), as well as publications that detailed the production of photographic materials (including chemicals and lenses). Ninety-nine volumes were published during the entire Meiji period; the majority are technical papers and instructions for use with specific products. For the much shorter Taishō period (1912–1926), ninety-seven volumes were published, almost as many as in the preceding period. How-to books aimed at amateurs constitute well over three-quarters of those publications. Though camera companies produced the largest share of technical writings throughout the period, nonindustry publishers began to enter into this growing, lucrative field. Maruzen and Hakubunkan were the earliest popular publishers to issue volumes on photographic technique, and by the 1920s specialized publishers, like Arusu and Shashin Geijutsusha, contributed a significant number of texts and journals to the field. But the figure for early Shōwa (1926–1945) is astounding: the total exceeds four hundred, and again the overwhelming majority of volumes are geared toward the amateur photographer.[18] These books include single volumes and multivolume series.[19] The average price of a how-to book during this period was about two yen (the range was from one yen twenty sen to three yen).

Another key avenue in the commodification and circulation of photographic knowledge was the photography journal. The earliest journals for amateurs appeared in the 1880s and were published by photographic supply companies such as Konishi Roku and Asanuma Shōkai. The most well-known examples are *Shashin Shinpō* (Asanuma Shōkai, 1882–1940) and *Shashin Geppō* (Konishi Roku, 1894–1940). Although both were first published as detailed product catalogues and distributed free to customers in their respective shops, by the turn of the century they took on the more familiar form of a popular journal. Photographs submitted by readers were selected and printed in the front. Advertisements for imported and domestically produced products appeared in the front and back. Club activities and photo exhibitions were posted in specialized columns. Most important for our purposes, longer descriptive articles about new photographic technique and technologies—darkroom methods, printing techniques, and recent camera models—filled the pages between ads and images. By the 1920s, magazine shelves at bookstores and libraries carried as many as seventeen

major monthly photography journals, including *Kamera* (Arusu, 1921–1956), *Asahi kamera* (Asahi Shinbunsha, 1926 to present), *Fuototaimusu* (Orientaru Shashin Kōgyō, 1924–1940), *Kōga* (Kōgasō, 1932–1933), *Shashin saron* (Genkōsha, 1933–1961), *Gekkan Raika* (Arusu, 1934–1941), and *Kamera kurabu* (Arusu, 1936–1941).

Despite the numerous volumes of this genre of how-to literature, there was no consistent name for its core readers, those who practiced photography as a hobby. How-to authors often refer to their readers as amateur photographers (*shirōto shashinka* or *amachua shashinka*), recreational photographers (*goraku shashinka*), or photography aficionados (*shashin kōzuka*). Furthermore, though I refer to these guides as "how-to" books, there was no single name for this genre of writing that specified photographic technique and provided instruction. For example, in the fifteen-year period from 1926 to 1941, when the largest numbers of how-to photography books were published annually, *Publishers' Annual* lists relevant titles under a variety of categories, even under several different categories within one year. Depending on the year and the publisher of *Publishers' Annual*, books on photographic technique are commonly listed under *bijutsu* (art), *kōgei* (industrial arts), *shumi* (hobby), or *goraku* (recreation), though sometimes titles of series are listed under *kōza* (educational books) and/or *yoyaku haihon* (subscription books).[20] Among the hundreds of volumes published in the 1920s and 1930s, however, several key words and phrases appear repeatedly in the titles of how-to books on photography, shedding light on the murky boundaries delineating instructional writing. The most frequently used key phrases are *shashin jutsu* (photographic technique),[21] as in Miyake Kokki's best-selling *Shumi no shashin jutsu* (1919) or the expression "verb + *kata*" (how-to + verb), as used in Yasukōchi Ji'ichirō's *Yasashii shashin no utsushikata* (1937). The latter appears so frequently that I feel justified in referring to this kind of writing as the "how-to" genre.[22] Other popular words are *kotsu* (the knack/secret), "noun + *hō*" (the way of + noun), and *yomihon* (textbook).

Handmade Cameras

Despite the near-total coverage of topics related to photographic technique from the 1910s, one aspect of photography that how-to literature did not address was how to make cameras. In an article for the September 1935 issue of *Asahi kamera*, "Amateur Photographic Technique of 30 Years Ago as Told by a Handmade Camera," Yoshikawa Hayao recounts a series of

photographs, dry-plate negatives depicting scenes of Tokyo during the victory celebrations following the Russo-Japanese War (1904–1905), that he made as a young lad of sixteen with his handmade camera.[23] A regular contributor to *Asahi kamera* and prolific author of instructional books on photography throughout the 1930s, Yoshikawa ostensibly wrote the article to commemorate the thirtieth anniversary of the victorious end of the war. Accompanying the eight photographs illustrating the article is a description of the handmade camera that he used to take the photos. Assembled by Yoshikawa in 1901, the camera "was made from a wooden box and the lens . . . , for which I devised a simple shutter attached to the front of the box, was an imperfect and extremely simple lens made from a 10-sen magnifying glass. Then, in the center, I connected a tin plate with a hole in it that was to act approximately as an F/12 aperture [diaphragm]."[24]

Yoshikawa goes on to describe the eight photographs he took, somewhat apologetically, since the camera, being handmade, produced rather clumsy images. And though the pictures are amateurish—a bit out of focus and often off center—Yoshikawa is proud of his small feat of engineering. "For those of you fed up with all of the high-quality cameras of today," Yoshikawa begins the last section of the article, "or, for those of you who have thought of trying to make your own camera, I want to offer some of my own ideas." He follows this up with a "recipe" for a homemade camera.[25] The details are slim, at best—no careful measurements or illustrated plans—and Yoshikawa admits that the readers may have to come up with a few ideas on their own to make the finished product. This lack of detail, however, is consistent with the fact that amateur practice at the turn of the century very often included constructing one's own camera, or at least parts of it. It is very likely that Yoshikawa assembled the camera of his youth following the instructions given in Ishii Kendō's *Crafts Library for Youth: Photography*. Written for boys in 1902, *Photography* describes the photographic process in twenty-six short chapters. In chapter 8, Ishii provides instructions for making a box camera, much like the one that Yoshikawa reminisces about in his article.[26]

Hands-on engagement with the mechanism of the photographic apparatus at the turn of the century was central to amateur practice. Snapshots taken with compact cameras using easy-to-advance roll film were still two decades away. The pioneering amateur photographer was often an ad hoc mixture of machinist, optical engineer, artist, and chemist. Yoshikawa's article is thus also an expression of nostalgia for the good old days of photography when

craftsmanship still governed practice.[27] In this vein, he laments the current trend in which photography is ruled by consumption, convenience, and waste:

> It seems that people are gradually coming to treat photography more and more lightly—taking a picture only to throw it away, taking yet another picture only to destroy it. Perhaps taking so many photos is the natural result of something that has become so convenient. But when I think about how I went all over the place with this handmade camera enthusiastically taking pictures and how those pictures lasted so well until today, from now on I will do my best to refrain all the more from a careless attitude toward taking pictures. Even if the camera is of the lowest quality, more than anything else, the correct path is to put your heart into every picture you take. Today's high-quality camera is already out of date within six months. And then you change to the next model. Perhaps this too is one kind of enjoyment, [participating in] the course of progress, but the foundation of photography is whether or not you take pictures.[28]

Yoshikawa's complaint about the materialistic attitude found among the current generation of amateurs is also a direct comment on the radical change in the relationship between the hobby photographer, photographic products, and practice. With the increasing industrialization of photography, the amateur was reconfigured from an engineer/chemist into a discerning consumer who understood the latest fashion trends and the importance of proper accessorizing.[29]

Yoshikawa's recipe for a homemade camera, rather basic and amateurish like the photos he took with it, was unique in the world of hobby writing at the time. Unlike Yoshikawa's article, most writing about the technical aspects of photography from the 1920s was strictly concerned with the picture-taking and picture-making processes. And by the mid-1930s, the industrialization of photography had so thoroughly removed camera making from the individual, amateur level that the very idea was portrayed in hobby journals as ludicrous. The cartoon shown in Figure 3.1 appeared in the December 1936 issue of *Asahi kamera* a little over a year after Yoshikawa's nostalgic reminiscences.[30] The image of this amateur engineer piecing together a camera from his brother's accordion and his grandfather's reading glasses is certainly droll. The simpleton's act, rather than restoring photography to the craft from which it had emerged, points to the absurdity of making a homemade camera. As the domestic camera industry focused its energies on developing the bifurcated market, it also became the sole purveyor in camera production.[31] And for the industry, hobby photography could no longer resemble a vocation if it were to become a profitable leisure-time activity.

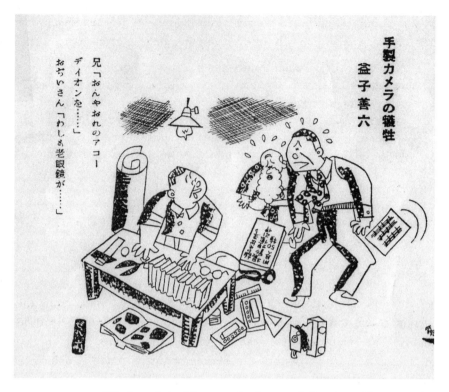

FIGURE 3.1 "Victim of the Homemade Camera." By the mid-1930s, the idea of constructing one's own camera, as portrayed in this cartoon, was seen as absurd. Source: *Asahi kamera* 22, no. 6 (December 1936): 970.

How-to authors of photographic books during the 1920s and 1930s frequently compare the burdensome nature of past photographic practice with the unfettered quality of contemporary photography. For example, in the preface to his best-selling book *Techniques of Hobby Photography* (1919), Miyake Kokki remarks that he gets weary just thinking about the equipment hobbyists had to lug around at the turn of the century. And likewise, "The amateur photographer of today certainly does not want to be mistaken for a commercial photographer."[32] Two decades later, how-to writers continued to tout the freedom afforded this generation of amateurs. The narrative in picture form shown in Figure 3.2 from a 1936 book on enlarging, *Methods of Printing Enlargements*, contrasts the hardships of photography before the invention of dry plates to the ease and freedom of choice afforded by compact cameras, roll film, and enlargers.

昔と今の寫眞術

乾板發明以前の寫眞家は，携帯用
暗室を持運び，撮影前に感光板を
自製しなければなりませんでした

第 1 圖

第 2 圖

便利なロール・フィルム，一握りの小型カ
メラ，印畫は引伸で自由な大きさに――
これが今日の寫眞術です。

第 4 圖

第 3 圖

FIGURE 3.2 "Photographic Technique, Then and Now." The hardships of photography before the invention of dry plates are compared to the simplicity of compact cameras, roll film, and enlargers. Source: Suzuki, *Arusu saishin shashin dai kōza*, 4.

The viewer sees the buffoon in Figure 3.1 with objects strewn about the workspace. On the floor are several books. The only one we can make out is the how-to book *Anyone Can Do It: Shooting, Developing, and Enlargement—a Collection of 50 Tools*: a typical, or rather, stereotypical title adorning other how-to guides from the period, referring to the only truly legible practice for the amateur since the 1920s, taking and making pictures. And how-to publications, along with cameras and film, became a central component in individual hobby practice. In fact, such publications were the primary means by which information about photographic technique circulated.[33] Though how-to writing could be found in magazines, books and pamphlets described everything about the picture-taking and picture-making processes and almost completely excluded camera making as a topic. More telling, perhaps, is that camera repairs were also not an object of knowledge peddling.[34] In fact, Konishi Roku opened its repair service in 1923, alleviating fears about potential mechanical disruption of these complex machines for the occasional market.[35] Even in how-to books dealing strictly with the camera as a technological object, such as Suzuki Hachirō's *Knowledge of the Camera and How to Choose a Camera*, "knowledge" refers first and foremost to presenting readers with the specifications of different brands of cameras for the purpose of shopping for one.

Discipline and Darkrooms: How to Take and Make Photographs

On the surface, how-to books proffer knowledge on mastering all aspects of photographic technique—from buying and getting to know your camera, storing plates and chemicals properly to outfitting a darkroom, making negatives, and printing out photographs. Though the process had certainly been simplified since the turn of the century, all levels of dedicated practitioners still needed, or were at least led to believe that they needed, to consult such texts for the proper execution of the various steps in the procedure. And this was certainly part of the appeal of hobby photography. If occasional photographers took pictures to record important family moments and to participate in the latest consumer trend, hobbyists were seduced by the chance to become an expert, to master the optical machine and the chemistry of light and shadow. Indeed, hobby photography offered its most ardent consumers, shop clerks and low-level office workers, a chance to produce something, to use their hands. The demands and goals of hobby

photography also fed into contemporary notions of leisure for middle-class men who favored "discipline over relaxation, industry over idleness, planning over non-planning in leisure practice."[36]

Discipline, industry, planning—these concepts dominate how-to books. Most books follow a uniform set of step-by-step instructions for each aspect of taking and making pictures and place emphasis on the rationality of the overall approach. Yoshioka Kenkichi's *The ABC's of Photographic Technique* is in many ways an archetypal how-to text. The table of contents alone is thirteen pages of rigorously structured categorization and subcategorization. In the preface, Yoshioka indicates that a rational approach to photography is part of what makes it fashionable: "Just as we want to throw away our clothing of yesterday to cut a new figure, we want [to keep up with] the photographic techniques of 1933, like the trend of small-model cameras, the popularity of enlarging, and the advancement of high-speed developers; and, likewise, in this age of efficiency, photography demands rational handling [*gōriteki sōsa*]."[37] The rational handling of photography is what constituted hobby photography as a suitable pastime for educated, middle-class men. In order to fulfill the demand for a rational approach, Yoshioka offers his book, "the most concise and rational introductory book on photography."[38] "Rational handling" was accomplished by following each step of the process in order. Just as it is natural for a student to advance from nursery school, to elementary school, to junior high, then high school, and university, Yasukōchi maintains that photography too has an implicit, natural order (*junjo*).[39] A newcomer to photography must start at the beginning and patiently follow the steps to become proficient.

As in Yoshioka's text, most how-to books begin with a chapter familiarizing the reader with the mechanics and optics of the camera. Shopping for a camera is also a common preliminary theme, as we saw in Chapter 1. Introductory sections typically discuss the differences among current models and offer tips on where to shop for a camera that suits the reader's needs, style, and pocketbook. Most authors start this section assuring their readers that they do not need to buy the most expensive camera to take good pictures and proceed to lay out the options, by price, extolling the features of moderate and even cheaper models. Typically, the next section, structured around "getting to know your camera," teaches rudimentary vocabulary and explains the various features of different camera models. In the preparatory section of Yoshioka's text, one section, "Anatomy of a Camera in Five Minutes," outlines the fundamental parts of a camera (Figure 3.3) and

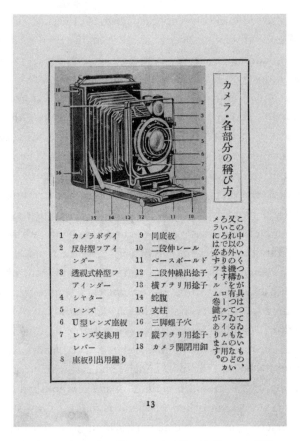

FIGURE 3.3 "Anatomy of a Camera in Five Minutes: What to Call Each Part of the Camera." This illustration outlines the fundamental parts of a camera for how-to readers. Source: Yoshioka, *Shashinjutsu no ABC*, 13.

the origins of the word *camera*, from the Latin *camera obscura*.[40] When we finally wade our way through the 110 pages of preparations, we move into the actual picture-taking process, where we encounter a list giving the order of the picture-taking steps, first for cameras with a tripod and then for handheld, roll-film cameras (both sets of steps end with the all-important rule of putting the camera back into its case after completing the shot).[41] This section also instructs readers on how to load the film and properly hold the camera, as well as the fundamentals of exposure for indoor/outdoor and day/night shots. Depending on the book, there may also be a discussion of flash photography.

Producing a negative is the first step in the process that necessitates darkroom work. Formulas for the various kinds of developing mixtures

take up many pages in how-to books. Diagrams of the proper placement of equipment and figures of the correct handling of film during the process conjure up a laboratory-like environment that the dedicated amateur must maintain to fully engage in the hobby. The darkroom is the hobbyist's mini-laboratory. Just as with all the other steps in the photographic process, hygiene and neatness are the rules of the day in maintaining a darkroom:

> Dark places simply get messy. Because you will no doubt become confused at moments when timing is everything or when you set out to work, wondering where that thing is, you must decide on a fixed and permanent place in which you put that beaker there and this instrument here. It is important to make a habit of this so that you can quickly grab the necessary equipment even in the dark.[42]

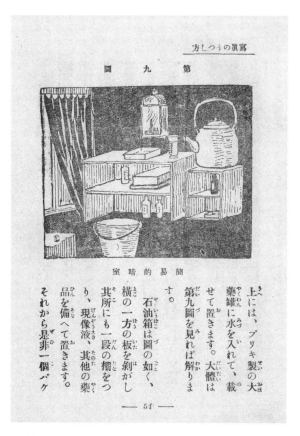

FIGURE 3.4 Illustration of a simple darkroom. Source: Miyake, *Shashin no utsushikata*, 54.

An illustration for a simple darkroom (Figure 3.4) appears in Miyake Kokki's best seller, *How to Take Photographs*. Just as household guidebooks made women responsible for a hygienic home, photographic how-to books made men responsible for a pristine darkroom. The topic of the home darkroom, as elsewhere throughout the literature, required an economical, rational, and now hygienic approach.[43] Clean, ideally running water, basins, and beakers are the instruments that equip the hobbyist's lab, where only properly trained men could engage with photographic science (Figure 3.5). A diagram for a well-organized darkroom is shown in Figure 3.6.

Developing film and outfitting the darkroom presented the hobbyist with one of his most vexing problems: space. As all authors remind their readers, a darkroom is just that, "literally, a 'dark room'"[44]—a room that can be made completely free of white and yellow light. Finding such a space put the hobbyist in a quandary, illustrated in Figure 3.7. Below the bell in the figure are the photographer's standard equipment: scissors, a bucket,

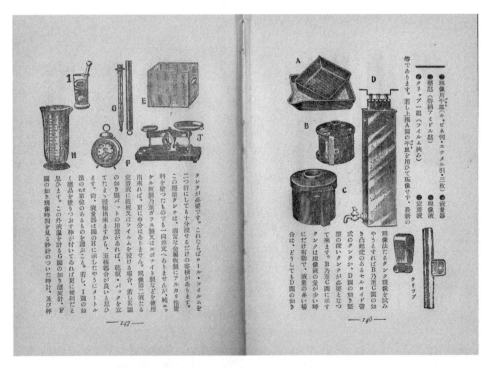

FIGURE 3.5 "Tools You Must Have to Develop Film." Basins and beakers are the instruments that equip the hobbyist's lab, where only properly trained men could engage with photographic science. Source: Rokugawa, *Roshutsu no hiketsu*, 147–148.

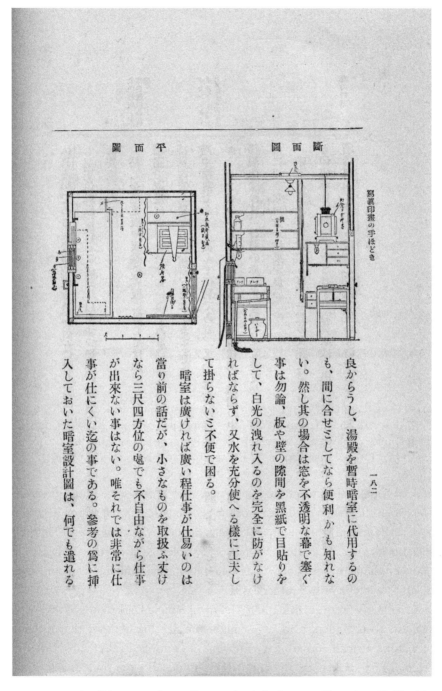

平面圖　　　　　斷面圖

良からうし、湯殿を暫時暗室に代用するの
も、間に合せこしてなら便利かも知れな
い。然し其の場合は窓を不透明な幕で塞ぐ
事は勿論、板や壁の隙間を黑紙で目貼りを
して、白光の洩れ入るのを完全に防がなけ
ればならず、又水を充分使へる樣に工夫し
て掛らないこ不便で困る。

暗室は廣ければ廣い程仕事が仕易いのは
當り前の話だが、小さものを取扱ふ丈け
なら三尺四方位の處でも不自由ながら仕事
が出來ない事はない。唯それでは非常に仕
事が仕にくい迄の事である。参考の爲に挿
入しておいた暗室設計圖は、何でも遣れる。

一八二

FIGURE 3.6　Diagram of a well-organized darkroom. Top view (*left*); side view (*right*). Reprinted with the permission of Hakubunkan Shinsha Publishers, Ltd. Source: Narita, *Shashin inga no tehodoki*, 182.

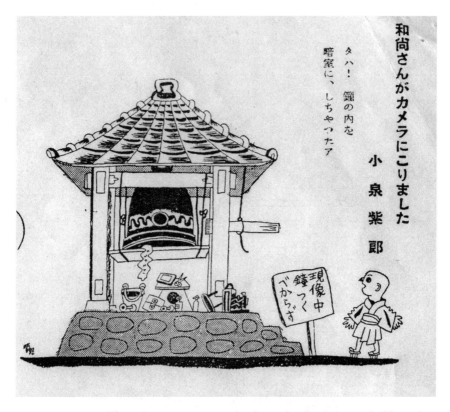

和尚さんがカメラにこりました

タハ！ 鐘の内を
暗室に、しちゃったア

小泉紫郎

FIGURE 3.7 "The Priest Learns a Lesson from the Camera." A hobbyist has
created a makeshift darkroom inside a temple bell and placed a sign outside
the temporary workspace, warning, "Developing, do not ring the bell." Source:
Koizumi, "Oshō-san ga kamera ni korimashita," 970.

and, of course, his camera (no longer necessary at this stage of the process).
How-to authors were well aware of the problem that space, especially space
completely free of white light, created for the hobbyist. Almost every author
suggests a closet (*oshiire*) as the most accessible light-free zone. Others rec-
ommend the bathroom since it has a supply of clean running water and can
be made white-light free rather easily.[45]

In a creative short article, "On Making a Simple Darkroom," Yasukōchi
suggests to beginners who have caught the developing fever that instead
of making a small corner of the kitchen or a cramped closet substitute for
a temporary darkroom, the enthusiast should take the time and a small
amount of money to construct a permanent developing area. "If it's a typi-
cal house, with just a few clever adaptations, you can turn any area into a
darkroom. With just a 4-*shaku* square space, you will be able to work just

fine."[46] Still other authors suggest that a Japanese-style room (*zashiki*) suits the beginner hobbyist best:

> In the summertime, there is no need to suffer the heat by stuffing yourself into a tiny closet. If you just wait for an evening when you can use nature's big darkroom [*shizen no dai-anshitsu*], it will be so much more enjoyable and hygienic. If you completely turn out the electric lights in a Japanese-style room, you can finish it off by completely closing the doors and *shōji*. If there is still some light coming from the moon or from outside the room, close the shutters (*amado*) and you can have the ideal darkroom.[47]

In 1939, Nagai Saburō suggests using as a model for the *zashiki*-style darkroom the official instructions on making your home as dark as possible for blackouts during air-defense drills. For those drills, people were asked to cover holes in their shutters and other spaces with black paper so the light from inside would not spill out. "This same effort and experience are quite useful in making your living room into a darkroom."[48] This is one of the rare instances among the examples of how-to books that I have seen in which the author refers to the everyday conditions of wartime. And as ever in do-it-yourself narrative form, the author takes a restrictive, limiting situation and turns it into an asset for the practical pursuit of leisure.

Following the outline of taking the picture and setting up a darkroom, most authors usually move to the next phase, developing the film, where the chemistry of photography begins. Suzuki Hachirō's *Photographic Mistakes and Their Origins* (1926) is representative here. For him, the most crucial part of the photographic process is *genzō* (developing), the point at which problems most frequently occur. Here, then, lies the motivation for writing a book on the causes of mistakes in photography. In the section on making a negative, which occupies the largest portion of the text, Suzuki goes into great detail on problems that may arise and how to prevent them. And of course, the text rigidly adheres to procedure: "For your photographic technique to advance, even though the photograph you take may not turn out to be a picture, you must follow the steps in order as I have outlined previously."[49]

Making the print from the negative (*yakizuke* or *inga-hō*) is the final basic step in making photographs. Most authors devote a small section, obligatory perhaps, to printing out photos by sunlight. By the 1930s, however, this process seems to have lost its popularity among amateurs, mostly because hobbyists prefer the accuracy of using a lamp rather than natural sunlight, "in which there is no way that you can obtain the expected

results since the amount of sunlight changes hour by hour; the artificial light method has the merit of allowing you to divide up the amount of light that you use."[50] After having dispensed with this charming but utterly passé process, most authors outline the various methods of printing and the various kinds of papers available on the market. The lengthiest discussions of printing concentrate on enlargement (*hikinobashi*), which became one of the biggest fads among hobbyists along with the use of the small-model camera.[51] Paraphrasing an epigram he picked up in a German photography journal, Yoshioka refers to enlarging as "big photographs taken by small cameras."[52] He guarantees that once you try the method, you will catch the enlargement mania (*hikinobashi mania*): "Once you've made it to enlarging, you can say that you have graduated from beginner photographic technique."[53] Figure 3.8 shows the advantages of enlarging, and Figure 3.9 depicts a man using a dodging device, special and expensive equipment promoted by photographic companies. Advertisements for enlargers appeared throughout journals, and companies often awarded them as prizes in photo contests. For example, in January 1925, Konishi Roku sponsored a contest in which entrants had to use one of three of their cameras (the Lily, Pearl, or Idea). The winners were to be awarded medals and prizes including imported enlargers.[54]

Time, like space, complicated and sometimes confounded the hobbyist's pursuits. Exposure times, fixing times, drying times—the entire photographic process revolves around the precise manipulation of time. And hobby photography required a commitment of personal, not only photographic, time. How-to books suggested to readers ways to productively use their time away from work. For example, in *Photographic Mistakes and Their Origins*, Suzuki not only suggests how to make efficient use of free time in pursuit of the hobby but brings the tone of discourse about time management to a Ben Franklin level of moralizing. Suzuki explains that though there are plenty of how-to books that demonstrate how to make a good picture, few reveal why failures happen in the first place or how to prevent them in the future. His presents his motto for the hobbyist: "In the process of making a negative [where failures most frequently occur], find the origin of the trouble and think about how to prevent it [the next time]."[55] His tips stress that a methodical and patient approach to the photographic process will help the newcomer avoid wasting time in the future. "A stitch in time" . . . , "Learn from your mistakes" . . . and "Use your time wisely." In this way, the efficient use of free time is established as funda-

FIGURE 3.8 "Advantages of Enlarging." Illustrations of what a photo looks like before and after it is enlarged, such as this one, filled how-to books and articles in photography magazines. Source: Suzuki, *Arusu saishin shashin dai kōza*, 4.

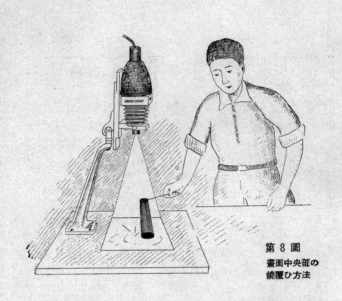

第 8 圖
畫面中央部の
燒覆ひ方法

球を結びつつけたもの，畫面の中に燒覆ひ部分のある場合に，これ等が役立ちます。（第8圖參照）

　Aは比較的面積の廣い場合，Bは狹い場合に用ひられ，綿の方は境界がはつきりせず，またその形をある程度變へられるので便利な場合があります。

　作例1……（第9～10圖）

　夜の劇場內賣店をスナップした寫眞で，ハレーション防止性のフィルムを用ひてありますが，なに分光源そのものを寫し込んであるのでこの部分は非常な露出過度となり，普通に印畫したのでは第9圖のやうにハレーションの害を受けて不明瞭となります。これを第6圖Bの用紙を使つて光源附近を燒出したのが第10圖，これなどは極めて簡單でしかも效果的な場合です。かう

16

FIGURE 3.9　Using a dodging device during the enlarging process. Photographic companies supported the enlarging trend wholeheartedly. Source: Suzuki, *Arusu saishin shashin dai kōza*, 15.

mental to amateur practice. And time was of the essence for this new breed of photographer. Miyake Kokki sympathizes with amateurs. On an occasional Sunday or the even more occasional holiday—a rare break, indeed, from their busy lives—office workers and students pick up their cameras and spend the day in the suburbs, taking photographs all day long, returning home exhausted, only to turn around to go back to work the next day, leaving their exposed films or plates on the shelf for another day. He berates hobbyists who do not develop their own film and plates and instead look to the camera shop as an accessory to their camera. But out of a kind of pity for those not blessed with the luxury of quality time away from work, he offers a list at the end of his book of reliable photo shops where such worker bees could have their films or plates developed.[56]

Man Hands and Female Models

Though readers are addressed as "gentlemen," images of female photographers appear in advertisements for products, fill the pages of how-to books, and decorate their covers.[57] Only one aspect of picture taking is appropriate for these women, however: *satsuei*, or "taking a photograph." *Satsuei* is the most elementary step in photography, so elementary that even a three-year-old girl can do it. If a woman is presented doing the work of photography at all in how-to literature, she is confined to the role of picture taker. It is only in demonstrating how to hold the camera correctly that women appear as active photographers. Thus, the women who surface in instructional writing as other than models in example photographs appear as indices of the level of ease of a particular photographic technique. Figure 3.10 is an illustration of handling the camera and using the viewfinder. Figure 2.12, which demonstrates the family circle, is in fact meant to display *satsuei*. In both cases, the female photographer represents the point being made in the text that the first step in taking a good picture is the careful, proper handling of the camera. In the last illustration on the bottom right in Figure 2.12, we can even see the outcome of this woman's precise (in reality, imprecise) manipulation: a somewhat awkward but charming portrait of husband and child. Though she models taking this picture, she is not represented using a flash, developing the film, or enlarging the print. Indeed, because of her ill-timed snap of the shutter, the portrait turns out to be less than picture perfect, a subtle reminder to readers that women fare better in front of the camera. For example, the image in the third illustration on the top right of

し、移動させることが出
來ます。但し、乾板カメラ
中の高級品に限られて居り
ます。建築物の撮影などに
使はれます。

水準器　よくファイン
ダーと仲善く並んでゐるも
のです。カメラを水平に保
つ道具ですが、仲々安定し
ないものですから、餘り便
利とも思はれません。從つ
て最近のカメラには殆ど見
られなくなりました。

―アイアフニグマ　―ダソイアフ

74

FIGURE 3.10 "Viewfinder, Magnifier." A young woman illustrates proper handling of the camera and using the viewfinder. Source: Yoshioka, *Shashinjutsu no ABC*, 74.

Figure 2.12 was presumably taken by her husband and, though not well centered, is certainly a more standard photographic portrait than the wife's finished product. Figure 3.11 features a female model in an advertisement for Sakura photographic supplies.[58] She is setting up a shot on her Pearlette camera, one of Konishi Roku's most popular cameras, which is placed on a stack of how-to books. On top of the stack is *Kamera/haikingu* (Camera/hiking). This advertisement is remarkable for its mere suggestion that this young girl may be a reader of how-to literature. Contrary to the way

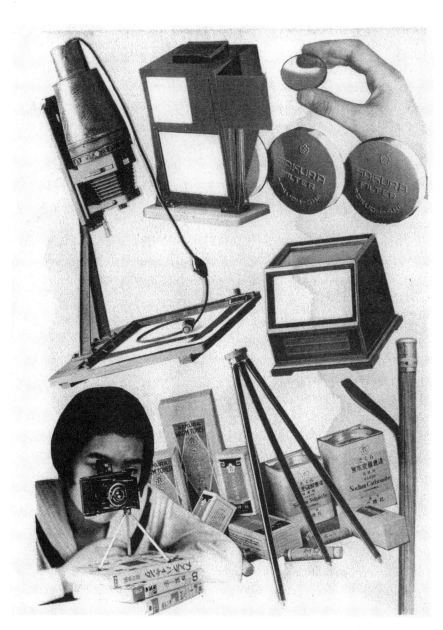

FIGURE 3.11 Advertisement for Sakura photographic products. In one of the more unique images that features a female model, a young woman sits amid a sea of photographic goods, including an enlarger. Reprinted with the permission of Konica Minolta, Inc. Source: *Pāretto gashū*, no. 5 (Spring 1934): n.p.

readers of how-to books are addressed, the message of the ad is that hobby photography is for everyone.

While women appear as mere picture takers in how-to literature, men appear as makers involved in every step of the process. Even the most rudimentary of actions, putting film into a Vest Pocket Kodak camera (Figure 3.12), requires a masculine touch. Most steps in the picture-taking and picture-making processes are demonstrated with the use of disembodied men's hands.[59] More complicated procedures such as mixing chemicals, preparing flashes, and printing out pictures demand a high level of skill and engagement that apparently only men possess (Figures 3.13 and 3.14). The social positioning of hobby photography is strongly informed by these gendered assumptions. Women rarely appear doing men's productive work (leisure) of photography. Men produce; women consume.[60] Or, more precisely, women consume film (by taking pictures) while men produce pictures (by developing and processing film).[61]

Given that women were rarely pictured as producers of photographs, it is hardly surprising that my research indicates that no how-to books written by women were published in the 1920s and 1930s. In photography journals, therefore, articles *by* women on photography are particularly noteworthy. In articles written for *Asahi kamera* in January 1930, two women give advice on sitting for a portrait. Hayami Kimiko's "Having Your Picture Taken Well" and Chiba Noriko's "Makeup and Clothing for Those Having Their Picture Taken" are among the only strictly how-to articles written by women from the period.[62] Hayami and Chiba instruct women on the basics of clothing and makeup for the many photoworthy occasions in a woman's life: graduation ceremonies, club commemorations, *o-miai* (formal meetings with prospective spouses), and weddings.[63] The authors provide extremely detailed guidance on posture, appropriate attire, and, in particular, makeup for black-and-white portraits. In addition to advising readers on everything from how to diminish the gaping-black-nostril effect or how to avoid looking fat or sick because of faulty makeup application, Hayami strongly urges sitters to trust the skill and mastery of the photographer in the same manner as a sick person trusts her doctor.[64] Just as how-to literature figures the hobbyist as a productive male creator, on the rare occasions when women give instruction, the writing conforms to strongly held notions of a woman's proper place in photography—in front of the lens.

ベスドコツダクツののひ使ひ方

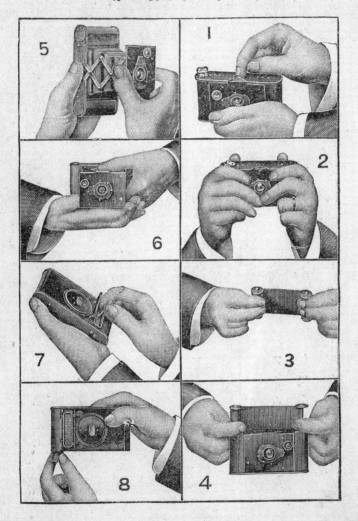

FIGURE 3.12 "How to Use a Vest Pocket Kodak." Even a simple action, such as loading film into a camera, was a man's job. Source: Takakuwa, *Fuimuru shashin jutsu*, 82.

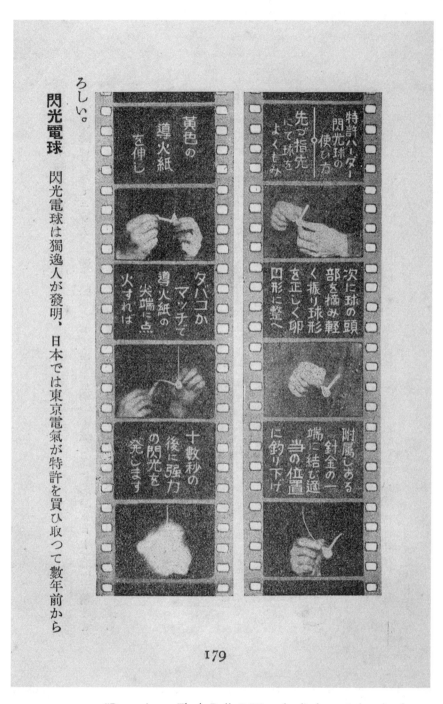

FIGURE 3.13 "Preparing a Flash Bulb." Disembodied men's hands almost always demonstrate steps of the picture-taking and picture-making processes, such as in this illustration of preparing a flash bulb. Source: Yoshioka, *Shashinjutsu no ABC*, 179.

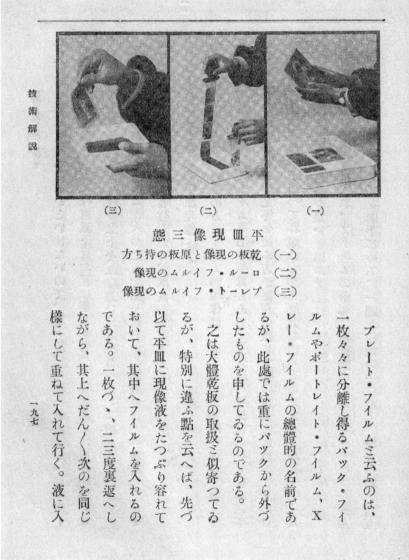

平皿現像三態

（一）乾板の現像と原板の持ち方
（二）ロール・フィルムの現像
（三）プレート・フィルムの現像

プレート・フィルムと云ふのは、一枚々々に分離し得るパック・フィルムやポートレイト・フィルム、Ｘレー・フィルムの總體的の名前であるが、此處では重にパックから外づしたものを申してゐるのである。

之は大體乾板の取扱ど似寄つてゐるが、特別に違ふ點を云へば、先づ以て平皿に現像液をたつぷり容れておいて、其中へフィルムを入れるのである。一枚づゝ、二三度裏返へしながら、其上へだんゝゝ次のを同じ様にして重ねて入れて行く。液に入

一九七

FIGURE 3.14 "Three Steps in Developing, Using a Tray." Complicated operations, such as developing negatives, require skills that apparently only men could possess. Reprinted with the permission of Hakubunkan Shinsha Publishers, Ltd. Source: Narita, *Shashin inga no tehodoki*, 197.

DEMOCRATIZING LEISURE

Camera Clubs and
the Popularization of Photography

By the end of the Meiji period in 1912, the pastime of photography, once a luxury affordable only to Japan's urban elite, was reaching the hands of white-collar workers, shop clerks, and students—young men, for the most part, who had taken up photography to explore the modern world of art and technology.[1] In part, the availability of cheaper, domestically produced cameras and developing materials fueled this popularization. Equally important, however, was the rapid growth in the establishment of camera clubs, arguably the single most effective institution in popularizing the art of photography. Camera clubs offered newcomers and old hands alike a chance to share their photographic experiences within a group of like-minded practitioners. By 1925, according to one poll, there were more than four hundred active photography clubs with a total membership of nearly thirteen thousand.[2]

The camera club was more than a social venue for similarly inclined amateur photographers. The photographic medium gave users access to a means of artistic self-expression and the tools to represent the world as they saw it. By spreading the idioms and practices of artistic expression among a wider audience, camera clubs joined museums, galleries, and exhibitions as primary institutional settings for the democratization of the fine arts in modern Japan. At the same time, clubs operated along democratic

procedural principles and provided members the opportunity to participate in democratically run organizations where they could exercise individual rights not granted to most of them in the wider political system. Seen in this light, clubs must be understood as among the most important spaces for the expression of liberal democratic ideals in the cultural sphere during the first half of the twentieth century. What is unique about camera clubs is that participants came into direct contact with democratic organizational forms through the exploration of artistic practices. This approach to the meaning and role of clubs helps us uncover the content of the "democracy" of the period—how it was practiced and understood by the growing number of middle-class men and women.

The participatory aspect of leisure-time activities, such as club photography, can be traced to at least the early Tokugawa period, when formal gatherings of like-minded artists, writers, and enthusiasts around aesthetic pursuits had become commonplace. Historical sociologist Eiko Ikegami explores the forces behind what she calls the "Tokugawa network revolution," in which groups of people not connected by the usual legal constraints of status began to network with each other, thereby trespassing feudal boundaries and limitations. People explored horizontal and voluntary ways of associating and found genuine joy in immersing themselves in aesthetic group activities and escaping the tedium and constrictions of the hierarchical feudal state structures.[3] The formation of voluntary associations based on common aesthetic interests, such as linked-verse poetry and dance or samisen playing, provided an important space for socializing on a somewhat level playing field.[4] For the early-modern period, Ikegami argues that aesthetic associations, or "aesthetic enclave publics," were safe havens where members could interact with one another unfettered by Tokugawa laws that strictly prohibited horizontal alliances based on political sympathies.[5] Formal socializing based on shared artistic proclivities was one of the few ways that people of different status in early modern society could and did interact somewhat freely.

In the early twentieth century, camera clubs (ideally) offered members a place to gather as artistic equals to explore the technical and aesthetic aspects of photography in a public setting. Members met regularly to delve into photographic techniques and appraise each other's work, activities that very much resemble Ikegami's "aesthetic socializing." Middle-class men, and to a far lesser degree, women, who made up the membership of camera clubs were gaining access not only to the world of photographic goods made re-

cently available to them through modern marketing and retailing but also to the vocabulary and techniques related to the production and appreciation of the fine arts. As venues of aesthetic socializing, camera clubs offered middle-class Japanese people the opportunity to produce photographic art and evaluate the work of others in light of the prevailing notions of what constituted fine art photography. Creating meaningful photographs required members to understand the techniques involved in photographic art and to incorporate those techniques into the making of images. Being able to appropriately judge photographic artwork necessitated a deep familiarity and fluency in the language of photographic aesthetics. Such competencies and fluencies among club photographers were gained in the context of club activities, which brought members into direct conversation with their peers about just what forms, techniques, and styles constituted the photographic fine arts. The camera club was a critical institutional structure through which photographers gained a theoretical understanding of the fine arts and, perhaps more important, put those ideas into practice when taking and making pictures.

While camera clubs most certainly functioned as institutions for democratizing the fine arts through aesthetic socializing, they offer historians an important example of how the new middle classes experienced localized forms of participatory governance, even if they could not always have those experiences as citizens of the nation. Camera clubs were voluntary associations, which, in modern democratic societies, are central to the development of liberal ideals outside the direct purview of any specific political institutions, such as political parties.[6] There has been very little research, however, on the significance of culturally oriented voluntary associations during this period. Clubs devoted to photography, ham radio operation, model plane building, and social dance—pastimes permeating the free time of Japan's new middle classes—offer scholars the opportunity to unravel the connections between cultural pursuits and associational behavior. As I argue in the following pages, these connections reveal not only the new middle class's passion for cultural activities but also their dedication to participatory forms of self-governance in the club context.

A Brief History of Photography Clubs

The foreign loan word *club* (*kurabu*) made its mark on the Japanese language in the mid-1860s. Hashizume Shin'ya details the evolution of the word *kurabu*, starting with its first appearance in the English-Japanese dictionary

Kaisei zōho eiwa taiyaku shūchin jisho, with the definition *nakama* (companions, associates) in 1863. *Kurabu* began to appear in publications with the *ateji*, or character equivalent, 苦楽部, in the 1880s. This character combination indicated a group who came together for a particular purpose and shared in both "the ups and the downs" (苦楽 *kuraku*). At roughly the same time, the *ateji* 倶楽部 began to appear in print. This now-standard combination of characters captures the more commonly understood meaning of the term *tomo ni tanoshimu bu* (a group that has fun together).[7] These linguistic inventions emerged at a time when political activists were organizing societies and clubs around demands for a constitution and broad voting rights. In addition to the aesthetic socializing of the early-modern period, associational life in twentieth-century Japan owed much of its early formation to the rise of the Freedom and People's Rights Movement of the 1870s and 1880s—an antigovernment movement that encompassed a wide range of political dissenters, from samurai to wealthy peasants. Voluntary associations of all kinds—recreational, educational, philanthropic—emerged in the wake of this flourishing political activism.

One of Japan's earliest photography associations, the Photographic Society of Japan (Nihon Shashin Kai),[8] was established in 1889 during the height of avid club formation in the Meiji period. Among its members were William K. Burton (1853–1899) and other foreigners employed by the Japanese government. Within three years of its inauguration, the club boasted more than 150 members, many of whom were members of the hereditary peerage, as well as some of Meiji Japan's most illustrious politicians, businessmen, and educators, including statesman Enomoto Takeaki (the first president of the society) and mathematician Kikuchi Dairoku. Members were extremely wealthy men with sufficient time and money to dabble in this most modern of technologies. Though the society was a social venue for elite male culture, it served for the most part as a forum for members to discuss the technique and art of photography, especially under the tutelage of Burton.[9]

Burton came to Japan in 1887 at the behest of the Meiji government to teach engineering at Tokyo Imperial University.[10] He is perhaps best known as the designer of Asakusa's pre-earthquake landmark, the twelve-story Ryōunkaku. A founding member of the Photographic Society of Japan, he regularly gave lectures to members on new trends in photography. He organized Japan's first international, and extremely influential, photography exhibition in 1893, which was attended by the empress. On display were

some 296 photographs by members of the London Camera Club, including Peter Henry Emerson. With the financial backing of Kajima Shinpei, Burton established the dry-plate manufacturing company Tsukiji Kanpan Seizō Kaisha. The company ultimately failed because the plates produced according to Burton's specifications could not withstand the high temperatures and humidity of Japan's summers. Nevertheless, Burton was one of the most prominent figures in late nineteenth-century Japanese photography. Most of the Japanese members of the society were commercial photographers or owners of photography-supply shops whose primary interest was in the promotion of the still-young domestic photography industry. For example, Egi Shirō of Tokyo's Egi Shōten, a camera and photographic goods supply shop established in 1880, and Ogawa Kazuma (1860–1929), a commercial photographer and owner of Tokyo's Ogawa Photography Studio, were both key figures in the establishment of the association.

From the 1890s, new photography societies and camera clubs were established on a regular basis. While many members of these clubs were commercial photographers or somehow involved in the camera industry, soon more and more members were urban elites who had no connection to the commerce of photography other than as consumers and were simply interested in the art and technique of this increasingly available medium. By the turn of the century, photography had become the pet hobby of many of Japan's leading artists and novelists. Writers like Ozaki Kōyō and Kōda Rohan, as well as painters like Kawabata Gyokushō, looked to photography as an artistic pursuit, a means of self-expression much like novels, poetry, and painting.[11] In part, the attention photography received from the literary and artistic elite helped legitimate its status as fine art. Though it won the acceptance of many, photography as an art form was the source of keen debate on the pages of *Shashin geppō* throughout 1904 concerning whether photography best served utilitarian or expressive purposes.[12] With the establishment of photography clubs like Yūtsuzusha in 1904, founded by Kuno (later Akiyama) Tetsusuke, Katō Seiichi, and Saitō Tarō, art photography came out on the winning side of this battle.[13] By the end of the Meiji period, the art photography movement intensified the establishment of new photography clubs across the country.[14]

While the controversy over the status of photography as a legitimate art is key to understanding the development of photographic style,[15] the debate in and of itself reveals little about why photographic activity was so often organized in the formalized setting of the camera club. Most histories of

club activities are nothing more than accounts of changes in photographic style, in which historians focus particular attention on the role of elite clubs and societies in the debates of 1904 and on the emergence of the high-modernist clubs in the 1920s. Looking at clubs that were not at the center of these high-art concerns, however, allows us to shift our attention to the more common meanings of photographic practice and associational life for ordinary Japanese people.

A Quantitative Look at Clubs and Membership

The number of camera clubs catering to ordinary Japanese people increased remarkably from 1910 to 1920, causing one observer in 1913 to note, "There is no precedent for the number of clubs that have been established this year. So many, indeed, that nearly every month everywhere new photography associations are appearing like mushrooms after the rain."[16] Ascertaining the precise number of camera clubs and active club members for the period under consideration, however, is unfortunately a difficult endeavor. Until 1925, there was no systematic accounting of participation in camera clubs. Among the few important sources for this period are the monthly photo-interest magazines published by Japan's leading camera companies, such as Konishi Roku's *Shashin geppō* and Asanuma Shōkai's *Shashin shinpō*. In addition to articles on the latest photo products, trends, and the work of photographers from Japan and abroad, *Shashin geppō* regularly published information about club activities, exhibitions, and contests in its "Miscellany" (Zappō) section. Typically twenty pages in length, the "Miscellany" column is filled with brief entries submitted by readers that detail the world of amateur photography, from its most illustrious institutions like the Photographic Society of Japan to the humblest activities of provincial clubs like the Ueda Photography Club of Nagano prefecture. For example, the November 1913 "Miscellany" section included information—summaries of club events, the public announcement of club rules, and monthly competition results—for over eighty-seven different activities sponsored by thirty-one different clubs. The other major photography magazine and *Shashin geppō*'s foremost competitor at the time, *Shashin shinpō*, also published a monthly column, "Communications from the World of Photography" (Shashin-kai tsūshin) that listed club events from around the country. Though there is some overlap in listings, many clubs exclusively published information in either one or the other of the magazines. These

miscellany sections provide researchers with an invaluable view into the world of club photography in the early twentieth century.

Unfortunately, these sources cannot provide an accurate estimate of the number of clubs and members from the time. Beginning in 1925, however, the Asahi Newspaper Company conducted surveys that allow for a more precise approximation of the number of active clubs and membership. Under the aegis of the newspaper company, the Association of Photographic Societies of Eastern Japan (Zen-Kantō Shashin Renmei) and the Association of Photographic Societies of Western Japan (Zen-Kansai Shashin Renmei) were established.[17] The company organized these two associations to create networks of information and communication between local and regional photographic clubs. In becoming a member-institution of one of these two leagues, a club made its resources available to the newspaper company in the form of photographs of the local area that could be published alongside articles in the regional editions of the newspaper.[18] As membership in the league was voluntary, the numbers regarding clubs and club membership cannot be considered entirely comprehensive, but they are still telling. From 1925 until 1932, the surveys show that the number of clubs registered with the league increased regularly, from 283 to 873. Membership during the same period generally increased as well, though numbers begin to decrease from 1931, starting with 13,000 members in 1926 (the first year that membership numbers were reported) and peaking at 19,408 in 1930. By 1935, the last year the league conducted the survey, the numbers had dramatically dropped. The editors give no explanation for this decrease, though it is likely to be a result of a decrease in the number of self-reporting clubs.

Democratizing Art Photography: Minimum Photography Club

The camera club served as a kind of classroom where the world of fine arts was introduced through the photographic medium. In the context of the club, members learned not only how to make artistic photographs but also how to evaluate those images in light of prevailing aesthetic standards. High-art exhibitions, even major annual events, often included the exemplary work of club photographers, granting these humble practitioners, at least temporarily, the status of "exhibited artist." Camera clubs were thus a pivotal mechanism in democratizing the fine arts, bringing opportunities to participate in the production, display, and evaluation of photographic

arts to Japan's middle classes.[19] One of Japan's earliest popular clubs was the Minimum Photography Club (Minimamu Shashin Kai; hereafter MSK). In 1913, with the informal backing of Konishi Roku, Akiyama Tetsusuke (1880–1944), a tireless champion of popularizing the art of photography among ordinary people, launched MSK for beginner photographers, more specifically for beginners who owned Konishi Roku's Minimum Idea camera (Figure 4.1).[20]

MSK was the first photography club organized around the ownership of a particular product. However, others would soon follow since Konishi Roku was also behind the formation of the Pearlette Photography League in 1925 for owners of the company's very popular vest-style camera, the Pearlette. Perhaps the most famous product-based club was the Leica Club (Raika Kurabu), founded in 1931 by owners of the coveted Leica-A camera produced by the German manufacturer. Kimura Ihei was this club's most illustrious member.[21] While the Minimum Idea was not Konishi Roku's first product aimed at the unskilled amateur—that honor belongs to the Cherry Portable camera released in 1903—the Minimum Idea was designed specifically for the young, beginner photographer. Perhaps it was with this particular kind of consumer in mind that Konishi Roku named their new camera, implying that the camera was extremely easy to use and was all that was required to yield good results. At a price of ten yen, the camera was stylish and roughly equivalent in cost to a bespoke suit made from imported British fabric.[22] The metal and black leather camera came preloaded with six plates and a red leather carrying case. According to an advertisement for the camera in January 1913, the same model was available for one yen less if you opted for the wool carrying sack,[23] certainly an attractive option for low-level shop clerks and white-collar workers.

The announcement for the inauguration of MSK appeared in an advertisement in September 1913 several months after the camera first arrived on the market. The ad begins, "Seeking members for MSK: A club has been formed for devotees [*aiyōsha*] of the Minimum Idea camera."[24] In addition to its focus on a particular product, another fairly unique feature of the otherwise run-of-the-mill MSK was that members could be considered active even if they lived outside Tokyo and physically could not attend the monthly meetings. Typically a member's presence was desirable in order to participate in the monthly club contest (*hinpyō kai*) in which participants reviewed and selected the best photographs brought in each month by members. The postscript to the club's announcement, however, allowed for a

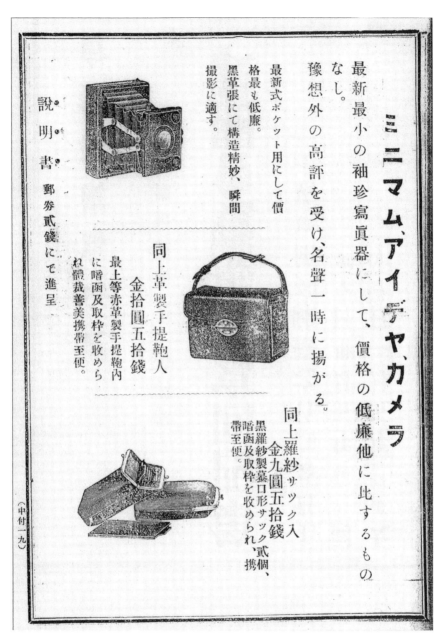

FIGURE 4.1 Advertisement for Konishi Roku's Minimum Idea camera, 1913. One of Japan's earliest popular clubs was the Minimum Photography Club, sponsored by Konishi Roku, which required ownership of the new camera. Reprinted with the permission of Konica Minolta, Inc. Source: *Shashin geppō* 18, no. 1 (January 1913): middle supplement, 19.

modified kind of membership: "For members who live outside Tokyo, please send in your prints the day before each regular meeting."[25] Club membership, then, was not based on the shared experience of association but rather on the shared ownership and use of the same product. Membership without the requirements of attendance meant that the club experience was not restricted to a particular locale. This notion of association—shared consumer item, attendance not required—facilitated expansion quite readily, and later it was the model for even larger and more anonymous camera clubs.

No Assembly Required:
Pearlette Photography League and Kamera kurabu

Just as the Minimum Idea camera and its associated camera club were symbolic of the spread of photographic practice to users of a new class during 1910 to 1920, so too were the Pearlette camera and the Pearlette Photography League (Pāretto Shashin Renmei) in the 1920s. As discussed previously, the Pearlette camera represented Konishi Roku's successful drive into the occasional photography market. And in terms of industrial production, the new camera represented yet another major step away from artisanal production toward a modern process of mass production, in part because the company started hiring engineers rather than craftspeople to design the new camera body at its production facility.[26] As the production process modernized, so too did the nature of association. With the Pearlette, Konishi Roku modified the classic camera-club model and expanded on its own experience with the MSK. The Pearlette Photography League was a national group formed on the basis of ownership of the same product. Members rarely, if ever, actually gathered as a single body. There were no meetings and no fees. All that was required was to fill out the card (Figure 4.2) that came packed in the box with each new Pearlette camera (Figure 4.3).[27] From a marketing perspective, the league was a singular innovation. Names and addresses were collected, presumably, for more than league-related business. Konishi Roku now had lists of potential customers for new products—and the Pearlette was a camera that demanded frequent updating and accessorizing. For example, Pearlette owners could purchase several different cases and straps (Figure 4.4), as well as attachments such as higher-quality lenses.

Once the preaddressed card reached the league's headquarters at Konishi Roku in Nihonbashi, the consumer's name and address were added to the nationwide list of league members.[28] Once registered, members were

FIGURE 4.2 Prepackaged membership card for the Pearlette Photography League. Once the preaddressed card reached the league's headquarters at Konishi Roku in Nihonbashi, the owner became a member. Source: Kishi, *Kamera tsukaikata zenshū*, 71.

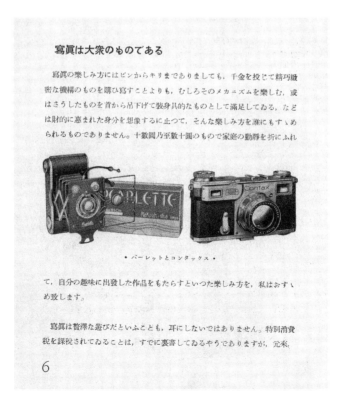

寫眞は大衆のものである

寫眞の樂しみ方にはピンからキリまでありましても，千金を投じて精巧緻密な機構のものを購ひ寫すことよりも，むしろそのメカニズムを樂しむ，或はさうしたものを首から吊下げて裝身具的なものとして滿足してゐる，などは財的に惠まれた身分を想像するに止つて，そんな樂しみ方を誰にもすゝめられるものでありません。十數圓乃至數十圓のもので家庭の動靜を折にふれ

• パーレットとコンタックス •

て，自分の趣味に出發した作品をもたらすといつた樂しみ方を，私はおすゝめ致します。

寫眞は贅澤な遊びだといふことも，耳にしないではありません。特別消費稅を課稅されてゐることは，すでに裏書してゐるやうでありますが，元來，

6

FIGURE 4.3 Pearlette camera and box. Source: Kishi, *Kamera tsukaikata zenshū*, 6.

・道具ケース・

・ファスナー付ソフト皮ケース・

29

部分をカットして、自分の組つた主體を適當なこの角度に印畫することも容易であるこ
とも容易でありますから、通宜にトリミングを試みれば
が容易でありますから、全面燒きの原板から、適宜にトリミングを試みれば
よい譯であります。

全面燒きでは抱角度が狹すぎるのでなるべく寬くとるといふことともいけれ
るのでありますが、スナップなどの場合、あまりカッキリ一杯の畫面の原板
ですと、少し餘裕の欲しいときに餘白が利かなかつたり、足が切れたり、頭
が拔けたりといつた畫になりますから、抱系角度が私達の視角度より廣いと
いふことは必要なことであります。

カメラの携帯

カメラを裸のまゝ上衣のポケットなどに入れて置くと、明暗の撮影に間に
合つて機會を從へないに場合もありますが、針金枠のファインダーを引かけ
たり、レンズに塵がついたり、器械を損める機會も多いので出來るだけケー
スを使用するのがカメラの保護の上に必要であります。

駒止手提型で
秘皮(ソフト・ケ
ース)製のもの
と、堅皮製のも
のとがあります。
後者は頑丈でか

厚度製でカメラの保護の上からも光分で、ホックを外して前板をとつと引
出せば大い譯です。撮影の容易さから申すと連寫ケースで撮るのは、實際速
りにくいやうら、裸の狀狀を主に勝てません。

FIGURE 4.4 Case options for the Pearlette camera. The Pearlette camera demanded frequent updating and accessorizing. Konishi Roku offered several different cases and straps that Pearlette owners could purchase, such as these. Source: Kishi, *Kamera tsukaikata zenshū*, 28–29.

granted several privileges, one of which was the right to join one of the many local chapters of the Pearlette Club (Pāretto Dōjin Kai) scattered throughout the country and administered by the league.[29] The local clubs, however, operated along typical club lines with monthly fees, meetings, and occasional exhibits of members' work. Upon registration, members received a Pearlette badge, and according to the "Pearlette League Bylaws," the regulations printed on the part of the preaddressed card that the purchaser kept, "When members of the league go out with their cameras, we request that you wear the badge. This way we think that you will enjoy the acquaintance of other friends of the hobby [*shumi no tomo*] with whom you can talk about the Pearlette and about photography."[30] Membership was thus defined by common consuming habits, not by formal face-to-face association.

Kamera kurabu, a monthly photography magazine edited by Suzuki Hachirō and published by Arusu, took the informal notion of a "club without meetings" one step further. *Kamera kurabu* was originally a publication for novice photographers that came as a slim supplement in each volume of the twenty-volume series, *Arusu Latest Courses in Photography (Arusu saishin shashin dai-kōza)*, published between 1936 and 1937. Upon publication of the last volume of the series, readers and contributors alike demanded that *Kamera kurabu* be published as an independent periodical.[31] As an independent publication, *Kamera kurabu*, subtitled *Popular Photography Magazine (Taishū shashin zasshi)*, invited readers to submit photographs for a monthly contest.[32] I discuss the significance of this contest in greater detail in Chapter 5, but for our purposes here, it is the transformation of subscribers—anonymous to one another—into club members that is striking. In fact, this club-without-meetings format was an important precedent for common postwar consumer product advertising and marketing schemes.[33]

Women's Camera Clubs

A beautiful autumn day in 1927 brought more than five hundred women to the outskirts of Kyoto for an outdoor photography competition organized by the Kyoto Vest Club in commemoration of its increased membership and the founding of its Women's Division.[34] The paths of the Arashi Yama and Hieizan districts were filled with camera-toting women snapping photos. An exhibition of the award-winning photographs was to follow in Kyoto's Takashimaya Department Store. The contest allowed submissions

and awarded prizes in three areas: art photography, landscape photography, and portrait photography. For the portrait portion of the competition, the sponsors provided several models, including two actresses from the film company Nikkatsu and four from Makino. Two years later on 20 January 1929, twenty women carrying their beloved cameras gathered in the freezing cold outside the Hachiman Shrine for the first photography shoot organized for the Women's Division of the Kyoto Photography League of Kyoto. Six years later Kondō Suga recalls the event with some embarrassment:

> There was a row of about twenty of us, and considering it was the first time around, the shoot was a success. I completely forgot about the cold and whatever else and became lost in clicking the shutter. Well, as for the results—whether I should show the pictures or whether they were out of focus—thinking about the pictures now, I get completely embarrassed. As always they were pretty awkward. But that photo shoot brings back so many memories that even now I have to smile.[35]

Outdoor photo shoots (*yagai satsuei kai*) had become a common occurrence among camera-club participants by the 1920s. What makes these two particular events less common is that they were specifically organized for female photographers. By 1930, there were well over five hundred clubs throughout Japan and the colonies, but only a handful were specifically for female photographers and only one offered membership to both sexes.

Unlike their male counterparts, very few female photographers of the prewar period are known today. Even less is known about women's camera clubs of the period. One small exhibition in 1993 represented an effort to generate interest in this obscure history. For just under two months, the Shōtō Museum of Art in Tokyo held a special exhibition, *Nojima Yasuzō and the Lady's Camera Club*.[36] Of the fifty-three prints included in the catalogue, thirty-two are portraits of women done by Nojima. The curator explains that there is little work by members of the club represented in the show because so much of it was destroyed or lost in the hectic years during and after the war. But one wonders if Nojima's portraits were not the real draw to the exhibition. Under the tutelage of Nojima, a founding editor of the high-art photo magazine *Kōga* and well-known photographer himself, several women formed the Lady's Camera Club in 1937. This was no ordinary group of women; most were highly educated, had lived abroad for some years, and were well-known artists or professionals in their own right. Among the members were Tsuchiura Nobuko, an architect who had worked in the United States for three years; Matsunaga

Tatsurue, an aspiring art photographer who, because she was a woman, was unable to attend the Tokyo Technical School of Photography and became one of Nojima's most trusted assistants; Mizoguchi Utako, a pioneer in the field of technical data processing; Tominaga Yoshiko, a painter; and Kuroda Yoneko, a mountain climber. Under the copresidency of Nojima and his wife, Inako, the very prestigious Lady's Camera Club operated like most camera clubs during this period, holding monthly meetings and occasional exhibits.

Even less is known about other women's clubs. Osaka's Uzuki Club was one such institution founded in April 1932 with the informal backing of Konishi Roku's Osaka Branch, where the members met monthly. Like most camera clubs from this period, Uzuki Club published its bylaws and summaries of its meetings and activities in a popular photography magazine, *Shashin geppō*. And also like most camera clubs, the Uzuki Club members democratically elected their officers, held monthly competitions, and participated in outdoor photo shoots. By all appearances, the club functioned in the same manner as any other club. One major difference, however, was how the club represented itself (and was represented) in written coverage of its events. Readers were constantly reminded that, even though it was a camera club just like any other, Uzuki Club was a club for women. For example, in commenting on the club's first exhibition in Tokyo, at Konishi Roku's exhibition space in Nihonbashi, one writer suggested, "Looking at the over fifty pieces on view, it's obvious that they are women's photographs. They are made with the delicate sensitivity of a woman, and many of the images are somehow soft and gentle."[37] More than three thousand people visited the exhibition over a four-day period. While amateur photo exhibitions were a common affair, perhaps the sight of these distinctly feminine photographs brought the crowds.[38] Among the club's membership was Yamazaki Yasuzō, who acted as the club's in-house judge for the monthly photo competitions. Each month this expert ranked the members' photographs and awarded prizes. At one April meeting early in the club's history, he remarked, "If we rank you [as photographers] from elementary-school children to university students, you have wonderfully deceived us and are all university students."[39] Apparently the deception lay in the fact that even though they were so skilled, these photographers were women! As will be discussed in Chapter 5, one of the most important ways that the world of amateur and hobby photography was legitimated was in the ranking of and commentary on amateur photographs by judges such as Yamazaki.

Making Sense of Club Bylaws

The miscellany section of monthly photo magazines, like *Shashin geppō*'s "Zappō," provided the forum where clubs made their activities public. The regular column devoted to Japan's early popular camera clubs provides more than a quantitative understanding of clubs and members; tedious though it may be to read today, it also offers a nuanced, qualitative view into the activities of camera clubs during the period. The column was the main venue for photo clubs to publish news of their events, members' photographs, and alongside these, the rather innocuous-looking club bylaws that each club duly published in one of the monthly magazines.[40] Through these bylaws we can explore the broader social and cultural meanings of club life in the early twentieth century. Bylaws offer rich details regarding the intended aims and activities of each club; they defined the purpose of the group, described activities, detailed membership restrictions and fees, and outlined procedures for election of officers.

The custom of publishing bylaws likely stemmed from local ordinances that restricted associational activities in imperial Japan. Associational life in modern Japan developed in a political climate of official suppression and scrutiny of public gatherings of any sort, not unlike the scrupulous laws of the Tokugawa period that restricted formations of horizontal alliances, as discussed by Ikegami.[41] Elements of the Law on Assembly and Political Association (Shūkai oyobi seishahō) promulgated in 1889, which limited the right of political assembly only to men eligible to vote and specifically targeted opposition political parties and the emerging labor movement, were reenacted in the Public Order Police Law (Chian keisatsuhō) of 1900 and remained in effect in various regulations and ordinances through the end of the Pacific War. For example, Edward Norbeck recounts the story of an American friend who tried to start a Tokyo branch of Phi Beta Kappa in the prewar period:

> Control by the Japanese government over associations, however, was always maintained, and it grew increasingly strict in the twentieth century. By the 1920s all organizations were subjected to the closest scrutiny. Douglas Haring, in a personal communication, described the difficulties shortly before 1920 of Americans who attempted to form a club of Phi Beta Kappa members in the Tokyo-Yokohama area with an idea of establishing the society in Japanese colleges. Hounded by the police, they finally abandoned the effort.[42]

From the turn of the nineteenth century, ordinances clearly specifying areas where photographic activities were prohibited, such as in militarily sensitive areas, were another likely cause for clubs submitting their bylaws to a public forum. Photography magazines and hobbyists' how-to books frequently published maps and updated lists of so-called prohibited zones (*yōsai chitai*).[43]

For the purposes of this study, the contents of these seemingly unremarkable bylaws offer a rare glimpse into the connections between associational life and aesthetic practices in the early part of the twentieth century. Most published bylaws look very similar to one another, although there is some variation, especially if the club has a singular photographic interest, for example, in portrait or landscape photography. The Appendix offers a translation of the Masaoka Photography Club Bylaws (Masaoka Shakō Kai Kiyaku), a representative set of club bylaws from the early Taishō period. The *shakō* of Masaoka Shakō Kai combines the character for *utsuru* (to take a photograph) and the character for *majiwaru*, which is the *kō* of *kōryû* (social exchange, mingling). This specific combination of characters is most likely a play on the more common *shakō*, in which *sha* means "society," and together the term means "socializing."

Sociality and the Camera Club

Bylaws usually stated the kinds of photographers who were invited to join that particular club. For example, the Masaoka Photography Club was open to those who were simply interested in photography (see Appendix, Article II). Other clubs were restricted to commercial photographers, such as the Dalian Photography Club, or to photographers with a specific interest, such as the Portrait Photography Research Society of Japan, a club that concentrated solely on portraiture. Generally speaking, however, clubs were open to camera enthusiasts of all levels. Terms commonly used to refer to photographers included *shirōto shashin-ka* (amateur photographer), *shashin kōzu-ka* (photography enthusiast), and *goraku shashin-ka* (hobby photographer). Often the term *shirōto* (amateur) was combined with *dōkō* (common interest) to form *shirōto shashin dōkō-ka* (those with a common interest in amateur photography). In the preface to the bylaws for the Singapore Camera Club, published in *Shashin geppō* in December 1921, the organizers state that the club was founded for Japanese residents (*zairyū hōjin*) with a common interest in amateur photography.[44] Though the

bylaws themselves do not list Japanese nationality as a prerequisite for join-
ing the club, it is clear from the preface that the club is for Japanese colonial
residents who are camera enthusiasts. One set of bylaws that does stipu-
late Japanese nationality as a requirement for membership was the Qingdao
Photography Club, established in 1915. Article II states clearly, "This club
is organized for Japanese people [*hōjin*] with an interest in photography."[45]
The sex of potential members was rarely mentioned as a restriction, but it
is safe to assume that the vast majority of members were men. Women did
join clubs, but these clubs were specifically organized for women (e.g., the
Uzuki Club of Kansai and the Lady's Camera Club of Tokyo) or women's
branches of major men's clubs (e.g., the Kyoto Vest Club Women's Divi-
sion). The Himawari Club of Tokyo, established in 1921, clearly specifies
in its bylaws that *either* men or women were free to join the club, but this
was extremely unusual: "One becomes a member, whether male or female,
on the condition that the individual is introduced by an acting member."[46]

The purpose and goals of the club were almost always stated in the by-
laws. For example, the Masaoka Photography Club was organized to study
photography as well as to promote friendship (*shinboku*) among members
(see Appendix, Article II). These two elements—study and friendship—were
fundamental to all local clubs. In Article III of its bylaws from November
1918, the Kai Photography Club of Yamanashi prefecture states: "The pur-
pose of this club is to promote friendship among members and to study
photographic technique."[47] In addition to fostering camaraderie, the cam-
era club served as a venue for the serious activity of study (*kenkyū*). The
Ōta Hot Research Club of Ibaragi prefecture established its club with the
goal of studying artistic photography, though the bylaws make no specific
mention of how this goal is to be achieved.[48] Some clubs, like the Kara-
futo (Sakhalin) Hobby Photography Research Society, used monthly fees
in part to procure relevant books and magazines for members to peruse
during meetings.[49] The Teikyū Club of Osaka provided unusually specific
articles delineating the nature of study. Section 4 of the Teikyū Club bylaws,
"Items Relating to Study," included the following five articles dealing with
the club's study activities:

> *Article XV* Each month the club will select an appropriate day to study
> photography.
>
> *Article XVI* The club will study the following two areas of photography:
> 1. Outdoor photography
> 2. Portrait photography

Article XVII To study photography, the club will invite suitable commercial photographers or judges to lead us thoroughly in their areas of expertise.

Article XVIII To study portrait photography we will occasionally open the studio where the club meets and practice with suitable models [*moderu*].

Article XIX In order to pay the various fees for field trips and models, additional fees, over and above regular club fees, will be collected from the members who participate in that particular meeting.[50]

The Shandong Photography Research Society offered extremely specific areas of study for their members. Article III of its bylaws states that in order to properly learn, members will learn about the following photographic techniques through direct experience: "(1) how to use a camera; (2) how to prepare chemicals; (3) how to take outdoor, indoor, and night, and other kinds of specialized photographs; (4) proper composition for portraits and landscapes; (5) how to make enlargements; (6) how to print photographs; (7) how to intensify plates and film; (8) how to prepare special prints; (9) how to alter plates and film; (10) how to color prints; (11) other techniques as required by the members."[51] The second article states that all members have access to the darkroom and any necessary equipment, such as cameras, paper, and chemicals, located at the Mizutani Photography Studio, where the club holds its meetings. Some clubs simply relied on the more experienced members of the club to lead the study portion of regular meetings. Others invited guest speakers to discuss the latest techniques. For example, the bylaws of the Kyokutō Friends of Photography Club of Suzaka-chō, Nagano prefecture, stipulate that in order to learn about art photography, the club would "occasionally invite an authority in the world of photography to conduct study [with the club]."[52]

In addition to the study of photography, Article III of the bylaws for the Dalian Photography Association, organized by and for commercial photographers working in northeast China, listed "the promotion of friendship among members" as its first goal.[53] Perhaps the recurrence of these elements was due in part to a kind of uniformity in the formal language of bylaws. But it also points to the intended nature of the club as venue for both the high-minded pursuit of knowledge and the less outright purposeful goal of relaxed socializing—the literal meaning behind the standard characters for *kurabu*, as mentioned previously. Howard Chudacoff discusses the

importance of middle-class associations like fraternal orders and didactic associations in fostering convivial relations among members in early twentieth-century America: "The most important function of these organizations [fraternal orders] was their encouragement to middle-class males to enjoy the company of men like themselves, away from domestic pressures and responsibilities."[54] This was certainly the case in modern Japan. Outdoor photo shoots were not frequent affairs; nevertheless, many club bylaws mention them at least as a regular annual event. Club comrades would gather at a local train station and journey to the suburbs or a nearby rural area for a day of photographing and picnicking. Members of the Masaoka Photography Club arranged one of their regular monthly meetings and their annual outdoor photo shoot for the same day in May 1921 in the area around the Haguro train station in Ibaragi prefecture.[55] A summary of the proceedings of that day was reported in the September 1921 issue of *Shashin geppō*. The contributor mentions that because of rainfall not many members turned out, but those who did thoroughly enjoyed themselves. They took pictures until three o'clock in the afternoon and then took the train to Kasama, where they disembarked to pay their respects at the Kasama Inari Shrine. From there they went to a local teahouse to convene their regular meeting and to discuss the prints from the previous month. The field trip focused on photography, but the train travel, the shrine visit, and the refreshments at the teahouse provided ample time to socialize with one another.

The Club as Promoter of Photography

Most bylaws stated that one of the primary goals in forming an association was to promote and further popularize photography. Members of the Masaoka club shared in the tripartite goals of promoting friendship, studying, and popularizing photography (*shashin no fukyū*). As in relation to study, club bylaws tend to be somewhat vague on the actual means of popularizing. Most clubs, however, sponsored at least one annual public exhibition of the members' work. Article XIX of the Teikyū Club bylaws states that the club will organize one spring and one fall exhibition each year that is open to the members of the club and the general public.[56] According to the bylaws for the YDC Photography Club, a club organized for amateur photographers at the Yokohama Dock Company, the club would curate four exhibitions annually, one each in February, May, August, and November.[57] Presumably, a public, accessible showing of club members' work (for ex-

ample, at a camera shop or, better yet, at a department store) would serve as inspiration for the audience either to take up a camera themselves or to attend more exhibitions. One club took its mission to popularize so seriously as to sponsor an exhibition titled *Exhibition to Popularize Knowledge of Japanese Photography* (Kokusan Shashin Chishiki Fukyū Tenrankai) (Figure 4.5).[58] The goals of this exhibition, organized by the Kobe Society of Commercial Photographers and held on the sixth floor of the Kobe Mitsukoshi Department Store, were to display to the general public (*ippan taishū*) the following points:

How necessary and how valuable photography is

The simplicity of taking skillful photographs

To display portrait photography from the three cities of Kyoto, Osaka, and Kobe

To show the current advanced state of domestically produced cameras and photographic materials[59]

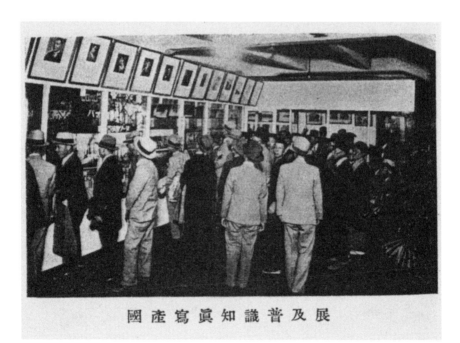

國 產 寫 眞 知 識 普 及 展

FIGURE 4.5 "Exhibition to Popularize Knowledge of Japanese Photography," Kobe, 1934. The exhibition was organized by the Kobe Society of Commercial Photographers and held on the sixth floor of the Kobe Mitsukoshi Department Store. Reprinted with the permission of Konica Minolta, Inc. Source: *Shashin geppō* 39, no. 7 (July 1934): 773.

In addition to showing the latest photographic techniques, such as microscopic and x-ray photography, the curators set up an actual photography studio where photographers used real models (*manekin-jō*, literally, "mannequin girls") and explained step by step how to take a proper portrait (Figure 4.6). So many people attended these live demonstrations that one observer noted all the heads in front of him were "like a black mountain [*kuroyama no gotoki*]" (Figure 4.7).[60] In addition to showing how to take a photograph, much of the exhibition was devoted to how to pose subjects for a photograph—what people should wear and how they should sit. Another section of the show displayed portrait photography from photographers in the three cities. The curators mention that there were so many excellent photographs, despite the restriction that all submissions had to be made with domestically produced products, that it was truly difficult to make enough space. This point was stressed to show just how far along the domestic industry had come in recent years.[61]

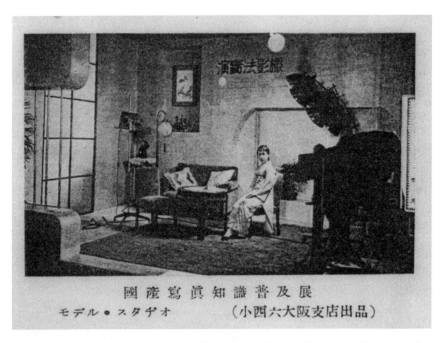

國 産 寫 眞 知 識 普 及 展
モデル ● スタヂオ　　　　（小西六大阪支店出品）

FIGURE 4.6 "Exhibition to Popularize Knowledge of Japanese Photography: Model and Studio (Display by Konishi Roku, Osaka Branch)," Kobe, 1934. In addition to showing the latest photographic techniques, curators set up an actual photography studio where *manekin-jō* served as models. Reprinted with the permission of Konica Minolta, Inc. Source: *Shashin geppō* 39, no. 7 (July 1934): 774.

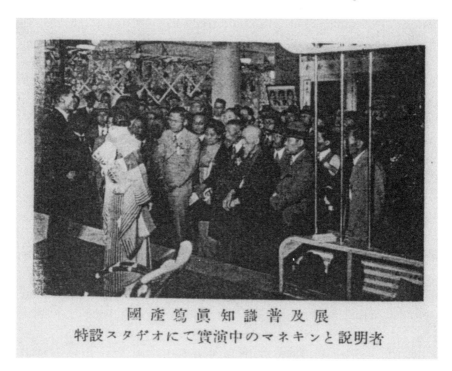

國 産 寫 眞 知 識 普 及 展
特設スタヂオにて實演中のマネキンと説明者

FIGURE 4.7 "Exhibition to Popularize Knowledge of Japanese Photography: Mannequin Girl and Presenter during a Demonstration in the Special Studio," Kobe, 1934. The exhibition featured live demonstrations, such as this one, a step-by-step demonstration of how to take a proper portrait. Reprinted with the permission of Konica Minolta, Inc. Source: *Shashin geppō* 39, no. 7 (July 1934): 774.

Urban and Provincial Camera Clubs

Historians of photography tend to locate the most active centers of photographic practice, including club formation, in Japan's major urban areas. Many of the club activities listed in magazines like *Shashin geppō* at the beginning of the Taishō period were, in fact, centered in these areas. Scholars of associations in Western Europe and the United States link club formation with a "new involvement in urban industrial society [that] seemed to bring with it a new need to create institutions on an intermediate level, larger than the family, yet smaller than the state."[62] Lynn Abrams states, "Sociologists have long recognized the connection between urbanization and the development of voluntary associations. Joining a club was not always a political statement but could be a reaction to the psychological stress imposed by the

comparative anonymity of urban industrial society."[63] Social scientists see the club, whether fraternal or recreational, as "not only [giving] the individuals a sense of belonging, but it also plays a role mediating change in a highly mobile society," a role that helped rural immigrants transition into their new lives in industrializing cities.[64] Whether camera clubs in Japan helped ease the transition of the individual into an alienated urban setting is not entirely clear, but the popularity of camera clubs among Japanese city dwellers is undeniable. The surveys conducted by the Asahi Newspaper Company certainly indicate that the greatest number of clubs were active in the largest urban centers. Nevertheless, camera clubs operated throughout all of Japan, even in its most remote regions. While the urban immigrant experience may help us understand the role of camera clubs in large cities such as Tokyo and Osaka, it does not speak to the experience of club members in, say, Toyama or Fukuoka. As we have seen, club activities were not limited to the major urban centers of Tokyo, Osaka, and Nagoya but were also conspicuous in provincial cities and towns in outlying prefectures, Japan's recently acquired colonial territories, and even abroad in the United States where recent Japanese immigrants lived in enclave communities. In addition to club listings for Tokyo, Nagoya, Kyoto, Kobe, and Osaka, a number of provincial clubs are represented in the *Shashin geppō* "Miscellany" column for 1913, including clubs from Niigata, Fukuoka, Tokushima, Kumamoto, Nagano, Tottori, Saga, Toyama, Chiba, Shizuoka, Seattle, Dalian, and Singapore.[65]

While urban club formation may have acted as an ameliorative to ease the tensions engendered by a highly mobile society, provincial clubs may have acted to assert traditional social bonds in a new context. In describing the evolution of associational life across time, anthropologist Robert Anderson differentiates between premodern associations, which are defined by paternalistic, guildlike organization, and modern associations, which are characterized by rational and bureaucratic modes of operation. According to Anderson, modern associations, while introducing "rational-legal modes," a concept I delve into more closely later, may actually work to reinforce social stratification at the local level by restricting membership to certain groups: "Far from modernizing traditional communities, rational-legal associations by themselves seem to actually enhance the capacity of old communities to persist structurally secure."[66] Given that clubs charged monthly fees and required ownership or at least access to pricey commodities (cameras, plates, film, and developing supplies), camera clubs in provin-

cial Japan more than likely were restricted to a select few and maintained an exclusivity that reaffirmed the power of elites in local communities. Most of these clubs held public events, exhibitions, or field trips that welded a cultural front onto an already highly visible economic and political status. The people involved in provincial camera club activities were likely to be local powerbrokers, and this new form of sodality gave them yet another opportunity to represent their elevated status to their neighbors.

Camera Clubs as "Mini-Republics"

While it is important to recognize the provincial camera club as potentially promoting the reinforcement of elite male sociability, camera clubs were also institutions that upheld democratic principles. Besides adaptation to urbanization or reassertion of traditional social relations, camera clubs consistently asserted in their bylaws a strident protection of what Lynn Abrams identifies as "individual merit and equality before the law."[67] Though the specific content of club rules reveals the aims and activities of particular camera clubs around Japan and its colonies, the same bylaws taken as an overall form also instituted the legal bureaucratic element of the modern association.[68] Anderson argues that with the modernization of political institutions in democratic societies, sodalities increasingly adopted electoral and bureaucratic norms and procedures. He continues:

> This new quality of associations may be characterized as rational-legal. . . . A rational-legal association possesses written statutes clearly defining the membership, participant obligations, leadership roles, and conditions of convocation. It normally possesses a legally recognized corporate identity. It is rational in the sense that as a body it is geared to efficiency in making decisions and taking action, particularly as leaders are, in principle at least, impartially chosen by election of the most qualified to take office. It is legal in the sense that compliance in decisions and actions is sanctioned by the impersonal force of law.[69]

As we have seen, Japanese camera clubs follow very closely this rational-legal model. Most clubs not only produced written sets of statutes but also abided by democratic electoral norms in choosing officers as well as in awarding prizes. In every set of bylaws examined, the procedure for the election of club officers is clearly outlined in separate clauses. For example, Article VI of the Masaoka Photography Club bylaws stipulates that the club members will elect two officers, whose terms are limited to one year, to manage the

affairs of the club. The Dalian Photography Association outlined in more detail than most clubs the election and responsibilities of officers:

Article V	The association will place the following officers:
	President (1)
	Vice president (1)
	Secretary (1)
	Consultants (several people)
Article VI	The officers will be elected each year for a term of one year at the spring general assembly; but they cannot be reelected.
Article VII	The president is the representative of the association and will manage the affairs of the club in the following areas:
	Items relating to the enforcement of the association's bylaws
	Items relating to each member's inquiries
	Items necessary for the execution of the association's goals
Article VIII	The vice president assists the president, and in the case of special circumstances for the president, the vice president will take over.
Article IX	The secretary is responsible for the accounts, general affairs, and other such matters.[70]

Interestingly, the club invoked term limits for officers, possibly to ensure that most participating members would have the opportunity to lead the group at some point during their membership.

Many clubs also included clauses in their bylaws permitting the removal of a member due to unseemly behavior upon a majority vote at a general meeting. Directly after stating the policies on electing club officers, Article XII of the Hishū Friends of Photography Club bylaws specifies two offenses for which a member can be removed from the club through a resolution passed in the general assembly: "(1) anyone who deviates from the intentions of the club, or (2) anyone who does not pay the fees for six months or more."[71] The Shandong Photography Research Society would remove members with a simple majority vote for failing to pay membership dues or for "sullying the honor of the club [*kai no taimen wo yogoshi*]."[72] These kinds of articles publicly represented the legalistic aspect of the club, in which compliance with club rules is supported by the impersonal force of law.[73]

The central participatory ritual of the camera club was the monthly photo competition. The basic format of the competition, an activity outlined in most bylaws, was that each member brought in prints produced since the

previous meeting (for example, see Appendix, Article VIII). Each month, club officers typically announced a particular theme for the next month's competition. When themes were used, they were often somewhat amorphous, such as "still life" or "portrait." More specific themes included "dusk" (*yūgure*), "vehicles" (*kuruma*), "people selling things" (*monouru hito*), "rivers" (*kawa*), and "rural dwellings" (*inakaya*). At the beginning of each meeting, members displayed their prints for the monthly photo competition. After each presentation, members discussed, critiqued, and finally voted for the best prints for that month. Some clubs awarded prizes, others published the names of the photographers and their winning photos along with a summary of the regular meeting in one of the monthly photo magazines like *Shashin geppō*, and still others displayed the best prints in some public place (a photography studio or community center) until the next meeting. In its bylaws of May 1922, the Karafuto Hobby Photography Research Society clearly states the technical requirements of photographs submitted to the monthly contest in a separate section titled "Detailed Regulations for Submissions at the Regular Meeting."[74] Members were to bring at least two prints of any size with all of the technical details clearly written on the back of the print. Photographs submitted to one competition could not be resubmitted.

In addition to fostering a competitive spirit among members, the monthly contest turned members into judges. Though some clubs invited experts to judge the monthly competitions (such as the Teikyū Kai and Uzuki Club), most clubs relied on a more democratic process of discussion followed by a vote. For example, Articles VIII through XIII of the Masaoka Photography Club bylaws deal with the inner workings of the monthly meeting. Most striking, and unusual for the fairly predictable content of bylaws, is Article XI, which states that members "have the freedom to criticize the submissions," regulating potentially antagonistic behavior that, perhaps contrary to the prevailing notions of friendliness and open participation, was a necessary function of the aesthetic sociality of the camera club.

Bylaws, then, gave members a right to vote but also made them accountable to the club, both in a pecuniary sense and as a representative of the club beyond the confines of its activities. This kind of legalistic understanding of rights and responsibilities was significantly more liberal than Japan's electoral system of the same period. In 1900 the national government lowered the tax qualification for voting from fifteen yen to ten yen per household, which, in effect, doubled the electorate from 1 percent of the male population to 2 percent. Not until 1928 was suffrage exercised

universally by Japanese men. Members, then, likely enjoyed rights in clubs that they did not have in the political sphere as citizens. Writing about associational life among the bourgeoisie in Germany during the last decade of the nineteenth century, Lynn Abrams notes, "Politically affiliated associations aside, voluntary clubs in the Wilhelmine era had a freedom not granted to individuals."[75] In particular, Abrams argues that voluntary associations represented a break from an authoritarian past associated with the church and the guild.[76] Voluntary associations embraced modern, democratic concepts and "in political terms the associations have been described as 'mini-republics,' preparing the ground for middle-class participation in democratic government."[77] Before 1928, Japanese camera clubs mirrored Abrams's "mini-republics," where partial citizens, not yet full-fledged, were able to exercise rights not yet granted in national politics. The club became a rehearsal for citizenship in participatory democracy.

This is even more so the case for women's camera clubs. Japanese women did not earn the right to vote until 1946. In 1888, women were barred from local political participation when "laws regarding municipal government established that only an adult male could qualify as a 'citizen' [*kōmin*]— literally, a 'public person.'"[78] Indeed, with the Law on Assembly and Political Association of 1890, which was further strengthened with the Public Order Police Law of 1900, women were barred on the national level from "joining political associations and from sponsoring or even attending meetings at which political discussion occurred."[79] But in camera clubs, women had both the right to vote and the responsibility of membership. Though some of the larger clubs had auxiliary divisions for women, there were very few clubs that accepted female members. Tokyo's Himawari Club, mentioned briefly previously, is the only club I have seen that allowed either men *or* women so long as they were introduced by a standing member of the club. In the bylaws for the Uzuki Club, published in the June 1932 issue of *Shashin geppō*, one article states that there will be two officers who are elected for six-month terms.[80] Uzuki Club also held regular monthly contests and voted on the best photographs. Despite being led by a man in their evaluation of photographic work, members still had the right to vote.

Camera clubs popularized the fine arts for a growing middle class of largely white-collar men and some women, but they also were spaces where modern subjects could exercise governance in a significantly more liberal way than they were otherwise permitted as citizens. By holding elections, guaranteeing full voting rights, and protecting the right to "critique,"

camera clubs were a place where ordinary Japanese people rehearsed democratic rights that they could not exercise in full until after the Pacific War. Furthermore, artistically inclined clubs, like the aesthetic networks of Tokugawa Japan, offered middle-class cultural producers localized and, perhaps more important, politically neutral, spaces to exercise liberal ideals. In terms of a broader view of Japan's twentieth century, looking at the specific ways that culturally oriented voluntary associations combined artistic activities with democratic procedures helps us better understand the flourishing of democratic movements in the postwar period. Without exposure to and experience with democratic forms of participation in the prewar period, there could be no lasting foundation, politically or culturally, for the accelerated adoption of democratic ideals after the war.

MAKING MIDDLEBROW PHOTOGRAPHY

The Aesthetics and Craft of Amateur Photography

While participating in camera clubs allowed for the experimentation with democratic forms of organization, taking and making photos brought the concepts and practices related to the fine arts to a wider public. But what sorts of pictures did hobbyists take and why?

Throughout the early 1930s, Japanese theorists of modernist photography lambasted hobby photographers for clinging to pictorialism, *geijutsu shashin* (literally, "art photography"), what they saw as an outdated aesthetic repertoire and characterized as imitative of painting. Modernist critics publishing in small enclave journals held hobby photography and its derivative aesthetic project responsible for degrading the potential of photography to stand independently among the fine arts. As photography's popularization proceeded, modernists frequently and with mounting vigor condemned all photographic imagery out of line with the prevailing modernist aesthetics of realism, montage, and constructivism. The intellectual legacy of this criticism continues to shape our historical understanding of Japanese photographic practice from the first half of the twentieth century. Modernist theories of aesthetics tended to strip the act of production—the taking and making of photographs—from photography and instead focused almost exclusively on the resulting image. The narrow focus on modernism and more specifically on the modernist *image* has occluded disparate photographic

practices that, in contrast, prioritized the craft of image making, in particular darkroom technique, as fundamental to the aesthetics of photography.

As I argued previously, the most dedicated of amateur photographers, the hobbyists, heralded the space of the darkroom as the laboratory for their creations. Mastery of technical skill was a fundamental goal, a key to the enjoyment of photography. And hobbyists unabashedly embraced technique (the process), not only content (the final image), as central to their aesthetic practice. Though modernist critics claimed amateurs to be imitative, amateurs themselves explored many lexicons of photographic representation. The accomplished among them were fluent not only in the visual language of most genres of photographic representation but in the various mechanical and chemical techniques required to create such images. In keeping with their enthusiasm for technical mastery and bravado, hobbyists tended to choose techniques that demanded the most of their darkroom skills—skills that modernists claimed made amateur images look like paintings.

The disparate ways that modernists and hobbyists formulated the aesthetic standards of their art tell us as much about the standards of photographic beauty prized by each group as they do about the social makeup of its practitioners. Modernists tended to elaborate aesthetic standards in the context of exclusive journals, small one-man exhibitions, and, most definitively, manifestos. In contrast, amateurs, especially enthusiastic hobbyists and the popular photography press, drew upon contest results, popular exhibitions, and the comments of judges and editors on selected photographs for publication to articulate standards of photographic beauty. My focus here is to expose the formation of the aesthetics of hobby photography, the forgotten element of photographic production in the first half of the twentieth century. It is in the spirit of balancing the historical books, then, that I take seriously the aesthetics of hobby photography, basing my conclusions on *their* work and writing rather than on the prevalent attitudes toward amateurs and their work found in modernist writing of the time or in the photographic criticism of today.

Defining Geijutsu Shashin

Although debates about the viability of photography as an independent art form took shape at the turn of the century, this discussion remained confined to the elite photographers who could afford both the time and money necessary to participate in photography as an artistic pursuit. One of the earliest and most influential articulations of the aesthetics of art photog-

raphy that reached the middle-class photographer was Fukuhara Shinzō's definition outlined in his April 1926 article "The Way of Photography," which appeared in the first issue of *Asahi kamera*, the magazine that quickly became the most widely read journal among amateur photographers during the period.[1] Fukuhara sought to apply the language of high-art aesthetic production to popular photographic practice and was a central figure in the popularization of high-art idioms among amateur photographers. He was one of the leading organizers behind the centenary anniversary of the invention of photography in 1925 and remained an ardent proponent of photography as a popular art form. The significance of "The Way of Photography" not only relates to its content but also stems from where it was published and the popular audience to whom it was directed. It became the manifesto, *the* aesthetic rule book, for amateur photographers—the majority of readers of *Asahi kamera*—who were drawn to Fukuhara's persuasive poetics as well as his experience as an amateur photographer.

In forceful prose, Fukuhara argues that the world of light (*hikari no sekai*) is the aesthetic basis of *geijutsu shashin*. His emphasis on light and its effects on photographic aesthetics stand in marked contrast to previous formulations of photographic beauty based on the ideals of painting.[2] Fukuhara's particular theoretical intervention centralizes light as the unchanging truth of photographic art and positions photography in the realm of the fine arts as an independently meaningful practice rather than as a strictly imitative one. He compares the fundamental aesthetic experience of photography, but does not subsume it, to other forms of artistic production such as music, haiku, and painting.[3] The photographer's job as an artist is to absorb and then express the overflowing emotional response to nature by using the contrast of light and shadow in a photograph (similar to using language for haiku and a pencil for drawing).[4]

A more comprehensive definition of the term *geijutsu shashin* can be found in Saitō Tazunori's how-to book, *How to Make Art Photographs* (1932). Saitō explains that *geijutsu shashin* is a relatively recent translation from English, tracing the original meaning to the phrase "pictorial photograph." He uses both the katakana expression *pikutoriaru fuotogurafu* and the English phrase "pictorial photograph" in the text.[5] Classic pictorialism used techniques such as painting on the negative or positive and materials such as soft-focus lenses and textured papers to create a romantic image.[6] Saitō's conception, however, is broader and reflects that the term was used throughout the 1920s and 1930s. He traces the origins of the earliest popular usage

of the term in Japanese to the Taishō period with the publication of the high-brow photography journals *Geijutsu shashin* in 1919 and *Geijutsu shashin kenkyū* in 1920 and delineates four different approaches to the aesthetics of pictorialism. In the first, the photographer expresses his subject matter poetically by employing a soft, descriptive technique that produces a time-less, sentimental mood, or what he refers to as lyrical expression (*jojōteki hyōgen*).[7] These kinds of pictures create a visual poem through the effective use of *nōtan*, or tonality, that "praises life and glorifies nature."[8] Impres-sionistic expression (*inshōteki hyōgen*), the second kind of art photograph, also captures the requisite sentiment of *geijutsu shashin*. In this case, how-ever, Saitō emphasizes the imprecise nature of human vision as the starting point of impressionist images. In impressionistic photography, artists reject mechanical detail and instead use soft-focus lenses or out-of-focus techniques to capture the approximate nature of the object's form, color, or movement.[9] Both of these approaches have a distinct set of technical and compositional attitudes but share in the photographer's desire to express an individual re-sponse to the subject matter and a singular motivation to capture beauty.[10]

Realistic expression (*shajitsuteki hyōgen*), Saitō's third category, takes an objective approach to image making made possible by the precision of modern lenses in which the "individuality of the photographer is subdued in order to master the photographic object."[11] Realist expression "exposes nature as it really is. In other words, it is an objective way of looking in which that which causes the photographer to be moved is of minimal sig-nificance in the productive attitude. It is an attitude that tries to express, as much as is possible, nature as it is seen directly."[12]

Constructivist expression (*kōseiteki hyōgen*), the fourth category and the one most closely associated with contemporary trends in high modernism (what Saitō and other photographic writers referred to as *shinkō shashin*) adopts a cooler, intellectual stance to picture making, emphasizing line and mass while rejecting an emotional, literary vision.[13] *Geijutsu shashin*, then, was a broad term in Japanese that encompassed not only the classic picto-rial modes of photographic representation but also styles usually associated with high modernism and even the avant-garde.

While the lyrical and expressionist modes of *geijutsu shashin* contin-ued to be among the most frequently submitted styles of readers' contest-winning photographs published in *Asahi kamera* until 1941 (Figure 5.1), there is a definite, if subtle, shift toward realistic expression from the mid-1930s. Increasingly, photographs like the ones shown in Figure 5.2 appear

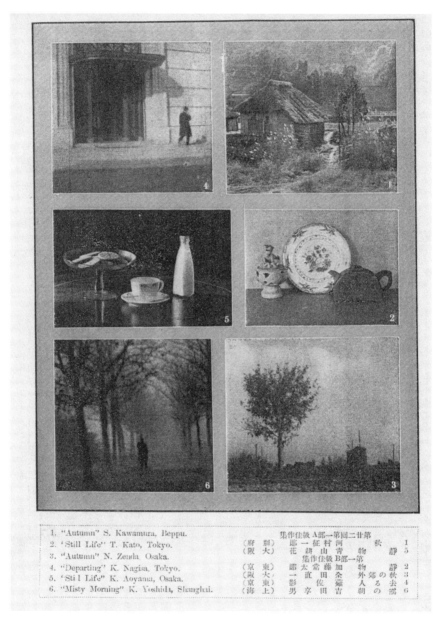

1. "Autumn" S. Kawamura, Beppu.
2. 'Still Life" T. Kato, Tokyo.
3. "Autumn" N. Zenda, Osaka.
4. "Departing" K. Nagisa, Tokyo.
5. 'Still Life" K. Aoyama, Osaka.
6. "Misty Morning" K. Yoshida, Shanghai.

集作佳敳A部一第回二廿第
（府　別）　郎　一　征　村　河　　秋　　1
（阪　大）　花　耕　山　寺　物　　静　　5
集作佳敳B部一第
（京　東）　郎　太　常　藤　加　物　　静　　2
（阪　大）　一　直　田　余　外　郊　の　秋　　3
（京　東）　影　佐　燕　人　る　去　　4
（海　上）　男　亨　田　吉　朝　の　霧　　6

FIGURE 5.1 Readers' winning submissions for *Asahi kamera* Monthly Photo Competition, Division One, April 1928. Judges favored the lyrical and expressionist styles of *geijutsu shashin* in 1928. Source: *Asahi kamera* 5, no. 4 (April 1928): 373.

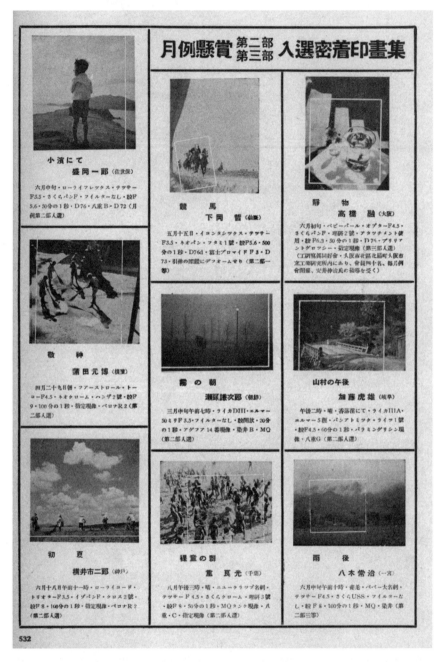

FIGURE 5.2 Readers' winning submissions for *Asahi kamera* Monthly Photo Competition, Divisions Two and Three, September 1938. Judges shift toward photographs using realistic depiction by 1938. Source: *Asahi kamera* 26, no. 3 (September 1938): 533.

as winning submissions. Though modernist critics argued to the contrary, the aesthetics of hobby photography was anything but a static bastion of traditional imagery. Amateurs experimented with many styles, and amateur taste evolved. Though conventional pictorialism definitely won out, it is important to emphasize that the meaning of "conventional" was transformed by the work of active amateur photographers.

The Modernist Attack on the Aesthetics of Geijutsu Shashin

In May 1926, Murayama Tomoyoshi, one of the premier figures of the avant-garde group Mavo, described the relationship of the avant-garde image and everyday life in an article for *Asahi kamera,* "The New Function of Photography."[14] In this short article, Murayama delineates four recent photographic trends, each of which he characterizes by the work of four photographers: Emil Otto Hoppé (1878–1972), Francis Bruguière (1879–1945), Man Ray (1890–1976), and El Lissitzky (1890–1941). While each of these artists exemplifies a specific trend in photography, Murayama is most interested in demonstrating whether these trends operate as socially engaged art forms and can thus take photography into the future on its own terms. For Murayama, Hoppé's work is the least engaged and El Lissitzky's work is the most. For our purposes, Murayuama's negative appraisal of Hoppé is most illustrative. Hoppé's work was extremely well received and well known in Japan. Fukuhara Shinzō arranged the first Japanese exhibition of Hoppé's photographs in 1923, and Hoppé's work was much touted in the 1927 International Photography Salon held in Tokyo by the Asahi Newspaper Company. According to Murayama, artists like Hoppé regard the camera as a machine that almost magically turns reality into art (*genjitsu wo "geijutsu-ka"*).[15] For these artists, the camera is a tool that enables the artist to "create" art. A photograph cannot stand on its own terms but must be willed into art. The manipulation of such techniques as the soft-focus lens and textured papers, however, forces the *geijutsu shashin* photographer to misrepresent reality. Thus, such an approach, by far the most popular approach for hobbyists, has no relationship to everyday life. The most valuable contribution this kind of photography offers is its ability to comfort and amuse viewers, especially in the form of portraiture: "I can only think of *geijutsu shashin* in which reality is misrepresented simply by a soft-focus lens, or in which shadows are arranged so that the horizon line is placed higher than usual, as

somehow extremely trifling. If one were to see this [style] as a painting, it would be an impressionist painting."[16]

Even more biting was Ina Nobuo's attack on *geijutsu shashin*. Ina, an editor of *Kōga* and leading high-modernist theorist of photography, wrote the now canonical article "Return to Photography," published in the inaugural issue of *Kōga* in May 1932. Ina's manifesto calls for photographers to "break away from art photography! . . . To break free from every conception of art and to destroy all idols!"[17] In trying to make photography into art, hobby photographers rely on—imitate—other art forms, most notably painting. As we have seen, how-to writers like Saitō Tazunori felt more than comfortable employing the language of painting and poetry to set the aesthetic standards of *geijutsu shashin*. For Ina, however, imitation is the very technique that bars photography from its full status as an independent fine art:

> When monkeys ape humans, they definitely do not become more human-like. On the contrary, when they imitate humans, they become most "monkeylike" [*saru rashiku naru*]. Photography, too, when it imitates "art," definitely cannot become "artistic." The concept of "art" itself is constantly in the process of changing. Yesterday's "art" is already not today's "art." When photography imitates "art," it is already yesterday's "art" that is imitated.[18]

Ina pointed to impressionism as the painterly style that most art photographers tried to capture in their landscapes and portraits. With mottoes such as "the blending of light and shadow" or "the harmony of light and dark," the imitative photographer aims to imitate impressionist painting.[19]

Ina, however, sought to define a new breed of photographer, one who willfully broke away from tradition and imitation. As rhetorical strategy, this construction of *geijutsu shashin* as imitation and mainstream allows Ina to establish the new photographer as the sole legitimate heir to a modern photographic aesthetic. He furthers his critique by relegating practitioners of imitative *geijutsu shashin* to the status of the "humble slaves of painting" (*kaiga no "kensonnaru" dorei*) who insist on following the "path toward painting" (*kaiga e no michi*).[20] In this mocking account of *geijutsu shashin*, photographers are the blind followers of a fictitious faith, or "Way" [*michi*]. The language of the "Way" refers to an entire history of art practice and transmission in Japanese culture in which a master trains his disciples, a tradition that for Ina reeked of outdated, conventional methods no longer appropriate to photography, "the child of mechanical civilization."[21] More important, Ina's sardonic remarks about *geijutsu shashin* as a practice

that followed a "Way" were, in fact, a not-so-veiled critique of Fukuhara's "Shashin-dō" discussed previously.[22]

In *How to Make Art Photography*, Saitō seems to defend against the criticism of *geijutsu shashin* as conventional and imitative. He sees the modernist trend simply as that, a highly fashionable trend. Furthermore, it is a trend *within* the overall field of *geijutsu shashin*, or an approach that emerged from within *geijutsu shashin* itself.[23] He claims that these new photographers are mistaken if they think that *geijutsu shashin* is simply an outdated mode or an old style (*kyūgata*) of photographic expression.[24] With regard to imitation in photographic practice, Saitō looks to the photographer's motivation in taking and making pictures. If the motivation emerges from "the excitement and suddenness of emotion in one's heart," then the photographer can and should use any and all methods to express that in an artistic way, even if the final image results in mimicry.[25] In fact, he argues that it is difficult to discern the difference between imitation that comes from a pure (*junsui*) and innocent motivation and impure (*fujunbutsu*) mimicry that has been consciously plagiarized (*hyōsetsu*).[26] If imitation emerges from a pure motivation to create a picture based on the individuality of the artist, then it deserves our praise; but the consciously imitated image demands our derision.[27]

Popularizing the Geijutsu Shashin Approach

MONTHLY PHOTOGRAPHY COMPETITIONS

The images in Figure 5.1 (1928) and Figure 5.2 (1938) appeared in *Asahi kamera* as the winners of the monthly readers' contest sponsored by the magazine. Since the publication of the magazine beginning in April 1926, the editors called for readers—unknown amateurs of all levels—to submit their work, selected the best from among the submissions, and then published the results in the following month's issue. The work of these unknown artists filled the pages between technical articles, exhibition reviews, and product advertisements. Each month, eager amateur photographers submitted their photographs in the hopes of having their images chosen, a distinction that conferred small prize monies and publication of their work in the journal. Because they were a regular feature of the magazine from the start, these venues of competition and critique offered more than recognition and rewards; they also set the ground rules for making tasteful, beautiful pictures. This was one arena in which the specific aesthetics of amateur photography were delineated.

Asahi kamera was not alone among photography journals, popular and elite alike, in sponsoring monthly readers' competitions. Popular magazines like *Shashin geppō*, *Shashin shinpō*, *Kamera*, and *Fuototaimusu* all held their own versions of monthly competitions.[28] The more exclusive, high-end journals, like *Gekkan Raika (Leica)* and *Shashin saron* (both published by Arusu) also published readers' photographs every month.[29] Even *Kōga*, known at the time as the highest of the highbrow photographic magazines, called for photo submissions each month in its "Call for Photographic Prints." However, nearly all of the photos chosen by the editors of *Kōga* were images made by luminaries like Kimura Ihei, Nojima Yasuzō, Hanaya Kanbei, and Yasui Nakaji.[30]

Readers of *Asahi kamera* were invited to submit images to the editorial staff, who would sift through the submissions, make selections, and award prizes. "The 150th *Asahi kamera* Monthly Call for Prize Photographs,"[31] tucked away at the back of the journal, was the same basic advertisement that *Asahi kamera* used every month for the entire run of the magazine before 1941. Readers submitted their work on any theme to one of three divisions for consideration by the editorial staff of the journal.[32] Division One was aimed at the extreme beginner (*goku shoshinsha*), who was asked to submit contact prints no larger than 9 × 14 cm (*hagaki-han*). Once a person's photos were selected three times in Division One, the individual was barred from submitting work to that division again. Division Two required prints that employed enlargement and were larger than 12.0 × 16.5 cm (*kabine-han*). In addition, photographers who submitted enlargements were required to attach the contact print to the back of the photo so the editors could compare the original shot with the final print, helping them judge the quality of the photographer's printing technique. Division Three, called the Monthly Competition (*Reikai Konkūru*), was for the most advanced amateurs among the readers. They were to submit their work to the Photography Committee, which would make the selections. Rules for submission, required information, and where to send the prints are also clearly stated in the advertisement. In boldface, the advertisement warns photographers to submit only work that has not previously won prizes or been shown publicly.

As of 1938, the first-, second-, and third-place winners of each division were awarded cash prizes (Division One: five, three, and two yen, respectively; Divisions Two and Three: ten, five, and three yen, respectively). All selections, including honorable mention, received souvenir medals. In ad-

dition to the prizes, the photographer's name and the title of each winning image were listed in the "Announcement of Winning Monthly Photographs" and recorded prominently in the table of contents. All of the images that placed and some of the honorable mentions from Divisions Two and Three were featured as full-page layouts in the front pages of the magazine, after the table of contents and first set of ads. The winners and selections for Division One were typically published, two to three on a page, toward the back of the magazine.

The rules for submission to the different divisions clearly established a ladder-of-advancement ethos for readers. The idea that once you have won recognition three times for your beginner photographs in Division One you would no longer be eligible in that division meant that you had improved; you were now too good to be called "extreme beginner." And among the three divisions, the word *sakuhin*, or "work of art," is used only in reference to the most advanced images, Division Three, implying that even beginners will someday create *sakuhin*, not mere *inga* (photographic prints). Indeed, Division Three is the only division with a separate and rather exclusive-sounding name, *Reikai Konkūru*, or "Monthly Competition." The French-inspired *konkūru* provided a cosmopolitan touch that the synonymous word *kyōgi* (competition) apparently did not possess (similarly *saron* [salon, exhibition] seemed more suitable for elevated work than the synonymous *tenrankai* [exhibition]). Even the prizes conferred differential status to beginners and advanced practitioners, whereby a first-place selection in Division One was only worthy of the same yen amount as a second-place prize in Division Two or Three. Where the winning images were featured and how large they were displayed also helped delineate the beginner from the advanced amateurs.

FUKUHARA SHINZŌ AND THE POPULARIZATION OF *GEIJUTSU SHASHIN*

As Saitō points out indirectly in his definition, the term *geijutsu shashin* was used originally to refer to the aesthetics of high-art photography. Elite photographers who dominated the world of *geijutsu shashin* from 1910 through the early 1920s wrote essays for small art journals like *Shashin geijutsu* and displayed their work in prestigious exhibitions and club shows. *Geijutsu shashin* was the exclusive aesthetic lexicon of amateur photographers, who during this period came primarily from the upper echelons of Japanese society. By the late 1920s, however, with the spread of photography among

middle-class men, popular photography magazines regularly featured accessible articles that explored the aesthetics of *geijutsu shashin*. Fukuhara Shinzō's writings, including "The Way of Photography," were the most prominent to articulate the aesthetic vocabulary of *geijutsu shashin* to a growing photographing public. And Fukuhara's experience as a well-known practicing photographer and as a leading businessman put him in the unique position to take the lead in popularizing *geijutsu shashin*.

After Fukuhara returned to Tokyo in 1913 from the United States and Europe, where he studied pharmacology and pursued his interests in photography, he took over the day-to-day management of his family's company, Shiseidō, when his father retired and neither of his older brothers was found fit to run the company.[33] Under Fukuhara's leadership, Shiseidō became Japan's most innovative cosmetics company. He established one of the first research labs in the industry and was among the earliest to focus on the value of design to advertising, setting up the company's design section in 1916. He opened one of Tokyo's most acclaimed public art galleries in the company's headquarters in Ginza in 1919 and one of the earliest full-service beauty salons in 1922. In the world of photography, he established his own publishing company, Shashin Geijutsusha, and the highbrow photo journal *Shashin geijutsu* in 1921. He was also an accomplished art photographer and in 1922 published his photographs from his time as a student in Paris in *Paris and the Seine*. He founded the Nihon Shashin Kai (Japan Photographic Society) in 1924 and became its first president, a position he held until his death in 1948.[34]

Fukuhara's role in bridging the worlds of retailing and art was a unique one and deeply informed his later work in the world of popular photography. His activities as a photographer and publisher from 1910 through the 1920s positioned Fukuhara as a leader in the exclusive circles of high-art photography. But his role as an innovative leader in retailing provided him with a keen understanding of the consumer market. With this unique combination of business acumen and creativity, along with a deep commitment to the arts, specifically *geijutsu shashin*, Fukuhara turned his attention to popularizing the art of photography among a broader base of consumers. More specifically, his close association with the Asahi Newspaper Company from the mid-1920s took Fukuhara from the realm of high-art photography to middlebrow popularizer of *geijutsu shashin*, in particular as one of the leading organizers behind the elaborate events celebrating the centenary anniversary of the invention of photography in 1925. Though he had already

written a great deal on photographic aesthetics for his highbrow journal *Shashin geijutsu*, he greatly expanded his readership among amateurs and hobbyists with the publication of "The Way of Photography."

"SELECTED BY SUZUKI HACHIRŌ"

Amateurs submitted their work to *Asahi kamera* and other magazines not only for the chance to be published but also to receive the rather candid critiques and comments that the magazines' editors doled out to any and all takers. Criticism was offered heuristically, judges and editors claimed, to aid the hobbyist, whether novice or old hand, in improving his technique and training his eye. These competitive venues offered more than momentary recognition and meager prizes; they also established what it meant in photographic terms to make beautiful photographs. Since the magazines published amateur images every month, readers quickly learned what pleased contest judges and magazine editors. Commentary published alongside winning photographs served as a kind of aesthetic textbook that set forth the rules and limitations of acceptable photographic style and form.

One of the more unique columns published from the mid-1930s was *Kamera kurabu*'s "Selected by Suzuki Hachirō" (Suzuki Hachirō-sen), a monthly feature in which advanced hobbyists submitted work to be selected for publication by editor Suzuki Hachirō. Along with Fukuhara Shinzō, Suzuki Hachirō (1900–1985) was a key figure in popularizing photography, particularly advanced photographic technique, for middle-class enthusiasts. Suzuki, also like Fukuhara, was a well-known photographer,[35] but it was his role as editor and how-to writer for Arusu Publishing that brought his experience to middlebrow consumers, who were hungry for well-written technical advice and clear instruction from an expert. By the end of his life, he had written more than forty instructional books and numerous articles. After struggling for several years as a commercial photographer, Suzuki returned to Arusu Publishing in 1936 to become the editor of *Kamera kurabu*, whose intended audience was beginner and intermediate hobbyists. He was also the editor and author of the ten-volume series *The Arusu Course in Popular Photography* (*Arusu taishū shashin kōza*), a subscription series that came out over a two-year period starting in 1937, which included *Knowledge of the Camera and How to Choose One*, discussed previously.[36]

For the first two years of publication, before Suzuki's arrival, *Kamera kurabu* was less a magazine than a pamphlet, measuring only 19.0 × 12.7 cm with fifteen to twenty pages of text and photos. As editor of

Kamera kurabu, Suzuki not only oversaw the production of the revamped magazine but also acted as judge for the advanced division of the monthly photographic prize, which was added to the magazine's monthly format in 1937. The competition, known by the generic name "Monthly Photography Competition," had two divisions, much like the *Asahi kamera* competition. Division One was for beginners, and selected work was published in a special column each month, "Brief Comments on the Monthly Division One Selected Prints," that included comments from the magazine's staff.[37] Suzuki himself made the selections for Division Two, intended for new artists whose "ambition it is to succeed in the world of art photography" (Figure 5.3).[38] Winners of Division Two had the privilege of having their work published in the pages of the magazine and their names printed in the special section "Selected by Suzuki Hachirō." Clearly, having Suzuki's name associated with one's photograph meant as much as the publication, prize

FIGURE 5.3. Winners of *Kamera kurabu*'s Sixth Monthly Photo Competition and of "Selected by Suzuki Hachirō," July 1936. Winners of Division Two, selected by Suzuki Hachirō, had their work published in the pages of the magazine. Having Suzuki's name associated with one's photograph meant as much as the publication, prize monies, and medals. Source: *Kamera kurabu* 2, no. 7 (July 1936): 56.

monies, and medals (offered to first-, second-, and third-place winners). Indeed, Arusu continually capitalized on Suzuki's name. In a supplemental advertisement for Arusu Fine Grain Developer from around this period,[39] Suzuki offers an extended testimonial on the efficacy of the developing powder (Figure 5.4). In extra-large, boldface print on the right-hand side of the ad is "Professor Suzuki Hachirō's long-awaited formula for the latest developer." Suzuki's selections for the monthly contest tend to fall under Saitō's definition of realistic expression, or pictures that "show nature as it really is." Though submissions to other popular photography magazines still included the lyrical and impressionistic approaches, Suzuki seemed to pick only realistic images. Many of the winning photographs are of natural phenomena, such as close-ups of plants and insects, but there are also many shots of people outdoors, not conventional portraits but action shots of people walking and working.

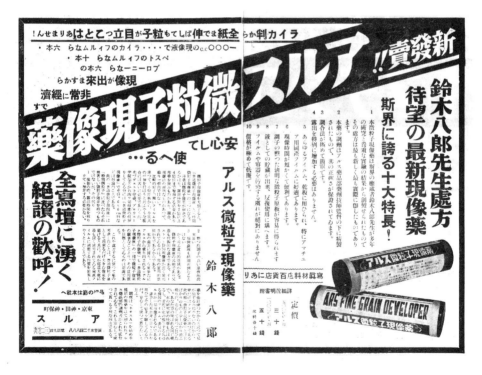

FIGURE 5.4 Advertisement for Arusu fine grain developer, ca. 1938. Extra-large, boldface print on the right-hand side of the ad proclaims, "Professor Suzuki Hachirō's long-awaited formula for the latest developer." Source: Found pamphlet, ca. 1938.

MARKETING *GEIJUTSU SHASHIN*

While popularizers like Fukuhara and Suzuki endorsed the vocabulary of *geijutsu shashin* for the middle-class photographer, the camera industry promoted photographic techniques that required not only artistic vision and technical skill but also the use of specialized and often expensive products. The marketing of these products did not rest solely on advertisements and window displays. In addition to these conventional means of publicity, the camera industry promoted its products in thousands of contests it sponsored in magazines it published.[40] As we have already seen, many of these contests asked readers to submit their photographic work for evaluation and possible selection and publication by editors. But it was the contests that required participants to employ a particular technique, such as enlargement, or to use a particular kind of paper that were the most widely publicized and exerted the most influence on the aesthetic choices of hobbyists. For example, Yamaguchi Shōkai of Nagoya held a contest in 1925 in which participants were required to use one of three enlargers—the Victor (for the highest quality [*sai-kōkyū*]), the Swan (for intermediate use [*chūkyū*]), and the Queen (the popular model [*minshūteki*]) (Figure 5.5). The full-page announcement serves the dual purpose of advertising the contest information and selling the product. Most important, however, is the claim in the ad that genuine *geijutsu shashin* must be made with an enlarger: "Photographic art is expressed with enlargement. . . . Enlarge your pictures with one of our three enlargers."[41] In this case, the layout and design of the contest announcement mimic a product advertisement, and the contest itself is simply a clever marketing ploy. Contestants are required to use the very products that they hope to win. Another contest from 1925 required contestants to submit enlargements printed on Bayer's H Bromide printing paper imported by Misuzu Shōkai. The promotion claimed that the successful *geijutsu shashin* is produced half by the skill of the photographer and half by the choice in photographic materials.[42] The contest-cum-advertisement goes on to proclaim that the favored paper of art photographers is Bayer's H Bromide.[43] After the details of the contest are laid out, the second page of this two-page ad uses the more conventional copy-heavy approach to advertisement, unlike the previous announcement for enlargers that incorporated cutting-edge graphic design and photography. Instead of striking visual techniques, this ad uses persuasive copy to draw on the hobbyist's desire to be seen as an artist, claiming that most "real" art photographers use this product.

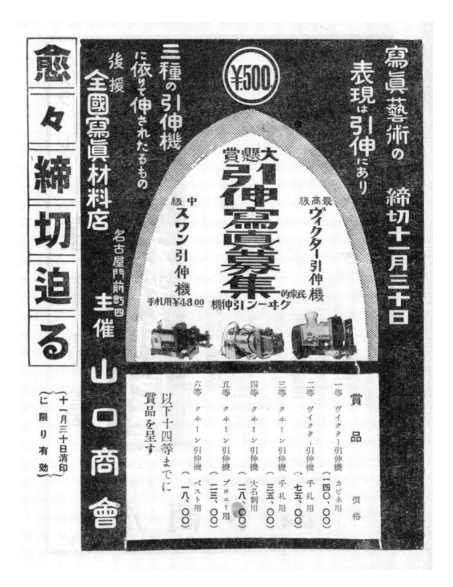

FIGURE 5.5 Announcement for Yamaguchi Shōkai Photo Enlargement Contest, November 1925. The full-page announcement serves the dual purpose of advertising the contest information and selling enlargers (which were also prizes in the contest). Most important, however, is the claim that genuine *geijutsu shashin* must be made with an enlarger. Source: *Kamera* 6, no. 11 (November 1925): n.p.

Still other competitions drew on the contestants' sense of national pride in order to promote the sale of domestic goods by requiring submissions to be produced with all Japanese-made products. Figure 5.6 shows an announcement for the Third Domestic Products Competition in Photography from the November 1935 issue of *Asahi kamera*. While the theme was open, the entries were required to be made with domestically produced plates, or film, and paper. Individual camera companies regularly sponsored competitions that required photographs to be produced with their products. Konishi Roku was especially fond of this format. Publicized with the slightly cumbersome heading "Promotion of Domestic Products Grand Prize—a Call for Photographs," in the January 1925 issue of *Shashin geppō*, the competition required photographers to use one of three of their cameras: the Lily, the Pearl, or the Idea. Winners of these contests usually acquired cash and/or photographic products and trophies, medals, or cups. Sometimes companies awarded other prizes, as in a contest held in 1936 by Misuzu Shōkai in which contestants had to use its Purobira paper (Figure 5.7). In addition to large cash prizes for all of the winners, the first-place winner received a Victor portable record player with a record case; second place, a gold wristwatch; third place, a travel trunk; fourth place, a silver cigarette case; and fifth place, a Citizen chrome wristwatch—a virtual laundry list of the most prized possessions for the white-collar worker in 1936.

CELEBRITY JUDGES AND THE PHOTOGRAPHY CONTEST

Contest-winning photographs offered hobbyists, readers, and the exhibition audience real examples of what editors and judges considered "good" photographs. More important, the judges themselves, often well-known photographers or critics, were used to draw contestants to particular competitions.[44] In cases where contests required the use of specific products, these judges indirectly became celebrity spokesmen for those products. But even in cases where no specific products were required, a famous person on the selection committee legitimated the art of amateur photography. Most contest advertisements prominently displayed the names of the judges.[45] Potential entrants experienced in the world of hobby photography were well acquainted, at least through print, with these judges. Entrants no doubt knew Suzuki Hachirō, the prolific how-to writer and editor of *Kamera kurabu*. They knew Fukuhara Shinzō, not only from his written work but also from his well-known photographs seen in galleries and published in books. The influence of these bearers of taste cannot be underestimated. Such a selection

國産懸賞寫眞大募集　第三回同

賞金總額七百五十圓
商工大臣賞銀製大カップ及
銀・銅メダル入賞者百十六名

賞

一等（一名）
△商工大臣賞銀製大カップ
△賞金参百圓

二等（二名）
△本誌銀メダル
△賞金百圓宛

三等（三名）
△本誌銀ノダル
△賞金五拾圓宛

佳作（十名）
△本誌銀メダル
△賞金拾圓宛

入選（百名）
△本誌銅メダル

募集規定

●畫題　自由
●大きさ　カビネ以上四切以内
●枚数　制限なし
●装幀　臺紙へ貼付せざること
●裏面　住所、姓名・畫題筧にデータ、使用乾板又はフィルムと印畫紙名を明記のこと
●締切　昭和十年十一月二十日
●送先　東京市麴町區有樂町貳丁目參番地東京朝日新聞社内
　アサヒカメラ編輯部、但封皮に「國産懸賞」と朱書すること
●原板　入選補印畫の乾板フィルム提供を乞ふ。但しこの提供なきものは審査より除外す
●その他　應募印畫は返却せず、入選印畫の版權は本誌に歸し、應募作品は未發表のものに限る

●應募資格　制限なし
●材料　乾板、フィルム、印畫紙とも國産品を使用すること

●審査　アサヒカメラ編輯部審査の際國産材料たることを確認するため各製造會社代表の立會を求む

入選發表はアサヒカメラ新年號誌上

主催　アサヒカメラ

締切迫る

FIGURE 5.6　Announcement for the Third Domestic Products Competition in Photography, November 1935. Entries were required to be made with domestically produced plates, or film, and paper. Reprinted with the permission of Asahi Shinbunsha. Source: *Asahi kamera* 20, no. 5 (November 1935): 618.

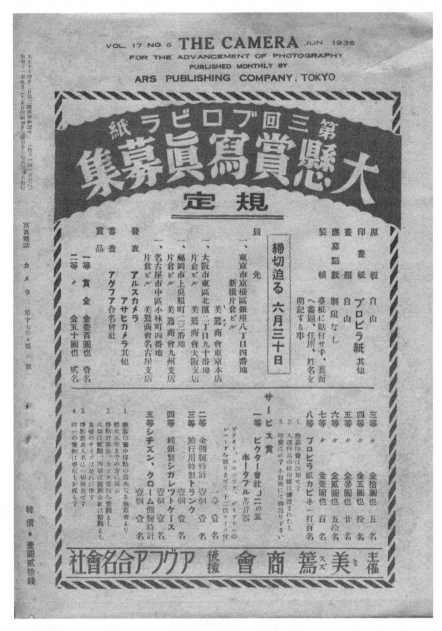

FIGURE 5.7 Announcement for Misuzu Shōkai Photo Contest, November 1925. For this competition, contestants had to use Misuzu's Purobira paper. In addition to cash prizes, this contest awarded winners a Victor portable record player, a gold wristwatch, a travel trunk, a silver cigarette case, and a Citizen chrome wristwatch. Source: *Kamera* 17, no. 6 (June 1936): back cover.

process not only imparted an aura of celebrity but also drew on the desire for expertise and authority, since entrants knew their work would be reviewed by professionals who had the stature within the photographic world to make educated, tasteful distinctions based on vast experience.

The names of the judges for many of these contests were often printed alongside the list of prizes. In a 1935 contest promoted in the June issue of *Kamera*, the Shōwa Photography Corporation asked eight people, including Yasukōchi Ji'ichirō (how-to writer) and Akiyama Tetsusuke (editor, how-to writer), Narusawa Reisen (*Asahi gurafu* editor), Ezaki Saburō (Konishi Roku engineer), and Nakayama Iwata (photographer), to judge a contest in which contestants were required to use Shōwa plates or paper in making their images. Experienced amateurs were certain to be familiar with these luminaries of the photographic world, most of whom were regular contributors either of essays or of photographs to the leading popular photography magazines. In 1936, the Association of Urban Beauty (Toshi Bi Kyōkai) backed an unusual contest whose theme was "urban beauty" (*toshi bi*) and "urban ugliness" (*toshi shū*) (Figure 5.8). The judges, too, were a

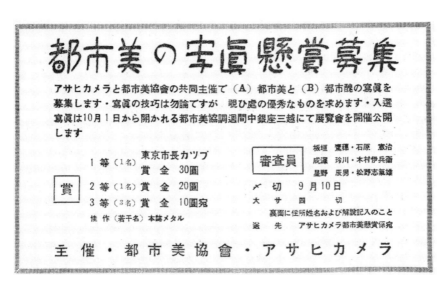

FIGURE 5.8 Celebrity judges listed prominently in announcement for *Asahi kamera*'s Photos of Urban Beauty Contest, September 1936. The judges were well known to readers of *Asahi kamera*. Among the judges were modernist critic and frequent contributor to *Asahi kamera*, Itagaki Takaho; *Asahi gurafu* editor, Narusawa Reisen; and photographer Kimura Ihei. Reprinted with the permission of Asahi Shinbunsha. Source: *Asahi kamera* 22, no. 3 (September 1936): 550.

somewhat unusual grouping, but most were well known to readers of *Asahi kamera*. Among them were modernist critic and frequent contributor to *Asahi kamera* Itagaki Takaho; *Asahi gurafu* editor Narusawa Reisen; and photographer Kimura Ihei. In addition to earning monetary prizes and medals, photographers would have their winning entries displayed at Ginza's Mitsukoshi Department Store. Kimura Ihei was the perfect expert judge for this contest, since much of his work from this period was consumed with documenting urban life, especially the enormous transformations that modernization brought to Tokyo's marginal populations. Takakuwa Katsuo, Suzuki Hachirō, and Kitano Kunio, all writers and editors for various Arusu photographic publications, served as judges for the Arusu Competition in Photography for the Support of Domestic Products (Kokusan Shinkō Arusu Shashin Dai-Konkūru) in 1938, a contest advertised in *Asahi kamera* intended to bolster the national policy of supporting domestic production against the influx of imports (Figure 5.9). In boldface type down the right-hand side, the announcement proclaims that to support the production of domestic goods is "The Great Work of the Photographic World in This Time of Crisis . . . From the beginning, we are proud to offer Arusu Photographic Chemicals, a purely domestic product. By making this your favorite product, you correctly follow the national policy of promoting domestic production." [46] Indeed, the government started to impose restrictions on the sales of imported cameras and photographic products. By sponsoring a contest that promoted domestically produced products, the camera and light-sensitive materials industries fell in line with government orders, even though such obedience caused economic hardship for the companies. [47]

In addition to using the tactic of inviting famous photographers to judge contests, marketers lured hobbyists to participate in contests, and ultimately to consume more goods, by displaying winning photographs in formal public exhibitions. In December 1921, the Mitsukoshi Vest Camera Club at the Mitsukoshi Department Store announced its "Call for the First Competition in Photography" in *Mitsukoshi*, the store's monthly promotional magazine (Figure 5.10). The competition included big-name judges, and the winning photographs would be exhibited at the Nihonbashi branch of Mitsukoshi and published in the magazine. This particular example allows us to see a typical course of contest events, from the initial contest announcement to the publication of winning results. The judges included a professor from Tokyo Bijutsu Gakkō (Tokyo School of Art); the chief photographer of Mitsukoshi's photography division; the editor in chief of *Shashin shinpō*;

the owner of Maekawa Photography Studio; Takakuwa Katsuo, editor in chief of *Kamera* magazine; and Akiyama Tetsusuke, editor in chief of *Shashin geppō*. All entries were to be taken with a Vest Pocket Kodak camera, one of the more popular items available at the store's camera counter. In the March issue of *Mitsukoshi*, a short article, "Exhibition of the Winning Vest Camera Photographs," accompanies reproductions of the winning images as well as a nice shot of the exhibition space itself (Figures 5.11 and 5.12). According to the article, from among over twenty-six hundred entries, twenty-one were selected for prizes, fifty were selected as "Excellent," and about one hundred were chosen for "Honorable Mention."[48] All of those chosen were exhibited at the store. The formal exhibition and the publication of winning images were added incentives that appealed less to pecuniary motivations and more to a contestant's desire for recognition.

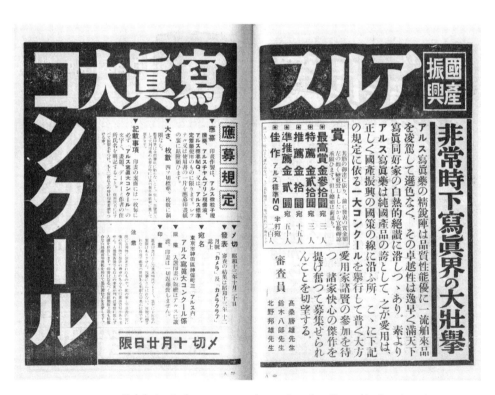

FIGURE 5.9 Celebrity judges support the national policy of bolstering domestic production, September 1938. Takakuwa Katsuo, Suzuki Hachirō, and Kitano Kunio, all writers and editors for various Arusu photographic publications, served as judges for the Arusu Competition in Photography for the Support of Domestic Products. Source: *Asahi kamera* 26, no. 3 (September 1938): A69–A70.

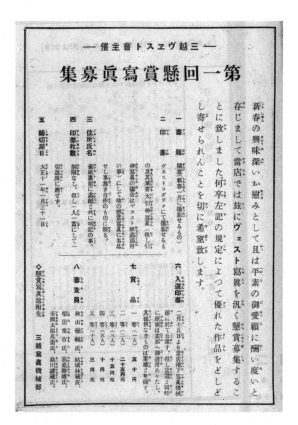

FIGURE 5.10 Announcement for the Mitsukoshi Vest Camera Club First Competition in Photography, December 1921. In addition to including big-name judges, the winning photographs would be exhibited at the Nihonbashi branch of Mitsukoshi and published in *Mitsukoshi* magazine. Source: *Mitsukoshi* 11, no. 12 (December 1921): n.p.

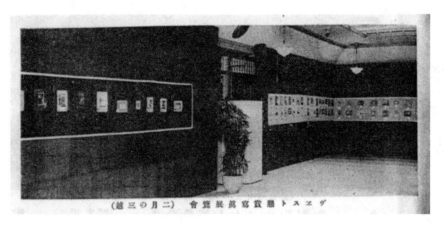

FIGURE 5.11 "Exhibition of Winning Vest Photographs," February 1922. The photographs were exhibited at Mitsukoshi Department Store. Source: *Mitsukoshi* 12, no. 3 (March 1922): 33.

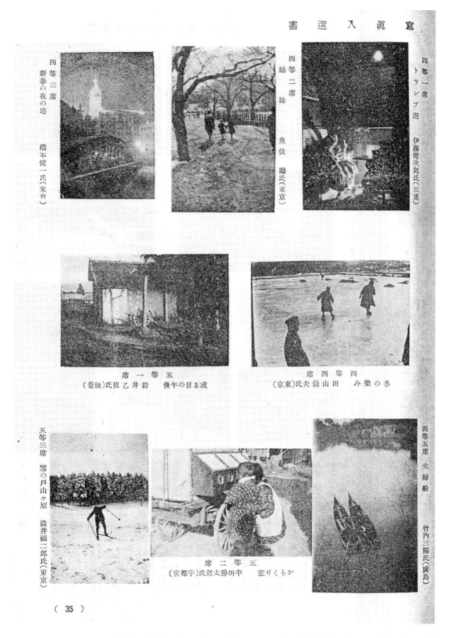

四等一席
トランプ遊　伊藤健次郎氏(三重)

四等二席
姉妹　魚住勵氏(東京)

四等三席
新春の夜の塔　橋本健一氏(東京)

五等一席
滅る午の機　岩井乙技氏(仙臺)

四等四席
冬の樂み　田山嶽夫氏(東京)

五等三席
雪の戸山ヶ原　瀧井福二郎氏(東京)

五等二席
かくり窓　半田勝太郎氏(宇都宮)

四等五席
夫婦船　竹内三陽氏(廣島)

(35)

FIGURE 5.12 "Prize-Winning Vest Photographs Exhibited at Mitsukoshi Department Store," February 1922. Source: *Mitsukoshi* 12, no. 3 (March 1922): 35.

Fukuhara Shinzō was one of the more prominent judges for contests during the period. In a 1930 example sponsored by *Asahi kamera*, Fukuhara's aesthetic expertise was called on to judge a contest that asked photographers to deploy "graphic patterning" in their submissions. After the judges decided on the winning designs, Matsuya and Matsuzakaya Department Stores would use the patterns in their new *yukata* lines[49]—an early example of "tie-in" marketing techniques. The contest announcement claims that one of the biggest problems facing photography in 1930 is how to get photographers to "bring the so-called hobby of art photography out of the ivory tower and make it more practical."[50] The judges included well-known writers, musicians, painters, editors, and professors. Another thematic contest for hobbyists that asked contributors to try their hand at commercial photography was advertised in the April 1936 issue of *Asahi kamera*, in which participants were asked to submit advertisement photographs for cigarettes.

FIGURE 5.13 Announcement of contest for commercial photography advertising cigarettes, April 1936. Participants were asked to submit advertisement photographs of cigarettes, using one of nine cigarette brands in their submission. Source: *Asahi kamera* 21, no. 4 (April 1936): n.p.

The photographers were obliged to use one of nine cigarette brands in their submission: "We're looking for photographs that capture the refreshment and atmosphere of smoking and use a still-life photograph incorporating cigarettes" (Figure 5.13).[51]

Making Middlebrow Aesthetics

CRAFTING AESTHETICS

Persuaded by the eloquent articulations of theory as well as the prize monies, recognition, and goods that contests offered, hobbyists embraced techniques that conformed to the aesthetic standards of *geijutsu shashin*. These techniques relied heavily on manipulation and handwork in the image-making process. Manipulation included such techniques as enlargement, painting or coloring the negative or the positive print, and the use of delicate oil-transfer procedures, all of which, as Christian Peterson argues, "required not only great manual dexterity but significant restraint and responsibility on the part of the photographer as well."[52] Though all of these techniques were widely written about and advertised, the most popular by far throughout the 1920s and early 1930s were the bromoil and bromoil-transfer processes, introduced by E. J. Wall in 1907. Figure 5.14 shows an example of a bromoil print done by Fuchigami Hakuyō (1889–1960), no rank amateur, but I use it here to illustrate the technical quality of the bromoil.

> [The bromoil technique] began with a regularly printed enlargement [rather than working on the negative, for example]. The print was chemically treated to bleach away and physically swell the image area. To restore the picture the photographer then brushed on an oil-based ink, which adhered only to the image area. Successful images required skillful use of the brush, a genuine artist's tool. Bromoil transfers required putting the brush-developed print through a press in contact with another sheet of paper, which became the final print.[53]

How-to books on art photography typically featured several chapters on the bromoil process, and popular photography magazines regularly published articles on the same subject throughout the 1920s and early 1930s.[54] For example, in *Shashin geppō*, Konishi Roku's photo magazine, the bromoil and bromoil-transfer techniques were covered in every issue every month from 1923 to 1926. Of the 177 photographs exhibited in the Honorable Mention section of the Twenty-First Kenten Exhibition of 1932, 161 photographs

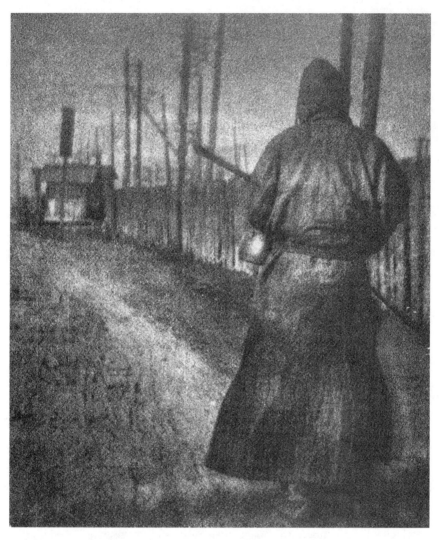

FIGURE 5.14 "Untitled," Fuchigami Hakuyō, Bromoil, 1930s. Source: Tōkyō-to Shashin Bijutsukan, *Nihon kindai shashin no seiritsu to tenkai*.

were bromoil or bromoil transfers.[55] Obviously, bromoil was *the* process of choice for amateur photographers.[56]

The popularity of manipulative processes cannot be explained solely by the appeal of the aesthetic implications of the resulting image or the coercive strength of the camera industry.[57] Manipulative processes allowed hobbyists not only to express themselves creatively but, more important, to display technical mastery over a complex apparatus. *Geijutsu shashin*, when properly executed, "offered visible evidence of the process of creation in the mark of the tool."[58] These are John Brinckerhoff Jackson's words for the appeal of the craftsman style among early twentieth-century middle-class Americans, but they apply equally well to the predominance of the *geijutsu shashin* aesthetic among Japan's middle class in the 1920s and 1930s. Jackson continues,

> If some of the esthetic manifestations [of the arts and crafts movement] were inept, the true importance of the movement lay in the new, or revived, dignity it gave to work—work done by hand, by workmen not in the factory but in the home or shop: for the value of this kind of work was not production in the industrial sense, but self-expression and self-justification. . . . The consequence of the belief was the conviction that the very *process* of work was no less beautiful, no less significant, than the finished article itself. The conviction derived in part from an esthetic reaction against the slick and impersonal aspects of the mass-produced item.[59]

In the *geijutsu shashin* movement, too, the focus on process—sometimes to the neglect of the resultant image—became a central component of the aesthetics of art photography. In the face of an ever-increasingly mechanized middle-class life, the creation of *geijutsu shashin* allowed a space for handwork and a craftsman's sensibility. Indeed, as Steven Gelber argues, hobbies, especially productive ones like arts and crafts style furniture making, are both an extension of and buffer against industrialization:

> As an extension [productive hobbies] needed to reproduce the beliefs and behaviors necessary for the continuation of capitalism. As a buffer they needed to give participants a sense of relief and perhaps empowerment in the face of centralized production. Not only were these two functions far from incompatible, they were virtually two sides of the same coin. Since the hobby was done at home in free time, it was under the complete control of the hobbyist. It was in other words, a reembracing of preindustrial labor, a re-creation of the world of the yeoman, artisan, and independent merchant. By the same token, because it was the re-creation of a thoroughly capitalist

world, the underlying values of that world—from market economies to the work ethic—were colonizing the home. As disguised affirmation, hobbies were a Trojan horse that brought the ideology of the factory and office into the parlor.[60]

Though I would argue that any practice so tightly tied to "a thoroughly capitalist world" could not also be under the "complete control" of the practitioner, Gelber's point that productive hobbies served to restore the value of handwork, even within the context of modern capitalism, is certainly germane to our discussion of amateur photography. Indeed, art photography amounted to what Christian Peterson has called a "technological folk art."[61] Peterson refers to the words of Adolf Fassbender, a leader in the American pictorial movement, to illustrate the concept of art photography as a craft, a skill cultivated over time that allowed the artist to overcome the limitations of mediocre photographic materials and less-than-ideal photographic conditions:

> "The photographic Artist," according to Adolf Fassbender, "is a man who has complete control over his medium; a perfect technician who is able to create at will, who can change where light and lens failed, where material was insufficient and value upset." Hand manipulation could rescue faulty negatives and overcome photography's then lack of color and three-dimensionality. Fassbender knew that photographic equipment alone was incapable of capturing the photographer's impressions of a scene. And since the medium was, in his words, "one mistake after another," pictorialists needed the skills to revamp, repair, remake, and recycle their pictures in order to make them artistic.[62]

The home darkroom, then, became more than an improvised scientific laboratory; it became a space where photographers combined an emotive response to nature with a skillful rendering of complicated darkroom procedures (using costly materials and equipment, of course).[63]

Takakuwa Katsuo, like Fukuhara Shinzō and Suzuki Hachirō, was another central figure in the popularization of hobby photography. Unlike Fukuhara, however, what Takakuwa advocated was hobby photography as *minshū geijutsu* (folk or people's art). Takakuwa's popularizing began in earnest in 1920 with the publication of his best-selling how-to manual, *Techniques of Film Photography* (*Fuirumu shashin jutsu*, 1920), which sold more than one hundred thousand copies, issued in more than 146 editions by 1924. Though he was an editor for Konishi Roku's *Shashin geppō* from 1910 to 1920, in 1921, with the backing of Arusu, he started his own

popular photography magazine, *Kamera*, which ran from April 1921 until December 1940. In "Looking at the Inaugural Issue," Takakuwa's mission statement, he makes it clear that this magazine is different because it is specifically for the amateur photographer (*kōzu shashinka*).[64] Takakuwa assures readers that *Kamera* would remain impartial, unlike other photography magazines, and would not become a mouthpiece for the camera industry to advertise its wares, though articles could cover "truly good products."[65]

In his call for the expansion of hobby photography, Takakuwa brought a class analysis rare among photographic commentaries. In an exchange with Ichikawa Eisaku that appeared in the pages of *Shashin geppō* throughout 1920, Takakuwa articulates his conceptualization of *shumi shashin* (hobby photography). The hobby photographer makes pictures first and foremost because he enjoys it, not because he intends to make a work of art. However, as the hobbyist becomes more adept, his work becomes more skillful and therefore more worthy of artistic merit. A *shumi shashinka* differs from a *bijutsu shashinka* in terms of his intentions,[66] but also in terms of the limits upon his freedom to create and make pictures. The *bijutsu shashinka* is bound by an aesthetic tradition that compels him to make certain kinds of pictures, using accepted styles and compositions. But the hobbyist is unfettered by such limitations: "Hobby photography has no form or tradition and is completely free; there is no need to be particular about composition; we have been liberated from all restraints and obligations."[67] Moreover, the *shumi shashinka* and the *bijutsu shashinka* differ greatly in terms of the circles in which they travel. In response to Ichikawa's confusion about why hobby and art photographers continue to be distinguished from one another, Takakuwa explains with an amusing analogy that the distinction is maintained, in fact, by *bijutsu shashinka* themselves:

> If today's art photography [*bijutsu shashin*] is the art of the nobility [*kizoku geijutsu*], then hobby photography [*shumi shashin*] is the people's art [*minshū geijutsu*]. If today's *bijutsu shashin*, made with its tradition, forms, printing methods, etc., is a feast with two side dishes [*ni no zen-tsuki gochisō*], then hobby photography is a simple dish at a chophouse [*nawa-noren shiki no ippin ryōri*]; this suits the taste of workers dressed in *happi* coats, and there are even times when a solemn gentleman dressed in a Prince Albert coat frequents such a restaurant. For those who pass through the curtain of the chophouse, there is no distinguishing among the people based on rank or wealth, but the takers of the two-side-dish feast limit it to themselves.[68]

Here, photography as an art for the masses is one that does not limit the creative instinct of the photographer by burdening him with rules and hidebound tradition. Anyone can take a photograph; and this is the power of photography, not only as a marketing ploy but also as a means of popularizing artistic practice among ordinary people.

THE AMATEUR'S REJECTION OF MODERNISM

Fuchigami Hakuyō's wonderfully kinetic bromoil " A Train Rushing " (Ressha bakushin; Figure 5.15) first appeared as the opening gravure image in the October 1930 issue of *Asahi kamera*. From the moment it was published, this image has symbolized the mastery of photographic form exhibited in Japanese modernism of this period. Today, "A Train Rushing" regularly appears in exhibition catalogues and histories of modern Japa-

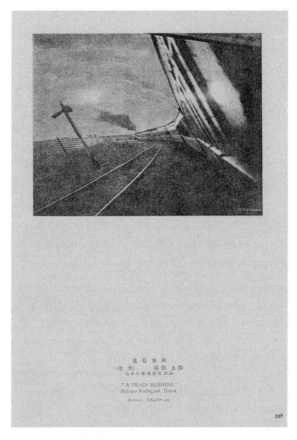

FIGURE 5.15 "A Train Rushing," Fuchigami Hakuyō, Bromoil, 1930. Source: *Asahi kamera* 10, no. 4 (October 1930): 349.

nese photography as the pinnacle of modernist photographic aesthetics.[69] In 1936, Kimura Kiyoshi contributed a cartoon to *Asahi kamera* that lampooned this by-now-archetypal image of Manchurian modernism. In "The Conductor's Speech" (Shashō-san no ben), which appeared in the December 1936 issue, the conductor grasps an overzealous photographer (Figure 5.16). Juxtaposed, these two images offer a glimpse into the often ambivalent affiliation between the aesthetic ideals of modernist photography and the practical sensibilities of hobby photography.

As discussed previously, high-modernist theorists and commentators openly expressed their antipathy toward amateur aesthetics. Though many historians have commented on this antagonism, few, if any, have taken seriously hobby photographers' deep familiarity with and attitudes toward modernism. Hobbyists, while quite knowledgeable about the latest trends in modernist photography, partly because the work of modernists was well exhibited and regularly featured in popular photography journals, expressed

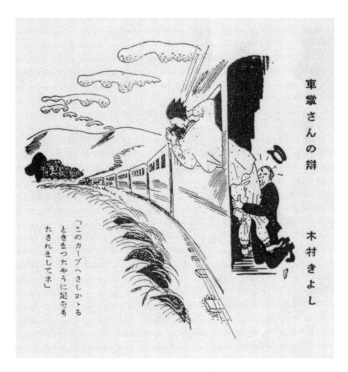

FIGURE 5.16 "The Conductor's Speech," Kimura Kiyoshi, December 1936. "I'll grab your legs tightly as soon as we get to the curve!" Source: *Asahi kamera* 22, no. 6 (December 1936): 970.

their own ambivalence about the modernist project. This is not to say, however, that hobby photography was simply a response to modernism; rather, hobbyists of the 1920s and 1930s, who were skilled in the techniques of many genres of photographic representation, rarely chose to work with modernist modes of representation. This choice reflects a rejection of modernism's often quite explicit commentary on middle-class art, lifestyle, and consumption. The aesthetic choices made by hobbyists, themselves members or aspiring members of that middle class, affirmed their practical approach to the craft of photography, an approach typically obscured in high-modernist manifestos.

Cartoons like the one shown in Figure 5.16 poked fun at the most cherished forms of modernist photography. In one from 1936, a photographer's

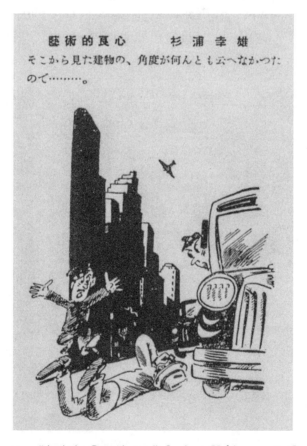

FIGURE 5.17 "Artistic Conscience," Sugiura Yukio, 1936. Cartoons like this one mocked the highly valued forms of modernist photography, such as the oblique-angle shot. Source: *Asahi kamera* 22, no. 6 (December 1936): 970.

"Artistic Conscience," as the piece is aptly titled, places him in great danger as he lies down in the middle of a bustling downtown street in order to get the perfect high-angle shot of a skyscraper (Figure 5.17). The oblique-angle shot—perhaps most memorably deployed by Albert Renger-Patzsch in "Blast Furnaces" in his book *Die welt ist schön* [The World Is Beautiful, 1928]—became one of modernism's most symbolic forms. The pages of high-end journals like *Kōga* and *Gekkan Raika* featured the work of Renger-Patzsch admirers, who took dizzying shots of factory chimneys and towering skyscrapers, for example, like the image in Figure 5.18, a shot by Asano Yōichi. Perhaps more daring than the photographer who took the picture is the man sitting on top of the towering chimney. Ina Nobuo

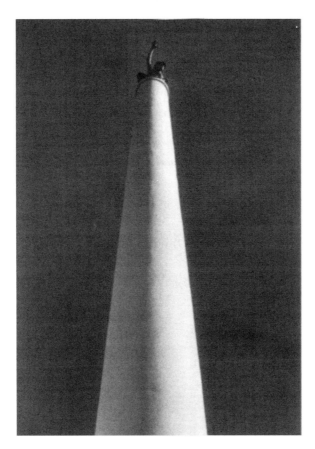

FIGURE 5.18 "Tower," Asano Yōichi, 1940. Source: Kanagawa Kenritsu Kindai Bijutsukan, *"Nihon no shashin 1930 nendai" ten zuroku*, n.p.

described the use of oblique-angle shots as one of the four approaches to modern photography.[70] In the cartoon, however, the prized formal element of the final photograph is exposed as a rather absurd folly whereby the means of capturing the scene is obscured by the impressiveness, scale, and surprise of the final image. Double exposures and montaged photographs are the focus of humor in two cartoons that appeared in a two-page spread that makes fun of the popularity of photography, "Shashin wo meguru jinsei" (A Life Surrounded by Photography). Appearing in the January 1933 issue of *Fuototaimusu*, these cartoons lampoon genres of photography that were highly regarded among modernists of the time (Figures 5.19 and 5.20). Nakayama Iwata and Hanaya Kanbei each in his own way deployed this technique in their work for *Kōga*. While modernists praised these formal approaches for their ability to capture the pace and conditions of modern life like no other art form, the hobby press and cartoonists often derided such techniques for their overly aesthetisized and often unrealistic vision.

Editors of popular magazines were sensitive to the sophisticated level of their audiences, who, if not familiar with the writings of Ina Nobuo or Itagaki Takaho, were certainly steeped in the modernist work of photographers like Koishi Kiyoshi, Hirai Terushichi, and Ōkubo Koroku,

FIGURE 5.19 "Double Exposure," Hirai Fusando, 1933. Modernist approaches to photography, such as double exposures, were regularly caricatured in cartoons that appeared in popular magazines like *Fuototaimusu*. Source: *Fuototaimusu* 10, no. 1 (January 1933): 87.

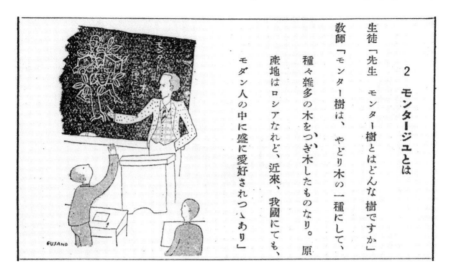

FIGURE 5.20 "What Is Montage?," Hirai Fusando, 1933. The student in the cartoon asks what sort of tree is the "montāju" (literally, "monta-tree"), a play on the Japanese character *ju* (tree). The teacher explains that the *montāju* is a mix of several tree varieties that originally came from Russia and has recently become popular among the "modern people of our country." Source: *Fuototaimusu* 10, no. 1 (January 1933): 86.

whose images appeared frequently in the pages of popular journals. For the humor of these cartoons to make sense, readers had to understand not only the techniques behind making such images but the place of modernism in the photographic world. Given the tendency of this audience to avoid making these kinds of images and the tendency of judges and editors to reward typical *geijutsu shashin*, a divide emerged between modernist modes of image production and popular approaches to image making. But the popular rejection of modernist aesthetics was not simply a blind refusal; it was one based on a deep understanding of the techniques and aesthetics of modernism itself.

Geijutsu shashin, not only as final product but also as total process, provided amateurs with an aesthetic language that matched their middle-class ideals; an active place in the world of consumerism befitting their newfound incomes; and an absorbing activity that placed value on craftsmanship. The popularity and commercial elements of hobby photography, however, stood in direct opposition to the values of modernism. Modernists carved out their niche, in fact, by attacking the fundamental joys of hobby photography—its growing popularity, its conventional aesthetics, and its deep connections

to the industry. Nevertheless, by the end of the 1920s *geijutsu shashin* had become a wide-scale, popular art movement, thanks in no small part to the inventive ways that the photographic industry and its coterie of experts tapped into the ideals and aspirations of an expanding audience of middle-class consumers.

EPILOGUE

The 1903 release of Japan's first domestically produced camera, Konishi Roku's Cherry Portable camera, made with an imported lens and assembled piecemeal from parts crafted by traditional cabinetmakers, marked the first step toward the realization of the company's goal in 1925 to place a camera in every Japanese household.[1] Though this goal would not be realized until the boom years of high-speed economic growth in the early postwar period, the foundation for the mass consumption of mass-produced cameras was firmly set in the prewar period by the pioneers of the photographic industry like Konishi Rokuzaemon himself. More important than the actual number of photography consumers and products were the patterns of production, marketing, and consumption established during this formative period.

Producers of cameras and light-sensitive materials went beyond conventional advertising and packaging to market their goods to the rising middle class by tapping into values associated with a new ethic regarding work and leisure. Spectacularly appointed show windows, expertly judged photography contests, and enlightening how-to books were calculated to draw on the values of educated taste, healthy competition, and self-cultivation—values held in high regard by the new and aspiring middle classes. Cameras were sold as essential accoutrements of the middle-class lifestyle and as the most appropriate means to document and represent that lifestyle.

For men, in particular, mastery of the photographic apparatus—from purchasing the appropriate camera to printing out images on the appropriate paper—marked membership in a techno-cultural elite. Photographers who demonstrated skillful photographic technique were rewarded in many ways. They won prizes in contests, and their work was published in popular magazines. Less tangible incentives came in the way that photography, with its particular emphasis on handwork and painterly techniques, allowed for the mark of the individual artist on the final image. Despite rigidly standardized aesthetics, amateur photographic practice offered photographers the semblance of total control over the process and means of representation, a kind of control largely absent from their workplaces.

On 29 January 1942, Konishi Rokuzaemon, the founder's son and second president, died at sixty-four. His funeral was held three days later, and more than three thousand people attended. His passing marked a new phase in the leadership of Konishi Roku and the company's productive role in the Japanese economy during the war.[2] The company rapidly turned from producing goods for the consumer market to focusing on munitions supplies, in particular, aerial cameras and light-sensitive materials. In April 1942, all factory workers at Konishi Roku's various plants were conscripted into military service. They continued to work in the same basic capacity but were now in service of the state, producing aerial cameras for the navy's air fleet. In 1943, by order of the state, all producers of photographic goods were either dissolved or amalgamated into other companies. Only three makers remained operative—Konishi Roku, Fuji Shashin Fuirumu (today's Fuji Film), and Tōyō Shashin Kōgyō. In 1943, Konishi Roku's retail business was ordered to close. In 1944, Konishi Roku relocated the remainder of its Tokyo facilities and workers to various locales in the Kantō region to escape the incessant fire bombing.

On the consumption side, hobbyists were feeling wartime deprivations as early as 1937. Shortages of leather, paper, and metal had begun to drive up prices of domestically produced cameras. In September of that year, the import and export of all cameras and light-sensitive materials, except in special cases, were prohibited by law.[3] Increased restrictions on where you could and could not take photographs, already in effect since the nineteenth century, placed even more limits on access to outdoor photographing and were issued almost monthly beginning in 1937. Pictures taken from one

hundred meters or higher, such as from the top of Osaka Castle, were prohibited. By 1940, the height limit had been lowered to twenty meters, and that year over two hundred people were arrested for violation of this ordinance. Taxes on cameras, which were regulated as luxury commodities, skyrocketed. In January 1943, the sales tax on cameras increased by 30 percent and on accessories and other materials by 80 percent.

In an effort to conserve paper and ink products, the state strictly controlled the publication of all printed matter. From late December 1941, shortly after the bombing of Pearl Harbor and the expansion of the war, the state canceled or consolidated all popular photography publications (there were more than twenty). *Shashin geppō* and *Shashin shinpō* were canceled. The remaining publications, like *Asahi kamera, Fuototaimisu, Kamera,* and *Kamera kurabu,* were consolidated into one of three photography journals: *Shashin bunka* (Photographic Culture), *Hōdō shashin* (News Photography), and *Shashin Nippon* (Photographic Japan). These magazines still concentrated on photography, but most of the content promoted the war effort with the use of photographic illustrations. Because of the restrictions on the sale and use of light-sensitive materials, especially film and paper, monthly photography contests disappeared from the pages of these magazines. Many professional photographers and well-known modernists continued to work as contributors to the three state-run propaganda journals, as this was the only avenue to access of photographic materials.

The wartime shortages and restrictions brought amateur photographic activity to a virtual standstill. This cessation of activities, though nearly complete, was relatively short-lived, however. The hiatus that the war imposed on the production and consumption of photographic goods was simply that: a brief break in a long-term trend of increased production, diversification, and consumption of products made domestically. While retail consumption virtually disappeared, production of cameras and light-sensitive materials for use by the military continued through the end of the Pacific War and rapidly increased immediately upon the occupation by the US armed forces in August 1945. By 1952, when Japan's gross domestic product reached the highest prewar levels, camera companies were producing close to four hundred thousand cameras annually for the consumer market, well above the highest prewar numbers.[4] The production of cameras in 1957 was no less than 470 times that of 1946, and a large proportion of those products were exported throughout the world, including to the United States and Western Europe.[5] The number of camera companies dramatically

rose from 82 facilities with 4,812 workers in 1948 to 606 facilities with 32,545 workers in 1958.[6]

Consumption of photographic goods and the publication of photography magazines also quickly rebounded after the war, when the prohibition on the publication of photography magazines was lifted. The editors of *Kamera* solicited photographs from amateurs for their monthly photography competition in January 1946, when publication resumed.[7] The Nude Photography Competition, held in May 1948, saw the return of thematically organized photography competitions.[8] To make submissions to those competitions, amateur photographers were able to get extremely difficult-to-come-by photographic products on the black market. For example, in 1946, amateurs in search of a new (probably a used) camera and film could procure a Konishi Roku Baby Pearl camera for 1000 yen; a roll of film for 40 yen; developer for 2000 yen a bottle; and, a developing tank for 150 yen.[9] How-to literature was revived as well. While many of the newly available publications were simply reprints of prewar best sellers, new series from Arusu and Genkōsha appeared as early as the early 1950s.

In the introduction to *Mitchaku no jitsigi* (Practical Printing Out, 1954), Tanabe Yoshio describes the joys of taking, and especially making, photographs:

> The number of postwar cameramen, even compared to the height of activity in the prewar period, is said to have increased several times over. But this only accounts for the number of amateurs who take pictures. The number of those who engage in so-called darkroom work on their own—developing, printing, and enlarging—has not increased as rapidly. However, everyone recognizes that the truly enjoyable aspect of photography for the person who does basically all the photographic work on his own are the steps after taking the picture. I think everyone can imagine the appeal of making pictures by yourself rather than simply looking at those you have taken after having turned them over to someone else to develop.[10]

This brief passage reveals, at least anecdotally, the continued popularization of the consumption of photography that had begun in the prewar period. But more important, Tanabe captures, in a rather simple way, the attitude that I have tried to recapture throughout this book of the true hobbyist toward taking and making pictures, an attitude that was shaped by amateurs and the industry during the prewar period. Darkroom work necessitated producing something on your own and under your own control—values that how-to writers had extolled for decades and that referenced the idealized lifestyles to which most hobbyists aspired.

APPENDIX

Masaoka Photography Club Bylaws

Article I This club is named the Masaoka Shakō Kai, and the office is located inside the Ōuchi Photography Studio in Masaoka-chō, Tamachi.

Article II This club is organized for people who share in the hobby of photography, and it has the goals of popularizing and studying [the practice of] photography and promoting friendship among members.

Article III Those who would like to become members of this club must be introduced by a member and receive the assent of all other members.

Article IV Members must pay a monthly fee of twenty sen.

Article V The member's fees will be used primarily for the maintenance of the club and for prize money.

Article VI The members will elect one president and one vice president. However, the term of office is for one year, and at the end of the term officers will rotate.

Article VII The officers will manage the regular affairs of the club, such as the collection and custody of the members' fees, changes in membership, and notification of regular meetings.

Article VIII Every month the club will hold a regular meeting to discuss and vote on submitted prints; and, if circumstances permit, the club will hold an outdoor photo shoot.

Article IX The club will choose from among the selected prints those that will receive honorable mention and those that will receive prizes.

Article X The submissions must be cabinet-sized prints or smaller and of the member's own composition.

Article XI Members have the freedom to criticize the submissions.

Article XII At the end of each regular meeting, prints submitted in the previous meeting will be returned to the exhibitor. The club will display the winning prints in the office.

Article XIII The officers will announce the following month's theme at each regular meeting.

Article XIV Members who wish to withdraw from the club must submit a notice of withdrawal to the officers. However, members who have withdrawn will not have the fees they already submitted returned to them.

Article XV Each year the club will hold one general meeting to announce the financial statement, one annual photography exhibition, and one party (*sawa kai*).

Concluded
April 1920
Masaoka Photography Club[1]

[1] "Zappō," *Shashin Geppō* 25, no. 6 (June 1920): 57–58. Bylaws translated by author.

NOTES

Introduction

1. Elizabeth Brayer, *George Eastman: A Biography* (Baltimore: Johns Hopkins University Press, 1996), 481.

2. Ibid., 479.

3. "Zappō," *Shashin geppō* 25, no. 5 (May 1920): 48.

4. Brayer, *Eastman*, 481.

5. Ibid.

6. Ibid.

7. "Zappō," *Shashin geppō* 25, no. 5 (May 1920): 47. That portrait of Eastman was published as a gravure in this issue.

8. The rise of artistic photography from the late nineteenth century parallels the rise of the academic field of anthropology and the use of photography in anthropological studies of Japanese colonial territories. Outside the history of the development of art photography, research on the production of photographic knowledge regarding Japan's imperial possessions is a rapidly growing body of scholarship within the study of the history of Japanese photography. For example, see Paul D. Barclay, "Peddling Postcards and Selling Empire: Image-Making in Taiwan under Japanese Colonial Rule," *Japanese Studies* 30, no. 1 (2010): 81–110; David Fedman, "Triangulating Chōsen: Maps, Mapmaking, and the Land Survey in Colonial Korea," *Cross-Currents: East Asian History and Culture Review* 1, no. 1 (2012): 205–234; Iizawa Kōtarō, "Jinrui gakusha no kamera ai: Torii Ryūzō," in *Nihon-shashinshi o aruku* (Shinchōsha, 1992), 91–102; Gyewon Kim, "Unpacking the Archive: Ichthyology, Photography, and the Archival Record in Japan and Korea," *positions* 18, no. 1 (Spring 2010): 51–87; Satō Kenji, "Ehagaki no naka no jinruigaku," in *Kankō jinruigaku*, ed. Yamashita Shinji (Shin'yōsha, 1996), 45–53; Ka F. Wong, "Entanglements of Ethnographic Images: Torii Ryūzō's Photographic Record of Taiwan Aborigines (1896–1900)," *Japanese Studies* 24, no. 3 (2004): 283–299.

9. Mikiko Hirayama, "'Elegance' and 'Discipline': The Significance of Sino-Japanese Aesthetic Concepts in the Critical Terminology of Japanese Photography, 1903–1923," in *Reflecting Truth: Japanese Photography in the Nineteenth*

Century, ed. Nicole Coolidge Rousmaniere and Mikiko Hirayama (Amsterdam: Hotei Publishing, 2004), 98. This debate is thoroughly covered in two pieces by Iizawa Kōtarō, "Nihon no 'Geijutsu shashin' ga hajimatta," in *Kamera omoshiro monogatari*, ed. Asahi Shinbunsha (Asahi Shinbunsha, 1988), 48–53, and "'Geijutsu-ha' to 'Kikaiteki shabutsu-ha,'" in *"Geijutsu shashin" to sono jidai* (Heibonsha, 1986), 24–33. See also Kaneko Ryūichi, "The Origins and Development of Japanese Art Photography," in *The History of Japanese Photography*, ed. Anne Tucker et al. (New Haven, CT: Yale University Press, 2003), 104–113.

10. From the turn of the century, revolutionary printing technologies allowed for the reproduction of photographs in newspapers and magazines on a mass scale. For a detailed discussion of the advances in reprographic technologies and how those advances ignited the publication of images in magazines and newspapers, see John Clark, "Indices of Modernity: Changes in Popular Reprographic Representation," in *Being Modern in Japan: Culture and Society from the 1910s to the 1930s*, ed. Elsie Tipton and John Clark (Honolulu: University of Hawai'i Press, 2000), 25–49.

11. Hirayama, "'Elegance' and 'Discipline,'" 101.

12. See especially Iizawa, *"Geijutsu shashin" to sono jidai*; and Kaneko, "Japanese Photography in the Early Twentieth Century," in *Modern Photography in Japan, 1915–1940*, ed. Ansel Adams Center (San Francisco: The Friends of Photography, 2001), n.p., and "Nihon pikutoriarizumu shashin to sono shūhen: Kakō sareta kindai," in *Nihon kindai shashin no seiritsu: Kantō daishinsai kara Shinju-wan made, 1923–1941-nen*, ed. Kashiwagi Hiroshi, Kaneko Ryūichi, and Itō Shunji (Seikyūsha, 1987), 9–38; see also Kaneko, "The Origins and Development of Japanese Art Photography," 100–141; Philip Charrier, "Nojima Yasuzō's Primitivist Eye: 'Nude' and 'Natural' in Early Japanese Art Photography," *Japanese Studies* 26, no. 1 (2006): 47–68; Fuku Noriko, *Shinzo and Roso Fukuhara: Photographs by Ginza Modern Boys 1913–1941* (SEPIA International Incorporated, 2000); Ozawa Kenji, ed., *Nihon shashin senshū*, vol. 2, *Geijutsu shashin no keifu* (Shogakukan, 1986).

13. Kaneko, "The Origins and Development of Japanese Art Photography," 102.

14. Iizawa Kōtarō et al., eds., *Nihon no shashinka bekkan: Nihon shashin-shi gaisetsu* (Iwanami Shoten, 1999), 46.

15. Ibid., 47.

16. For the significance of this journal to modernism in Japanese photography, see Iizawa, *Shashin ni kaere: "Kōga" no jidai* (Heibonsha, 1988). Iizawa's book includes reprints of some of the magazine's seminal articles, photographs, and an extended history of the entire *Kōga* enterprise, including biographies of the main contributors: Nojima, Nakayama, Kimura, and Ina Nobuo (1898–1978). In 2005, Iizawa and Kaneko edited a slightly altered version of *"Kōga" no jidai* with two new analytical essays, one each by Iizawa and Kaneko, in *Nihon no shashin-shi no shihō, bekkan: Kōga no kessakushū* (Kokusho Kankōkai, 2005).

17. Ina joined Nojima, Nakayama, and Kimura on the editorial staff beginning with the second issue.

18. Kerry Ross, "Returning to Photography: Ina Nobuo and Real Photography in 1930s Japan" (Master's thesis, Columbia University, 1997), 10–11.

19. Gennifer Weisenfeld has shown how companies like Kao and Shiseidō were instrumental in using photography to help create the context for Japanese visual modernity. See especially Weisenfeld, "'From Baby's First Bath': Kaō Soap and Modern Japanese Commercial Design," *Art Bulletin* 86, no. 3 (2004): 573–598, and "Selling Shiseido: Cosmetics Advertising & Design in Early 20th-Century Japan," MIT *Visualizing Cultures*, 2010, http://ocw.mit.edu/ans7870/21f/21f.027/shiseido_01/sh_essay01.html.

20. Kaneko Ryūichi, "Realism and Propaganda: The Photographer's Eye Trained on Society," in Tucker et al., *The History of Japanese Photography*, 191. See also Kashiwagi Hiroshi, *Shōzō no naka no kenryoku: Kindai Nihon no gurafuizumu wo yomu* (Heibonsha, 1987), 9–65; Hasegawa Akira, "'Hōdō shashin' no yukue," in Kashiwagi, Kaneko, and Itō, *Nihon kindai shashin no seiritsu*, 161–189; Natori Yōnosuke, Ishikawa Yasumasa, and Nihon Shashinka Kyōkai, *Hōdō shashin no seishun jidai: Natori Yōnosuke to nakamatachi* (Kōdansha, 1991).

21. John Dower, "Ways of Seeing, Ways of Remembering: The Photography of Prewar Japan," in *A Century of Japanese Photography*, ed. Japan Photographer's Association (New York: Pantheon Books, 1971), 20.

22. Iizawa Kōtarō, "The Evolution of Postwar Photography," in Tucker et al., *The History of Japanese Photography*, 211–212. See also Iizawa, *Sengo shashin nōto: Shashin wa nani wo hyōgen shite kita ka* (Chūkō Shinsho, 1993).

23. For an illuminating dissection of this debate, see Julia Thomas, "Power Made Visible: Photography and Postwar Japan's Elusive Reality," *Journal of Asian Studies* 67, no. 2 (May 2008): 365–394.

24. The archives of Konishi Roku provide the basis for an exhaustive account of the rise of the company and is richly documented in Konishi Roku Shashin Kōgyō Kabushiki Kaisha Shashi Hensan-shitsu, ed., *Shashin to tomo ni hyakunen* (Konishi Roku Shashin Kōgyō Kabushiki Kaisha, 1973). Comparable, though less voluminous, company histories have been published for Asanuma Shōkai, Canon, and Nikon. For a rare exception to this characterization in the field of American history, see Nancy Martha West, *Kodak and the Lens of Nostalgia* (Charlottesville: University of Virginia Press, 2000). Reese Jenkins provides an in-depth account of the early history of the camera industry in the United States, including Kodak, in his *Images and Enterprise: Technology and the American Photographic Industry, 1839 to 1925* (Baltimore: Johns Hopkins University Press, 1975).

25. The call to reclaim retailing as a part of historical research is in Frank Trentmann, "Beyond Consumerism: New Historical Perspectives on Consumption," *Journal of Contemporary History* 39, no. 3 (July 2004): 386–387.

26. Ibid., 375.

27. Hatsuda Tōru, *Hyakkaten no tanjō* (Sanseidō, 1993); Jinno Yuki, *Shumi no tanjō: Hyakkaten ga tsukutta teisuto* (Keisō Shobō, 1994); Miyano Rikiya, *Etoki hyakkaten "Bunka shi"* (Nihon Keizai Shinbunsha, 2002); Brian Moeran, "The Birth of the Japanese Department Store," in *Asian Department Stores*, ed.

Kerrie L. Macpherson (University of Hawai'i Press, 1998), 141–176; Yamamoto Taketoshi and Nishizawa Tamotsu, eds., *Hyakkaten no bunkashi: Nihon no shōhi kakumei* (Kyoto: Sekai Shisō-sha, 1999); Louise Young, "Marketing the Modern: Department Stores, Consumer Culture, and the New Middle Class in Interwar Japan," *International Labor and Working-Class History* 55 (1999): 52–72.

28. The exception to this characterization is the work of Gennifer Weisenfeld on Shiseidō and Kaō in "'From Baby's First Bath'" and "Selling Shideido."

29. On modern girls and consumption, see Miriam Silverberg's seminal treatment, "Modern Girl as Militant," in *Recreating Japanese Women, 1600–1945*, ed. Gail Lee Bernstein (Berkeley: University of California Press, 1991), 199–213, and "After the Grand Tour: The Modern Girl, the New Woman, and the Colonial Maiden," in *The Modern Girl around the World: Consumption, Modernity, and Globalization*, ed. The Modern Girl around the World Research Group (Durham, NC: Duke University Press, 2008), 354–361, and *Erotic Grotesque Nonsense: The Mass Culture of Japanese Modern Times* (Berkeley: University of California Press, 2007); Barbara Hamill Sato, *The New Japanese Woman: Modernity, Media, and Women in Interwar Japan* (Durham, NC: Duke University Press, 2003), especially chaps. 1, 2; Jan Bardsley and Hiroko Hirakawa, "Branded: Bad Girls Go Shopping," in *Bad Girls of Japan*, ed. Laura Miller and Jan Bardsley (New York: Palgrave Macmillan, 2005), 111–125. For modern girls as laborers, see the recent collection of essays in Alisa Freedman, Laura Miller, and Christine Yano, eds., *Modern Girls on the Go: Gender Mobility and Labor in Japan* (Stanford, CA: Stanford University Press, 2013).

30. Cultural-historical studies of the modern consumer in Japan include Penelope Francks, *The Japanese Consumer: An Alternate Economic History of Modern Japan* Cambridge: Cambridge University Press, 2009); Andrew Gordon, "Consumption, Leisure and the Middle Class in Transwar Japan," *Social Science Japan Journal* 10, no. 1 (2007): 1–21; Gennifer Weisenfeld, "Japanese Modernism and Consumerism: Forging the New Artistic Field of 'Shōgyō Bijutsu' (Commercial Art)," in Tipton and Clark, *Being Modern in Japan*, 75–98.

31. Indeed, the marketing of photography in the early twentieth century helped consolidate the prevailing gendered stereotypes about production and consumption: "women as passive consumers and men as producers." See Roger Horowitz and Arwen Mohun, "Introduction," in *His and Hers: Gender, Consumption, and Technology*, ed. Roger Horowitz and Arwen Mohun (Charlottesville: University of Virginia Press, 1998), 2. This book is meant to offer a glimpse into the historical construction of that stereotype in Japan.

32. Christopher Breward, *The Hidden Consumer: Masculinities, Fashion and City Life, 1860–1914* (Manchester, UK: Manchester University Press, 1999), 3.

33. Sociologist Robert Stebbins explains that a hobby is "serious leisure" because it is a "specialized pursuit beyond one's occupation, a pursuit that one finds particularly interesting and enjoyable because of its durable benefits," and that people who practice hobbies "are serious about and committed to their endeavors, even though they feel neither a social necessity nor a personal obliga-

tion to engage in them." Stebbins, *Amateurs, Professionals, and Serious Leisure* (Montreal: McGill-Queen's University Press, 1992), 10. For more on the history of serious leisure, see Steven Gelber, *Hobbies: Leisure and the Culture of Work in America* (New York: Columbia University Press, 1999).

34. Recent studies include David Ambaras, "Social Knowledge, Cultural Capital, and the New Middle Class in Japan, 1895–1912," *Journal of Japanese Studies* 24, no. 1 (Winter 1998): 1–33; Francks, *The Japanese Consumer*; Mark A. Jones, *Children as Treasures: Childhood and the Middle Class in Early Twentieth Century Japan* (Cambridge, MA: Harvard University Asia Center, 2011); Jordan Sand, *House and Home in Modern Japan: Architecture, Domestic Space, and Bourgeois Culture, 1880–1930* (Cambridge, MA: Harvard University Asia Center, 2003); Miriam Silverberg, "Constructing the Japanese Ethnography of Modernity," *Journal of Asian Studies* 51, no. 1 (February 1992): 30–54; Tipton and Clark, *Being Modern in Japan*; and Young, "Marketing the Modern."

35. Gennifer Weisenfeld, *Mavo: Japanese Artists and the Avant-Garde, 1905–1931* (Berkeley: University of California Press, 2002), 14–16. The Tokyo School of Fine Arts, which opened in 1887, established its Photography Department in 1915.

36. Joan Rubin defines the term "middlebrow" through a historiographic accounting as the "unprecedented range of activities aimed at making literature and other forms of 'high' culture available to a wide reading public." Rubin, *The Making of Middlebrow Culture* (Chapel Hill: University of North Carolina Press, 1992), xi.

37. Ibid., xvi. Photography experts functioned as promoters and arbiters of photographic beauty and taste in the same way that "new-middle-class reformers articulated a vision of society in which they functioned as the principal promoters of national progress." Ambaras, "Social Knowledge," 2.

38. Susan Porter Benson demonstrates how US department stores in the late nineteenth and early twentieth centuries combined innovative retail strategies and customer services with spectacular architecture and attractive display to facilitate the spread of consumption among new social groups. See Benson, *Counter Cultures: Saleswomen, Managers, and Customers in American Department Stores 1890–1940* (Urbana: University of Illinois Press, 1986).

39. Pierre Bourdieu discusses the distinction between "occasional" and "dedicated" photographers in "The Cult of Unity and Cultivated Differences," in *Photography: A Middle-Brow Art*, trans. Shaun Whiteside (Stanford, CA: Stanford University Press, 1990), 13–72.

Chapter 1

1. Lori Anne Loeb, *Consuming Angels: Advertising and Victorian Women*, quoted in Breward, *Hidden Consumer*, 101.

2. According to national surveys on household accounting for salaried workers for 1926–1927, *Kakei chōsa hōkoku* (A Report on the Survey of Household Accounting) conducted by the Naikaku Tōkei Kyoku (The Cabinet Bureau of Statistics), 26.47 percent of workers' monthly income (32.91 yen) was spent on food, another 13.82 percent (17.18 yen) on clothing, and

4.85 percent (6.03 yen) on leisure expenditures. These are the monthly averages for all salaried workers who were polled nationwide. The survey also lists separately the averages for four categories of salaried workers (*kyūryō seikatsusha*): civil servants (*kankōri*), bankers and company employees (*ginkō kaisha-in*), teachers (*kyōshi*), and police officers (*junsa*). Naikaku Tōkei Kyoku, *Kakei chōsa hōkoku, dai-nikan: Kyūryō seikatsusha, rōdōsha no bujō, 1926–27* (Naikaku Tōkei Kyoku, 1927), 314–325. Included in the food expenditures (*inshokubutsu-hi*) are grains, fish, meat, chicken eggs, beans, dried goods, cow's milk, seasoning, and meal delivery service (*demae*). This figure does not include the cost of what is termed "luxury expenditures" (*shikō-hi*), which include tobacco, alcohol, and snacks. Clothing costs (*hifuku-hi*) include clothing and personal effects. Though details of the costs of food and clothing are listed in separate columns in the report, leisure expenditures (*shūyō goraku-hi*, literally, "cultivation and leisure expenses") are not specified. Other forms of consumption are itemized separately: "entertainment" (*enkai*); "gifts" (*zōtō*); "travel expenses" (*ryokō-hi*), which includes the subcategories of "recreation" or "picnics," and "other." Not listed separately, and thus most likely the kinds of expenses assumed under the category "cultivation and leisure expenses," are the costs of such things as hobbies, movie tickets, and reading materials—the stuff of contemporary leisure-time consumption.

The monthly figures for laborers polled in the same survey are 32.64 percent (29.82 yen) for food, 12.99 percent (11.87 yen) for clothing and personal effects, and 3.57 percent (3.26 yen) for leisure. Ibid., 326–329. To get a sense of the value of the yen at the time, here are a few prices from around 1926 (100 sen = 1 yen): 200 milliliters of milk = 8 sen; 1.8 liters of soy sauce = 72 sen; 100 *monme* (1 *monme* equals approximately 3.75 grams) of chicken eggs = 40 sen; 1 *shō* (1 *shō* equals approximately 1.8 liters) of azuki beans = 32 sen; 100 grams of middle-grade tea = 50 sen (in 1924); 10 kilograms of white rice = 3.20 yen; 1 student's uniform = 35 sen; 1 pair of *tabi* (Japanese socks with split toes) = 67 sen; custom-made suit = 30 yen (1921); museum entrance fees, 1 adult = 10 sen (1922); movie ticket, 1 adult = 30 sen (1921); 1 Iwanami *bunkobon* (paperback book) = 20 sen; monthly radio broadcast fees = 1 yen. Prices cited from Shūkan Asahi, ed., *Nedan-shi nenpyō: Meiji, Taishō, Shōwa* (Asahi Shinbunsha, 1996).

3. The other volumes in this series are *Utsushikata no dai-ippō* (How to Take Pictures: The First Step, 2); *Kamera wo tsukaikonasu kotsu* (The Knack of How to Use a Camera, 3); *Utsushikata no dai-nihō* (How to Take Pictures: The Second Step, 4); *Tadashii roshutsu no kimekata* (How to Decide on the Correct Exposure, 5); *Dare ni mo dekiru genzō no yōryō* (Anyone Can Do It: The Essentials of Developing, 6); *Fuirumu to fuirutaa hayawakari* (A Quick Guide to Film and Filters, 7); *Yakitsuke kara hikinobashi made* (From Printing to Enlarging, 8).

4. Suzuki Hachirō, *Arusu taishū shashin kōza: Kamera no chishiki to erabikata* (Arusu, 1937), 28.

5. Ibid., 29.

6. Ibid., 30.

7. Ibid., 31.

8. Ibid.

9. Ibid., 28. In Japanese the phrase is "kazari yori mo jushitsu wo tore."

10. Ibid., 27.

11. Ibid., 37.

12. Ibid., 38–39.

13. Ibid., 37. Suzuki uses the word *senpai*, which I have translated as "experienced colleague," but in this case, it likely refers to a friend or colleague who is a more advanced photographer.

14. Ibid.

15. Ibid., 40.

16. Ibid., 43.

17. In addition to Suzuki's *Kamera chishiki to erabikata*, the following is a small sampling of other popular how-to books that delineate shopping for or choosing a camera as one of the first steps in taking and making photographs: Kitano Kunio, "Kamera no erabikata," in *Hyakuman nin no shashin jutsu* (Kōgasō, 1940), 41–43; Miyake Kokki, "Kamera no sentaku," in *Shumi no shashin jutsu*, 86th ed. (Arusu, 1923), 14–31; Narita Ryūkichi, "Nanika kamera to renzu wo aganametara [*sic*] yoi ka?," in *Shashin inga no tehodoki* (Hakubunkan, 1929), 68–71; Rokugawa Jun, "Kamera sentaku no hyōjun," in *Roshutsu no hiketsu: Kamera yomihon*, 4th ed. (Bunkyōsha, 1936), 30–31; Sawa Kurō, "Kogata kamera no sentaku," in *Amachua shashin kōza*, vol. 9, *Kogata kamera shashin jutsu* (Arusu, 1937); Takakuwa Katsuo, "Shashinki no shurui to ōkisa to sono sentaku," in *Fuirumu shashin jutsu*, 146th ed. (Arusu, 1924), 13–25; Yasukōchi Ji'ichirō, "Kamera no sentaku," in *Yasashii shashin no utsushikata* (Arusu, 1937), 35–37; Yoshioka Kenkichi, "Kamera no sentei no hyōjun to naru mono," in *Shashin jutsu no ABC*, 2nd ed. (Seikōkan, 1933), 36–42.

18. Some authors separate the step of choosing a camera from that of actually buying one, as does Suzuki, but most treat "choosing" and "purchasing" as the same step.

19. On images of the female consumer, see Silverberg, "The Modern Girl as Militant." For a perceptive discussion of the ways in which automobiles were marketed to male consumers, see Sean O'Connell, *The Car and British Society: Class, Gender and Motoring, 1896–1939* (Manchester, UK: Manchester University Press, 1998).

20. Suzuki, *Kamera no chishiki*, 27.

21. Yomiuri Shinbunsha Benri-bu, ed. *Shōhin yomihon* (Chikara no Nihon-sha, 1937), preface, n. p.

22. Ibid., 42.

23. Ibid., 232.

24. Ibid., 182.

25. Ibid., 284.

26. Ibid., 285.

27. Brayer, *George Eastman*, 481.

28. "Īsutoman-shi kangeikai," *Shashin geppō*, 25, no. 5 (1920): 47. Born Sugiura Rokusaburō in 1847 to a rice merchant's family in Koishikawa, Rokusaburō

was apprenticed to the pharmaceutical house Konishiya Rokuzae Ten after his father bought shares in the enterprise in 1858. After serving fifteen years as an apprentice, Rokusaburō adopted the trade name Konishi Rokuzaemon and opened a lithographic and photographic supply import shop, Sekiban Shashin Zairyō-shō, in Inarichō. In 1876, he became the sixth-generation successor to the Rokuzaemon name and moved his business to Nihonbashi. From his rather modest beginnings as an importer of chemicals, Rokuzaemon transformed his business into a vast corporation worth over 4 million yen in 1936 and Japan's premier producer of both cameras and light-sensitive materials before the end of the second Sino-Japanese War. Konishi Roku, *Shashin to tomo ni,* 13–26, 438.

29. "Īsutoman-shi kangeikai," 48.

30. Brayer, *George Eastman,* 481.

31. Konishi Roku, *Shashin to tomo ni,* 280.

32. "Īsutoman-shi kangeikai," 48–49.

33. Miriam Silverberg, "Remembering Pearl Harbor, Forgetting Charlie Chaplin, and the Case of the Disappearing Western Woman: A Picture Story," *positions* 1, no. 1 (Spring 1993): 42–46.

34. The retail end of the business went through several name changes, though the alterations were relatively minor. The shop was called Konishi Roku from 1873 until it became a limited partnership company (*gōshi kaisha*) in 1921 and was thereafter known as Konishi Roku Honten. The company then became a joint stock company (*kabushiki gaisha*) in 1937. Konishi Roku, *Shashin to tomo ni,* 304–305, 437–438. Most scholars refer to the company during the prewar period as Konishi Roku. For this reason and for the sake of clarity, I have adopted Konishi Roku when referring to the shop from any period, except when the details demand otherwise. The company changed its name to Konica in 1987 and has more recently merged with Minolta in 2003 and now is called Konica Minolta. "Corporate Information: More about History," Konica Minolta, accessed July 28, 2013, http://www.konicaminolta.com/about/corporate/history_timeline_3.html.

35. Konishi Roku, *Shashin to tomo ni,* 39.

36. Rokuzaemon stated that the purpose behind establishing the production plant, a 660–square meter laboratory-like facility, was to "offer high-quality, affordable domestically produced light-sensitive materials to photographers, which in turn would contribute to the nation by driving out imported goods." Ibid., 133.

37. One measure of the incredible success that the Sakura brand had achieved within three decades from its inception was that by 1935 Rokuōsha employed over one thousand men and women in a facility of over thirty thousand square meters. Konishi Roku, *Shashin to tomo ni,* 376.

38. The archetypal Meiji-period shop was built in the *dozō-zukuri* style, literally "made from earth" style. *Dozō-zukuri* is an architectural term for a warehouse made of thickly plastered earth. Though the shogun's government officially forbade townspeople from using the *dozō-zukuri* style during the Tokugawa period (1600–1868), many did so anyway, and it was widely adopted in especially dense sections of Edo (today's Tokyo). *Dozō-zukuri* became

the most prevalent form of shop architecture in Tokyo, especially after the city enacted new fire-prevention codes in 1881 that required all buildings to be constructed of either stone, brick, or mud. Kawahigashi Yoshiyuki, "Misezō no fukyū to 'Zō no machi' no seiritsu," in *Kenchiku-shi no mawari butai: Kindai no dezain wo kataru*, ed. Nishi Kazuo (Shokokusha, 1999), 129–143. For a brief discussion of the rapid incorporation of *dozō-zukuri* after the enactment of the 1881 fire-prevention regulations, see Takayanagi Mika, *Shōuindō monogatari* (Keisō Shobō, 1994), 32–33.

39. Konishi Roku, *Shashin to tomo ni*, 254. In describing the emergence of the culture of American department stores, Susan Porter Benson argues that the department store drew on early nineteenth-century retail precedents, like the urban specialty store and the suburban general store, but that the scale of operation of late nineteenth-century department stores required innovative ways to attract and then sell products to customers. Such new institutions combined innovative retail strategies and customer services with spectacular architecture and attractive display. Benson, "'A Homogeneous Business': Organizing the Department Store," in *Counter Cultures*, 31–74. In addition to the stunning new shop and a focus on attractive, up-to-date display, Konishi Roku incorporated many innovations in the day-to-day running of retail operations and customer service, discussed later.

40. Detailed descriptions of the new shop can be found in "Konishi Roku no shinchiku rakusei," *Shashin geppō* 21, no. 6 (June 1916): 56–59; and Konishi Roku, *Shashin to tomo ni*, 253–254.

41. Ishii Kendō, *Shinpoteki kei'ei hō kouri shōten hanjōsaku* (1909), quoted in Takayanagi, *Shōuindō*, 106. For a concise overview of this literature, see Takayanagi, *Shōuindō*, 105–112.

42. In the case of the American department store, show windows were adopted in the mid-nineteenth century and "were dressed with an artistic eye, as managers renounced the traditional practice of cramming windows with vast quantities of unrelated merchandise and instead presented smaller lots of items in a pleasing and esthetic way. For the bored or idle, window-shopping became a welcome diversion. Parading up and down the streets, women examined the goods displayed as well as their own reflections in the plate glass and the mirrors cannily placed to pander to their vanity. They stopped to discuss the merchandise and the quality of the displays with their friends, their loitering in public space legitimized by its association with consumption." Benson, *Counter Cultures*, 18.

43. Takayanagi, *Shōuindō*, 100. There had been many attempts throughout the late nineteenth century to produce high-quality plate glass in Japan, but none were successful until Shimada Magoichi manufactured it in 1903 in Osaka. See ibid., 101–102, for statistics on the importing of plate glass to Japan.

44. Takahashi Junjichirō, *Mitsukoshi 300–nen no kei'ei senryaku: Sono toki kei'eisha wa nani wo ketsudan shita ka* (Sankei Shinbunsha, 1972), 94. The world's first escalator was introduced at the 1900 World's Fair in Paris.

45. Louise Young presents the escalator on the same order with "the latest scientific gadgets and electrical machinery," such as ventilation systems and bathroom facilities that "transported shoppers into a mechanized utopia." Young,

"Marketing the Modern," 64. In *Counter Cultures*, Benson argues that the escalator had become a necessity in order to manage the flow of foot traffic: "Transportation within the store became an ever more pressing issue as selling departments spread to upper floors. Elevators had marked a significant advance over the staircase, but they could not move customers in a continuous flow and at busy times became bottlenecks.... The advantages of moving staircases were impressive: one could transport as many people in an hour as forty elevators" (39).

46. "Konishi Roku no shinchiku rakusei," 56–57.

47. Ibid.

48. See Hatsuda's *Hyakkaten no tanjō* for a full discussion of the origins of department-store display methods in domestic and international exhibitions. For an analysis of the modern retail and display methods and the development of a "masculine form of shopping environment," see Breward, "The Spectacle of the Shop: Provision for the Male Consumer," in *The Hidden Consumer*, 100–151.

49. "Free entry," or "the right to look around the store without the obligation to make a purchase," is a phrase used to describe the retail style of department stores and other retail shops that emerged in the mid-nineteenth century in the United States. See Benson, *Counter Cultures*, 19–20.

50. Takayanagi, *Shōuindō*, 126. *Za-uri* is the Japanese term for "sitting sales," and *chinretsu hanbai* is the term for "display sales." For a brief discussion of the adaptation of display sales at Mitsukoshi, see Takahashi, *Mitsukoshi 300–nen*, 59–62; and Hatsuda, *Hyakkaten no tanjō*, 83–90.

51. *Etsu* is the Chinese reading for the character *koshi* in "Mitsukoshi."

52. Takahashi Yoshio, *Hōki no ato* (Shūhōen, 1932), quoted in Takayanagi, *Shōuindō*, 126.

53. Members of the Tokugawa family, particularly the last shogun, were among Konishi Roku's most illustrious regular customers. Konishi Roku, *Shashin to tomo ni*, 105.

54. Ibid., 311.

55. *Shashin geppō*, 17, no. 4 (April 1911).

56. Konishi Roku, *Shashin to tomo ni*, 261. The early-modern form of bookkeeping was called *daifukuchō*. According to the *Oxford Dictionary of Economics*, double-entry bookkeeping is "the system of keeping accounts in which, as a check on accuracy and consistency, every payment appears twice, in different accounts, once as a credit and once as a debit. Thus a sale appears as a credit for the department making it and a debit for the customer, while a purchase appears as a debit for the department making it and a credit for the supplier. Double-entry books can if desired be represented in a single table, using rows for credits and columns for debits. As a check on double-entry accounts, every debit item must have a corresponding credit, and the totals of all credit and debit entries must be equal." "Double-entry bookkeeping," *A Dictionary of Economics*, 3rd ed. (Oxford University Press, 2002), Oxford Reference Online, accessed 1 August 2005, http://www.oxfordreference.com/views/ENTRY.html?subview=Main&entry=t19.e887.

57. Jill McKinnon, "The Historical and Social Context of the Introduction

of Double-Entry Bookkeeping to Japan," *Accounting Business and Financial History* 4, no. 1 (1994): 183. According to McKinnon, this method of accounting was fairly limited to the large merchant houses and did not apply to rural merchants. McKinnon's article offers a brief but useful description of early-modern accounting, or the double-classification system, "which differed in kind, though not in purpose or intention, from Western (originally Italian) double-entry bookkeeping" (184).

58. Takayanagi, *Shōuindō*, 118.

59. Ibid.

60. Western accounting methods were introduced to the Japanese reading public by Fukuzawa Yukichi with his 1873 translation of H. B. Bryant, H. D. Stratton, and S. S. Packard's *Bryant and Stratton's Common School Book-Keeping* (1871) and to national bank employees with the translation of Alexander Shand's *The Detailed Method of Bank Bookkeeping*. With Fukuzawa's translation a veritable publishing boom in accounting textbooks erupted throughout Japan. Takayanagi, *Shōuindō*, 124; and McKinnon, "Double-Entry Bookkeeping to Japan," 192. Other retail operations turned to Western forms of bookkeeping in managing their finances from the late nineteenth century. The Mitsukoshi Department Store adopted double-entry bookkeeping in 1893, as did the Daimaru Department Store in 1908. Takayanagi, *Shōuindō*, 124–125.

61. *Nihon shashin shōgyō tsūshin*, 5 February 1951, quoted in Konishi Roku, *Shashin to tomo ni*, 261.

62. Ibid., 209. Mitsukoshi similarly restructured its workforce in 1894, and Daimaru did so in 1907. Takayanagi, *Shōuindō*, 123.

63. Konishi Roku, *Shashin to tomo ni*, 209–210.

64. The formal adoption of these new terms in the company rules may have been influenced by the language used in the Commercial Code of 1899, which, among other things, "detailed the legal requirements for the formation and liquidation of joint stock corporations, the rights and duties of the organs of the corporations (directors, auditors and the general meeting), and the external reporting requirements." McKinnon, "Double-Entry Bookkeeping to Japan," 194. Apparently, though the names of positions had changed, workers continued using *kozō*, *tedai*, and *bantō* in verbal exchanges until the beginning of the Taishō period in 1912. Konishi Roku, *Shashin to tomo ni*, 209.

65. Sakamoto Fujiyoshi argues that Japan's first modern company rules were instituted at Mitsubishi Kisen Kaisha in 1875. Sakamoto Fujiyoshi, *Nihon koyō shi* (Chūō Keizaisha, 1977), 124.

66. The full text of the "Shop Rules" is provided in Konishi Roku, *Shashin to tomo ni*, 209–214.

67. Ibid., 211.

68. Konishi Roku, *Shashin to tomo ni*, 212.

69. Known by many appellations (*gekkyū-tori* [monthly salary receiver], *yōfuku saimin* [suited paupers], *kyūryō seikatsusha* [a person who makes a living with a monthly salary], *koshiben* [lunch-bucket man], etc.), the white-collar labor force encompassed a broad range of workers—civil servants, teachers, police officers, company employees, retail workers—all of whom

collected their salaries once, sometimes twice, a month. For discussions of the various words used to indicate the white-collar labor force and the disparities among those workers, see Maeda Hajime, *Sarariman monogatari* (Tōyō Keizai Shuppanbu, 1928); in English, see Earl Kinmonth, "Afterward: The Sarariman (Salary Man)," in *The Self-Made Man in Meiji Japanese Thought* (Berkeley: University of California Press, 1981). In fact, it was this very broad range of work and the disparities in pay that made it difficult for social scientists to classify white-collar workers as a "class" and impeded activists in the organization of the salaried labor force. Kitaoka Juitsu, "Kyūryō seikatsusha mondai gaikan," in *Kyūryō seikatsusha mondai: Dai 2 kai shakai seisaku kaigi hōkokusho*, ed. Shakai Rippō Kyōkai (Shakai Rippō Kyōkai, 1933), 1–5. The Japanese government started to pay monthly salaries to bureaucrats from the beginning of the Meiji period when many Euro-American employment practices were incorporated. The private sector soon followed suit. Sakamoto, *Nihon koyō shi*, 55.

70. Konishi Roku, *Shashin to tomo ni*, 210. From 1919, the daily hours of operation were from 8:00 a.m. to 6:00 p.m. all year. Ibid., 357.

71. Inoue Sadatoshi, "Kyūryō seikatsu mono no tsūkin jikan oyobi kyūjitsu," in Shakai Rippō Kyōkai, *Kyūryō seikatsusha mondai*, 88.

72. Ibid., 90–92.

73. Konishi Roku, *Shashin to tomo ni*, 212. From 1919, regular shop holidays were the first and third Sunday of each month, New Year's Day, and O-bon. Ibid., 357.

74. Inoue, "Kyūryō seikatsu mono no tsūkin jikan oyobi kyūjitsu," 88.

75. Ibid.

76. Under the Meiji system of employment at the shop, once an apprentice finished his compulsory education, he moved onto the second floor of Konishi Roku's headquarters, which was a dormitory for apprentices, and began his formal training. In addition to room and board (they received no salary), apprentices received a small allowance for their twice-yearly trips home during the New Year's and O-bon holidays. Konishi Roku, *Shashin to tomo ni*, 209.

77. Ibid., 212.

78. This older form of employment was known as *detchi seido*. Takayanagi divides the typical employment structures for large retail operations into three types: *shikise bekka-sei* (system in which young apprentices receive lodging, clothing, and allowance in exchange for their labor); *sumikomu bekka-sei* (system in which employees receive salary and live with the owner); *tsūkin bekka-sei* (system in which employee receives a salary and commutes to work). Takayanagi, *Shōuindō*, 123.

79. Konishi Roku, *Shashin to tomo ni*, 212.

80. Ibid., 312. Konishi Roku historians place this discussion under the heading "Efficiency Promoted by Western Suits and Shoes, except for the *Tenshu*," and they attribute the increase in staff and the recapturing of lost revenue from the earthquake during the twelve months of 1925 to the efficiency gained by employees donning Western suits and shoes.

81. Yomiuri, *Shōhin yomihon*, 285.

82. Miyake Kokki, *Shumi no shashin jutsu*, 8th ed. (Arusu, 1919), 235–243. Miyake's publisher continued the tradition of providing more exhaustive listings of shops (discussed later), when it began publishing its *Arusu shashin nenkan* (Arusu Photography Annual) in 1925 and registered the names, addresses, and phone numbers of many retail photography shops in the major cities throughout Japan and its colonies.

83. The number of shops by ward are as follows: Asakusa-ku, 20; Shitaya-ku, 8; Nihonbashi-ku, 17; Kanda-ku, 18; Kyōbashi-ku, 20; Shiba-ku, 19; Kōjimachi, 11. Takakuwa Katsuo and Nakajima Kenkichi, eds., *Arusu shashin nenkan, 1926–nenpan* (Arusu, 1926), 52–56. The total number of shops recorded for Tokyo prefecture (Tokyo-fu) was 217 and within that for Tokyo City (Tokyo-shi) was 168.

84. This is not to say that as photographic technologies advanced over the decades, chemistry was no longer a key element in the photographic process. In fact, darkroom chemistry was a key element in the making of photographs that the industry sought to sell to hobbyists.

85. The camera counters at both Mitsukoshi and Shirokiya were included in the 1926 edition of Takakuwa and Nakajima, *Arusu shashin nenkan.*

86. The primer on the history of the Japanese department store is Hatsuda, *Hyakkaten no tanjō.* Jinno's monograph *Shumi no tanjō* documents the innovative role of Mitsukoshi in catering to and creating middle-class consumption and taste. Yamamoto and Nishizawa's edited collection *Hyakkaten no bunkashi* incorporates an array of cultural historical methods to document Japan's consumer revolution. For a concise article in English on the emergence of the modern Japanese retail industry, see Young, "Marketing the Modern," 52–70.

87. Miyake, *Shumi no shashin*, 236.

88. *Mitsukoshi* 10, no. 4 (1920): 33.

89. Ibid.

90. *Mitsukoshi* 12, no. 5 (1922): 14–15.

91. *Mitsukoshi* 12, no. 8 (1922): 9.

92. Ibid.

93. *Mitsukoshi* 10, no. 8 (1920): 9–10. In general, Mitsukoshi's camera prices were very high, but even so, these particular cameras were extremely expensive.

94. *Mitsukoshi taimusu* 5, no. 1 (1907).

95. *Mitsukoshi* 1, no. 6 (1911): 9.

96. "Ichi-jikan shashin no kaishi," *Mitsukoshi* 1, no. 6 (1911): 6.

97. *Mitsukoshi* 12, no. 1 (1922). For example, it cost fifteen sen to develop a roll of vest camera film and another five sen to make prints (eight pictures). Customarily, professional camera studios provided drop-off developing services as a sideline to their portrait business. Personal communication with Kaneko Ryūichi, April 2002.

98. I have seen no record that enumerates used-camera shops in Tokyo. Pawn shops also dealt in the camera trade. For example, tucked away in the back of the March 1938 issue of *Asahi kamera* is an inconspicuous ad for Akabane Shichiya (Akabane Pawn Shop). *Asahi kamera* 26, no. 3 (1938): A86.

99. Suzuki, *Kamera no chishiki*, 47–48.

100. *Kamera kurabu* 2, no. 7 (1937). Other shops used similar marking systems to categorize the used products in their ads. For example, Ginza's Kaneshiro Shōkai offered a bit more detail about the condition of their second-hand goods: "*'Shindō'*: a product that is the same as a new one and has been used for less than two months. *'Tsugishin'*: next to new and has been lightly used for practice. *'Jōko'*: the next after *'tsugishin.' 'Chūko'*: the so-called *chūko* is a product that is intact and in which the surface is not unsightly. *'Ko'*: a product that follows the previous category, which is not intact and the surface is slightly worse." *Asahi kamera* 21, no. 4 (1936): A22.

101. *Asahi kamera* 26, no. 3 (1938): A30.

102. *Fuototaimusu* 13, no. 3 (1936). The same ad also appeared in *Kogata kamera* 6, no. 1 (1936).

Chapter 2

1. "Photographic Centenary Commemoration" is the somewhat cumbersome translation given to the title of the anniversary celebration by the editors of *Asahi gurafu*, who were among the main sponsors of the event. See Narusawa Reisen, ed., *"Asahi gurafu" shashin hyakunen-sai kinen-gō* (Asahi Shinbunsha, 1925) n.p. (last page).

2. Bernard E. Jones, ed., *Encyclopedia of Photography* (1911; repr., New York: Arno Press, 1974), 376–377, 158. In 1829 Niepce made arrangements to exchange information with Daguerre, who had also been working on a similar process. Niepce died in 1833, but Daguerre continued their work and in 1839 published the process that now bears his name.

3. Narusawa Reisen, "Shashin no hatsumei no hanashi," in *"Asahi gurafu" shashin hyakunen-sai kinen-gō*, 2–3.

4. All twelve lectures were given on two evenings at the Shōkō Shōrei-kan in Marunouchi and were open to the public (the male public). On the first evening, November 10, in addition to Fukuhara's lecture, the following lectures were presented: Nagai Masaaki, doctor of pharmacology and scientist, "Nihon no saisho no shashin-shi" (Japan's First Photographer); Mori Yoshitarō, Tokyo Bijutsu Gakkō, professor of photography, "Shashin no hatsumei to sono seichō" (The Discovery and Growth of Photography); Nakajima Matsuchi, photographer, lecture on early photography; Egashira Haruki, Konishi Shashin Senmon Gakkō, professor, "Tennenshoku shashin no hanashi" (A Discussion of Color Photography); Ezaki Kyoshi, Nihon Shashin-shi Kyōkai, director, "Shōzō shashin ni oite eigyō shashinka ni nozomu" (Taking Portraits with the Aim of Becoming a Studio Photographer). On the second evening, November 11, the following lectures were presented: Ogawa Tadamasa, photographer, "Nihon saisho no shashin kai" (Japan's First Photographic Association); Akiyama Keisuke, Konishi Shashin Senmon Gakkō, Tokyo Shashin Kenkyū Kai, professor, "Nihon ni okeru shashin no enkaku" (The History of Japanese Photography); Kamata Shūji, Tokyo Kōtō Kōgei Gakkō, professor, "Nichijō seikatsu to shashin" (Photography and Everyday Life); Ichioka Tajirō, scientist, "Shashin kōgyō no hanashi" (A Discussion of the Photography Industry); Konishi

Shigenori, Konishi Shashin-kan, curator, "Shashin no honshitsu to sono shimei" (The Essence and Mission of Photography); and Hirano Kazutsura, photographer, no description provided. Ibid., 4, 7.

5. Konishi Roku, *Shashin to tomo ni*, 321.

6. *Shashin geppō* 30, no. 11 (November 1925): preface, 2.

7. *Shashin geppō* 34, no. 6 (June 1929), n.p.

8. *Shashin geppō* 30, no. 6 (June 1925), n. p.. The October issue that same year features another ad for the Pearlette, this time in the hands of a kimono-clad beauty. The copy mentions that the camera is perfect for beginners who want to take family photos. Marketing photography as a family-friendly activity is discussed later.

9. Shūkan Asahi, *Nedan-shi nenpyō*, 87, 208.

10. Iizawa Kōtarō asserts that the new consumers of photography after World War I came from the middle classes who owned cameras but did not have a darkroom in their homes and thus took their exposed film, plates, or packs to photography shops for developing. *"Geijutsu shashin,"* 80–81. Though how-to writers frowned upon the idea as sacrificing the fundamental enjoyment of hobby photography (darkroom work), they often suggested to hobbyists who were too busy to develop their own film that they entrust it to a reputable shop. See Miyake, *Shumi no shashin jutsu*, 10.

11. Itō Hidetoshi, "Shashin minshūka ni taisuru ikkōan," *Shashin geppō* 28, no. 1 (January 1923): 50. Konishi Roku proclaimed in an ad several years later that the foundation of the "democratization of photography" was the Pearlette. *Shashin geppō* 34, no. 5 (May 1929): preface, 1. Interestingly, the phrase is placed in quotes in the ad, perhaps in reference to Itō's article.

12. Fukuhara Shinzō, "Shashin-dō," *Asahi kamera* 1, no. 1 (April 1926): 30.

13. "Tettori bayaku dare ni mo dekite, dare ni mo omoshiroku mirareru no ga waga shumi shashin de aru." Takakuwa Katsuo, "Shashin-shi Ichikawa-kun ni kotaete shumi shashin no tachiba wo akiraka ni suru," *Shashin geppō* 25, no. 10 (October 1920): 668. See "Amachua no jidai: Shashin zasshi no shin-tenkai," a section in Iizawa's *"Geijutsu shashin,"* for a helpful outline of the positions of Takakuwa and Fukuhara in debates around the nature and goals of amateur practice during the Taishō period.

14. Arjun Appadurai refers to the commodification of knowledge as the "traffic in criteria, . . . [the] buying and selling of expertise regarding the technical, social, or aesthetic appropriateness of commodities." Appadurai, "Introduction: Commodities and the Politics of Value," in *The Social Life of Things*, ed. Arjun Appadurai (Cambridge: Cambridge University Press, 1986), 54.

15. Both Itagaki Takaho and Ina Nobuo, two of the earliest theorists espousing a distinctly modernist approach to photographic aesthetics, embraced machine aesthetics as the most appropriate means of expression in the age of industrial capitalism. See especially Itagaki Takaho, "Kikai to geijutsu to no kōryū," in *Kikai no metoroporisu*, vol. 6, *Modan toshi bungaku*, ed. Unno Hiroshi (Heibonsha, 1990), originally published in *Shisō*, September 1929; and Ina Nobuo, "Shashin ni kaere," *Kōga* 1, no. 1 (May 1932): 1–13.

16. Yasukōchi, *Yasashii shashin no utsushikata*, 12.

17. Yoshioka, *Shashin jutsu no ABC*, 2.

18. In his study of French photographic practices of the 1960s, *Photography: A Middle-Brow Art*, Bourdieu found that occasional photographers—literally, people who take pictures only occasionally—document family events, social gatherings, or vacations. For this group of photographers, "photographic practice only exists and subsists for most of the time by virtue of its family function or rather by the function conferred upon it by the family group, namely that of solemnizing and immortalizing the high points in family life, in short, of reinforcing the integration of the family group by resserting [*sic*] the sense that it has both of itself and of its unity" (19). The private, informal images produced by occasional photographers worked to sustain the family, especially in the context of the massive mobilization of populations from country to city, when connections to the family became increasingly distant. Even pictures taken on vacation serve as memorials to a particularly special or significant moment in a family's history.

In contrast to occasional photography, Bourdieu defines "dedicated" (hobby) photography as "ardent practice which privileges the act of production [and] naturally goes beyond its own product, in the name of the quest for technical and aesthetic perfection" and as practice that "always presupposes something that is both more and different from a simple intensification of occasional practice." He refers to dedicated photographers regularly as "deviants" and "fanatics" because they reject the aesthetic standards established for conventional images (38).

19. The Kodak system could be said to be the model for the more recent *tsukai-sute* (disposable) system that made a huge impact on camera consumption during the 1990s.

20. Iizawa, *"Geijutsu shashin,"* 80–81. In his article on the marketing of photography during the 1970s in Europe, Don Slater uses sales statistics to argue that selling film, not cameras, to occasional photographers is where the real profit of the photography market exists. Slater, "Marketing the Medium," in *The Camera Work Essays*, ed. Jessica Evans (London: Rivers Oram Press, 1997), 178–181.

21. Sociologist Robert Stebbins defines "serious leisure" (hobbies) as activities that "develop specialized skills, reward perseverance, integrate participants into a specialized subculture, and provide them with benchmarks by which they can measure their achievements." Stebbins, *Amateurs, Professionals,* quoted in Gelber, *Hobbies*, 11.

22. Historian Steven Gelber traces popular and scholarly discourses on hobbies as leisure-time work in 1930s America in his article "A Job You Can't Lose: Work and Hobbies in the Great Depression," *Journal of Social History* 24, no. 2 (1991): 741–766. According to Gelber, hobbies, or productive leisure, incorporated a work ethic that was consistent with the maintenance of industrial capitalism but also offered its participants the psychological rewards of work-like activities in a time of unemployment or compensation for alienating work in times of employment. Gelber, *Hobbies*, 11.

23. An alternative reading of this cartoon could refer to an article from

Asahi kamera that ran just five months earlier on using patterns in commercial photography. What is represented in the cartoon as a failure could be an aesthetic achievement in a different context (and in the hands of a "skilled" photographer) or a commercial success, for example, for a shampoo advertisement. Kobayashi Hidejirō, "Shashin moyō, sono satsuei hō," *Asahi kamera* 9, no. 3 (March 1930): 276–283.

24. The comment that young people mostly come to the shop as a form of entertainment is evidence that Konishi Roku actively sought to create its shop as a venue for a leisure-time experience that did not necessarily have to end in the purchasing of goods.

25. "Amachua wo kataru: Zairyōya-san no zadankai," *Asahi kamera* 21, no. 4 (April 1936): 637–638.

26. Ibid.

27. Ibid., 643.

28. Ibid.

29. Ibid.

30. "Shashin josei-gun kōshinkyoku," *Asahi kamera* 19, no. 1 (January 1935): 49–54.

31. Tsurudono Teruko, "Shashin no tanka," in "Shashin josei-gun," 52–53.

32. Sugiwara Kiyoko, "Fujin to shashin," in "Shashin josei-gun," 49.

33. Yamada Yaeko, "Shashin to ikuji," in "Shashin josei-gun," 50.

34. Kimura Shizuko, "Shashin no tanoshimi," in "Shashin josei-gun," 49.

35. Miriam Silverberg plots the negotiations of the café waitress caught in the mire of an expanding culture of consumption and eroticism in her essay "The Café Waitress Serving Modern Japan," in *Mirror of Modernity: Invented Traditions of Modern Japan*, ed. Stephen Vlastos (Berkeley: University of California Press, 1998), 208–225.

36. Bromide shops are small shops and stalls that sold (and still do) photos and postcards portraying actors, singers, sports stars, and pop idols. "Bromide" refers to the "bromide paper" used in developing photographs, even when such paper is not used.

37. Yomiuri Shinbunsha, ed., *Eiga hyaku monogatari: Nihon eiga hen 1921–1995* (Yomiuri Shinbunsha, 1995), 26–27. Miriam Silverberg opens her essay on the modern girl with reference to this film. For Silverberg, the film's title offers a useful, analytical device to interrogate popular representations of the modern girl in contrast to the lives of real modern girls. Silverberg, "Modern Girl as Militant," 240. The cinematic title is also reminiscent of the title of the autobiography of the female political radical Kaneko Fumiko, *Nani ga watakushi wo sō saseta ka*, written in prison before her execution for plotting to assassinate the emperor in 1926. For a concise biography and a translation of a portion of her autobiography, see Mikiso Hane, *Reflections on the Way to the Gallows: Voices of Japanese Rebel Women* (Berkeley: University of California Press, 1988), 75–124.

38. Yamakawa as paraphrased by Silverberg, "Modern Girl as Militant," 248.

39. In a rich account of the car in British society, Sean O'Connell exposes the deeply rooted cultural attitudes about gender that defined people's very negative

ideas about the female driver, ideas that continue to influence opinions today (despite the continued "facts" produced by insurance companies to the contrary). O'Connell, "'A Myth That Is Not Allowed to Die': Gender and the Car," in *The Car and British Society*, chap 2.

40. Jordan Sand, "At Home in the Meiji Period: Inventing Japanese Domesticity," in Vlastos, *Mirror of Modernity*, 198.

41. Judith Williamson, "Family, Education, Photography," in *Culture/ Power/History: A Reader in Contemporary Social Theory*, ed. Nicholas Dirks, Geoff Eley, and Sherry B. Ortner (Princeton, NJ: Princeton University Press, 1994), 236. Williamson breaks down the relationship between the family and photography into three parts—identification (media and advertising representations encourage identification with ideal family types), consumption (families consume representations of themselves in formal studio portraits), and production (families produce informal images of themselves with their own cameras and film) (237).

42. "Shashin shumi no katei-ka mo taisetsu de aru." Nagai Saburō, *Arusu shashin bunkō: Katei anshitsu no tsukurikata* (Arusu, 1939), 4.

43. Yasukōchi, *Yasashii shashin*, 4–5.

44. Yanagita Yoshiko, "Haha to shite mita shashin," in "Shashin josei-gun," 52.

45. Ibid.

46. With regard to the missing father in family photos, Williamson offers this comment: "Perhaps the most influential family image in our culture has been that of the Madonna and child; father was absent long before he had to hold the camera." Williamson, "Family, Education, Photography," 237.

47. Sand, "At Home in the Meiji Period," 197–207.

48. Ibid., 206.

Chapter 3

1. Konishi Roku, *Shashin to tomo ni*, 278.

2. The one exception to this generalization is the astounding collection of how-to books published throughout the twentieth century housed at the Japan Camera and Optical Instruments Inspection and Testing Institute (JCII) Library, which is associated with the JCII Camera Museum in Tokyo.

3. Iizawa Kōtarō takes up the issue of hobby photography briefly in one section of his chapter on amateur photography in *"Geijutsu shashin."* Even so, it is only in the context of establishing the somewhat technologically overdetermined point that the handheld camera and roll film, which allowed photographers to immediately capture moments of everyday life, produced the aesthetics of the snapshot. And to the extent that he concentrates at all on the ordinary hobbyist, Iizawa is most interested in exploring the very important point of how the amateur aided and abetted the popularization of art. He does list some of the key how-to texts from the Taishō period but, again, only to illustrate, with somewhat unique examples, the point of the rapid expansion of amateur photography that occurred due to the popularization of small cameras and roll film. Iizawa, "Amachua no jidai," in *"Geijutsu shashin,"* 76–103.

4. I take the term "photographable" from Pierre Bourdieu, who uses it in this way: "Even when the production of the picture is entirely delivered over to the automatism of the camera, the taking of the picture is still a choice involving aesthetic and ethical values: if, in the abstract, the nature and development of photographic technology tend to make everything objectively 'photographable,' it is still true that, from among the theoretically infinite number of photographs which are technically possible, each [social] group chooses a finite and well-defined range of subjects, genres and composition." Bourdieu, *Photography*, 6.

5. Steven Gelber discusses the ways in which hobbies were understood in American culture as a legitimation of leisure-time pursuits "by filling some part of nonwork time with productive activity." Gelber, *Hobbies*, 19.

6. Earl Kinmonth describes the plight of the highly educated middle-class man, seeking advancement in society, who spends several years pursuing a degree only to find that there are too few employment opportunities in the white-collar sector: "Between 1919 (Taishō 8) and 1929 (Shōwa 4) the number of male graduates from national universities, private universities, and private colleges tripled, so that instead of the approximately six thousand who sought placement during the height of the World War I boom, there were more than seventeen thousand seeking placement as the economy plunged into the most severe portion of the generally depressed interwar years. This average annual growth rate in excess of 11 percent was several times the growth rate of the economy and was soon reflected in the placement rates of graduates. The percentage of university and college graduates reported as having found work soon after graduation declined from approximately 80 percent in 1923 (Taishō 12) to 50 percent in 1929 (Shōwa 4) and to a bare 36 percent in 1931 (Shōwa 6)." Kinmonth, *Self-Made Man*, 288.

7. Hirsohima-shi Shakai Ka, ed., "Kyūryō seikatsusha seikatsu jōtai," in *Rōdōsha seikatsu chōsa shiryō shūsei: Kindai Nihon no rōdōsha zō 1920–1930*, vol. 2, *Kyūryō rōdōsha*, ed. Nakagawa Kiyoshi (Seishisha, 1994), 1.

8. Ibid., 34.

9. For heads of household, the twenty-six most popular hobbies, in descending order, were reading (309), baseball (264), fishing (234), Go (207), music (174), Japanese chess (*shōgi*, 160), gardening (124), sport (103), cinema (93), tennis (90), Noh songs (82), ikebana (63), drama (53), shrine visitation (37), travel (34), sumo wrestling spectatorship (31), calligraphy and illustration (*shoga*, 31), Japanese flute (30), literature (*bungei*, 29), billiards (27), walking (23), photography (21), drinking (19), raising chickens (17), needlework (16), and commercial entertainment (*kōgyō mono*, 16). Many hobbies were reported only once, for example: ballads sung to samisen accompaniment (*nagauta*), Chinese classics (*kanbun*), study, playing cards, violin, architecture, candy making, beekeeping, goldfish, and shellfish gathering. Ibid., 35.

10. In "Kyūryō seikatsusha mondai gaikan," the introduction to a series of essays documenting the material conditions of salaried workers published in 1933, Kitaoka Juitsu describes the economic situation of most salaried workers with the colorful and popular phrase of the day, "suited paupers" (*yōfuku saimin*; 4). Though job stability, education, and social standing were high,

wages were comparatively low, especially for the middle and lower echelons of salaried employees such as police officers and schoolteachers (6). For example, Kitaoka compares the wages/salaries of intellectual workers to those of physical laborers and found that full-time elementary schoolteachers earned 750 yen/ month; metal workers, 850; machinists, 835; and shipbuilders, 650 (15). Hence, Kitaoka regards the class of salaried workers as hybrid, partially bourgeois, and partially proletarian (10). It is largely in response to the tight economic circumstances in which most readers found themselves that the *Yomiuri Newspaper* began publishing its column "Handy News," the encyclopedia of shopping for everyday products discussed previously.

11. Determining the number of how-to books published during the 1920s and 1930s poses many problems, not the least of which is the absence of "how-to" as a publishing category. Another major obstacle is the fact that how-to books appeared within many different categories. However, a very rough estimate based on the number of total publications for the categories in which how-to books appeared in *Shuppan nenkan* (Publishers' Annual) is that the total number of such books amounted to roughly 5 percent of annual sales during the years 1926–1945.

12. This cookbook is cited in Katarzyna Cwiertka, "How Cooking Became a Hobby: Changes in Attitude toward Cooking in Early Twentieth-Century Japan," in *The Culture of Japan as Seen through Its Leisure*, ed. Sepp Linhart and Sabine Frühstück (Albany: State University of New York Press, 1998), 47.

13. Minami Hiroshi, ed., *Kindai shomin seikatsushi, daigokan: Fukushoku, biyō, girei* (San'ichi Shobō, 1986). Volume 5 of *Kindai shomin seikatsushi* also includes several articles and excerpts from health and beauty manuals, such as *Donata ni mo wakaru: Yōhatsu no musubikata to shiki no okeshō* (Shibundō, 1928) by Hayami Kimiko, the author of "Utsusare jōzu: Kore dake no kokorogake ga taisetsu," *Asahi kamera* 19, no. 1 (January 1930), one of the only photographic how-to articles written by a woman from this period. This volume also includes several etiquette manuals from the time. Other volumes in Minami's series, while not so centrally focused on how-to manuals, include them as examples to explore other aspects of modern living. Volume 9, *Ren'ai, kekkon, katei*, includes a series that appeared in *Fujin no tomo* called "Jochū no tsukaikata," an article on dealing with maids from 1912. *Jūtaku no sōji hōhō*, a how-to manual on housecleaning, and *Kagu no erabikata to tsukaikata*, a guide to choosing and using furniture, both from 1938, appear in volume 6, *Shoku, jū*.

14. Jordan Sand traces the marketing of domesticity, as both scientific management of the home and the more affective arts of decoration and design, in popular women's magazines from the Taishō period in "The Cultured Life as Contested Space: Dwelling and Discourse in the 1920s," in *Being Modern in Japan*, 99–118.

15. Interestingly, there are no examples of these kinds of books in the Minami Hiroshi volumes, not even in the volume on leisure (volume 8, *Yūgi, goraku*), which includes local surveys on leisure, materials related to radio listening, and catalogues of record titles.

16. Eiko Ikegami writes about early-modern variants of the "how-to" book

in her discussion of associational politics among aesthetic communities and the rise of commercial printing, in *Bonds of Civility: Aesthetic Networks and the Political Origins of Japanese Culture* (Cambridge: Cambridge University Press, 2005), esp. chaps. 11, 12.

17. Unless otherwise noted, the following summary of publication data is derived from Nihon Shashin Kyōkai, eds., *Nihon shashin-shi nenpyō* (Kōdansha, 1976).

18. Not included in any of these numbers are magazines, pamphlets, product manuals, and *shashin-shū* (photographic collections). The *shashin-shū* were especially numerous during the late Meiji and Taishō periods; many memorialized victorious battles of the Sino- and Russo-Japanese Wars, the emperor and his family, General Nogi Marusuke, major floods, and earthquakes. The number of collections by leading photographers begins to take off during the Taishō period as well. Also not included in these numbers are the product catalogues produced by the various photographic companies.

19. The *Nihon shashin-shi nenpyō* includes only a mere fraction of series titles in its listings.

20. Iizawa refers to how-to books as "amachua muke no shashin jutsu keimō sho [books on the advancement of photographic technology for the amateur]." Iizawa, *"Geijutsu shashin,"* 86. Unfortunately, *keimō sho* does not appear as a category for publications during these years. The various scholars who describe the how-to books reprinted in Minami Hiroshi's *Kindai shomin seikatsu-shi* use no consistent genre name for the manuals reproduced therein. For example, Yanagi Yōko uses such terms as *dokushū sho* (self-improvement/study books), *shidō sho* (guidebooks), and *jitsuyō nyūmon sho* (practical introductory books). Yanagi Yōko, "Kaidai: Fukushoku," in *Kindai shomin seikatsu-shi, daigokan: Fukushoku, biyō, girei*, ed. Minami Hiroshi (San'ichi Shobō, 1986).

21. *Shashin jutsu* is sometimes rendered as *kamera wūku* (camera work) in *kana* printed alongside the characters. See Rokugawa Jun, *Roshutsu no hiketsu*, 139.

22. Again, there is no formal category of "how-to" in *Shuppan nenkan*, hence my hesitancy in using it. It is interesting to note that the phrase "how-to," meaning a popular field of instructional writing, does not even appear in the English language until the 1950s. The *Oxford English Dictionary* online offers this definition: "How-to: 9. Followed by an infinitive: In what way; by what means. how to do = the way in which one should (or may) do; also ellipt., as how to, and often used attrib., as 'how-to' discourse, 'how-to-do-it' manual, etc.; also (in titles of books, etc.) followed by a verb."

23. Yoshikawa Hayao, "Tesei kamera ga kataru 30 nen mae no amachua shashin jutsu," *Asahi kamera* 20, no. 3 (September 1935): 349–352.

24. Ibid., 349.

25. Ibid., 352. The recipe reads as follows: "To make a camera, take a magnifying glass with a focal length of about 10 centimeters. An atom-sized pack [a plate format measuring 4.5 × 6.0 inches] is fine. Don't use the pack holder; I think it is easier to make the fitting directly. For the case, which should be a box type, it's better if it is not a folding case. For the shutter, use a plate of tin and

put a hole in it of less than 3 millimeters. If it is made so that it can be pulled by a rubber band, then you will be able to achieve a speed of somewhere between 1/25th of a second and 1/50th of a second. Of course, you paint the inside of the camera with black ink or india ink. As for the viewfinder, get an appropriate one at a photo shop and attach it to the top of the camera. If you make it so that it can be clearly focused, it will be quite useful." Ibid.

26. Ishii Kendō, *Shōnen kōgei bunko: Shashin no maki* (1902; repr., Hakubunkan, 1918), 37–39. *Shashin no maki* was one of twenty-four practical learning volumes for children. Other volumes included *Tetsudō no maki* (Railway, volume 1), *Suidō no maki* (Waterworks, 2), *Denwa no maki* (Telephone, 5), *Tokei no maki* (Watch, 15), and *Kenchiku no maki* (Architecture, 24). According to the description in an advertisement found in the seventeenth edition from 1918, these volumes were intended "to explain in detail the practical aspects and the glory [*seika*] of science through step-by-step practical instruction and the observation of present conditions."

27. What was true for amateur and professional photographers was also true of the industry at the turn of the century. Konishi Roku manufactured its earliest cameras by piecing together separately produced and imported parts. Typically, lenses were imported. But the company subcontracted to a cabinet-maker (*sashimono-shi*), Hasegawa Rinosuke, who produced the wooden boxes for the box cameras, and to a metal caster (*imono-shi*), Omori Takezō, who made the metal parts. Konishi Roku, *Shashin to tomo ni*, 36. For more on the early photographic industry in Meiji Japan, see Luke Gartlan, "Samuel Cocking and the Rise of Japanese Photography," *History of Photography* 33, no. 2 (2009): 145–164.

28. Yoshikawa, "Tesei kamera," 352.

29. Though Yoshikawa figures the turn to consumerism in photography a recent phenomenon, Ishii's account of photography for boys from 1902 describes a young boy needling his father for a new camera. The boy first became interested in photography by reading all the books on the subject that he could find. His enthusiasm grows, and he decides that he needs a camera to practically test the theories he has read about in books. He asks his father to buy him a cheap camera. The boy's father refuses, saying that a cheap camera does not make for a good toy and that the boy will only want to buy a new one in a short time. As we saw in the previous chapter, this exchange calls attention to the cycle of desire and consumption that became the oil in the machine for successful camera companies from the turn of the century. Ishii, *Shashin no maki*, 31–33.

30. Mashiko Zenroku, "Tesei kamera no gisei," *Asahi kamera* 22, no. 3 (September 1936): 970.

31. In an interview he conducted with Joanne Lukitsch from 1987, John Tagg argues that with the expansion of photography in Europe and the United States in the late nineteenth century, though the means of photographic representation spread, "the means of production [did] not. Of course the immediate means of production [did], but this was the very process by which photography underwent its second industrial revolution in the 1890s, producing massive monopolies like Eastman Kodak. So on the one hand, the means of production

were certainly not democratised: handing things over, as with personal computers, meant yet greater concentration of ownership of the means of production and a more deeply entrenched division of knowledge. Amateurs did not know how to take a camera to bits if it went wrong, or how to make their own film, or even how to print. Such knowledges were yet more concentrated, invested and professionalised." John Tagg, "Practicing Theories: An Interview with Joanne Lukitsch," in *Grounds of Dispute: Art History, Cultural Politics and the Discursive Field* (Minneapolis: University of Minnesota Press, 1992), 90.

32. Miyake, *Shumi no shashin jutsu*, 6–7.

33. One of the distinguishing marks of the nineteenth-century portrait photographer was his hands-on training under the tutelage of a practicing professional. Though manuscripts circulated among, and were even written by, some of Japan's early professionals (most notably by Ueno Hikoma, who published a volume on the collodion wet-plate process in his three-volume text on chemistry of 1862, *Seimi kyoku hikkei*), most photography was learned practically, in the context of the commercial portrait studio. This remained the formal method of training professional photographers until the first photography schools and departments were established in the late 1910s and early 1920s. As the amateur market began to take shape from the last decade of the nineteenth century, information about photographic techniques began to circulate in a more regularized, less personal manner. Books, journals, and pamphlets—now mass-produced on modern printing presses—describing the dry-plate process and the proper use of products soon replaced handwritten and woodblock-printed manuscripts detailing the daguerreotype process and, later, wet-plate processes.

34. One exception that I have found is another article by Yoshikawa Hayao, "Kamera no te-ire wa dō sureba yoi ka," in Matsuno, *Shotō shashin jutsu hyakkō*, 28–30. Yoshikawa, the writer who gave instructions on how to build a handmade camera, offers simple maintenance tips such as how to clean the lens properly and how to very simply and carefully clean the inside of the camera.

35. The history of leisure motoring in Great Britain resembles the changes in hobby photography with regard to the user's command of the motor itself. Early enthusiasts were required to be minimally familiar with the inner workings of their respective machines. Sean O'Connell describes the trials and tribulations of England's first pleasure motorists for whom "every journey involved the strong possibility of a breakdown or puncture. . . . By 1914 the motorist could expect to be within reach of a garage or repair shop with at least rudimentary knowledge of motor mechanics. But, it was not until the inter-war years that they could be truly sanguine about undertaking lengthy drives in the rural areas of Britain. In these years cars became more reliable, garages more numerous, and the AA and RAC 'get you home' services, complete with networks of approved mechanics and phone boxes for the use of members, became more widespread." O'Connell, *The Car and British Society*, 82.

36. Chris Rojek, "Leisure and 'The Ruins of the Bourgeois World,'" in *Leisure for Leisure*, ed. Chris Rojek (London: Macmillan Press, 1989), 109. Rojek argues, "In some areas of leisure (for example, sport, music, photography) there is a strong pressure on participants to 'reach professional standards'" (109).

37. Yoshioka, *Shashin jutsu no ABC*, 1.
38. Ibid.
39. Yasukōchi, *Yasashii shashin*, 12.
40. Yoshioka, *Shashin jutsu no ABC*, 13.
41. Ibid., 113–115.
42. Yasukōchi Ji'ichirō, "Kantan na anshitsu wo tsukuru ni wa," in Matsuno, *Shotō shashin jutsu hyakkō*, 86.
43. This is one example of how-to writing on photography converging with how-to writing on the home, both displaying an almost obsessive concentration on hygiene (*eisei*).
44. Narita, *Shashin inga no tehodoki*, 182.
45. For example, see ibid.
46. Yasukōchi, "Kantan na anshitsu," 84. One *shaku*, also known as a "Japanese foot," is equal to 30.3 centimeters.
47. Rokugawa Jun, *Roshutsu shōkai: Shashin jutsu 12 kagetsu*, (Kyōbunsha, 1936), 304–305. This book was reprinted four times in a period of four months from June to October 1936.
48. Nagai, *Katei anshitsu*, 6.
49. Suzuki Hachirō, *Shashin shippai to sono gen'in* (1924; repr., Arusu, 1926), 4.
50. Rokugawa, *Shashin jutsu 12 kagetsu*, 359.
51. Iizawa sees enlargement and the small-model camera as the tools that helped spread amateur activities in the period. Iizawa, "*Geijutsu shashin*," 83.
52. "Kogata kamera de ōgata shashin." Yoshioka, *Shashin jutsu no ABC*, 295. "When you look at German photographic journals and books, there are some very interesting slogans that use nice wordplay. . . . But among them the most typical is 'Klein Aufnahmen . . . grosse Bilder'[sic]. In Japanese it means, paradoxically, 'a big print from a small shot,' but it comes from the popularity of the enlarging process" (ibid.).
53. Ibid., 296.
54. "Kokusan shōkan dai-kenshō shashin bōshū," *Shashin geppō* 31, no. 1 (January 1925): prefatory advertising section.
55. Suzuki, *Shashin shippai*, 8.
56. Miyake, *Shumi no shashin jutsu*, 7–11.
57. In general, how-to writers address readers as a male audience, using such addresses as *shokun* (gentlemen), *shokei* (fellows), and *waka-danna* (young men). Some authors specifically refer to the occupations or social positions, typically reserved for men, of their readers. For example, in *Shumi no shashin jutsu*, Miyake specifically refers to office workers and students as the photographers who have no time to develop their exposed film and plates (10).
58. Sakura is the brand-name of many of Konishi Roku's accessories and products.
59. Moreover, the disembodied images often include just a glimpse of the cuff of a Western shirt and suit, as in the image in Figure 3.12, another reference to the kinds of men to whom camera companies and publishers marketed their products—clerks and office workers.

60. Social and cultural historians of technology, particularly in the field of American history, have uncovered not only how gender informs the production and consumption of technology in society but also how historians have privileged a history of production over consumption. For interesting historiographic perspectives, see Ruth Oldenziel, "Man the Maker, Woman the Consumer: The Consumption Junction Revisited," in *Feminism in Twentieth-Century Science, Technology and Medicine*, ed. Angela N. H. Creager, Elizabeth Lunbeck, and Londa Schiebinger (Chicago: University of Chicago Press, 2001), 128–148; and Steven Lubar, "Men/Women/Production/Consumption," in *His and Hers: Gender, Consumption, and Technology*, ed. Roger Horowitz and Arwen Mohun (Charlottesville: University of Virginia Press, 1998), 7–37.

61. How-to writers also devote a great deal of attention to teaching photographers how to take pictures of women. Title after title offers the hobbyist tips on producing superlative photographic portraits of women. Typical titles include variations on "Onna no utsushikata" (Taking Photographs of Women) and "Onna no hyōjō" (Women's Expressions).

62. Hayami, "Utsusare jōzu"; and Chiba Noriko, "Utusareru kata no okeshō to kitsuke," *Asahi kamera* 10, no. 1 (January 1930): 48–51.

63. Hayami, "Utsusare jōzu," 48.

64. Ibid., 49.

Chapter 4

1. A version of Chapter 4 appeared as "'Little Works of Art': Photography, Camera Clubs and Democratizing Everyday Life in Early Twentieth-Century Japan," *Japan Forum* 25, no. 4 (December 2013): 425–457.

2. Tokyo Asahi Shinbunsha, ed., *Nihon shashin nenkan* (Asahi Shinbunsha, 1925), 32; and Iizawa, *"Geijutsu shashin,"* 109.

3. Ikegami, *Bonds of Civility*, 9.

4. Ibid., 33.

5. Ibid., 366–367.

6. Outside the wealth of works on the history of labor unions, the emergence of modern voluntary associations in late nineteenth- and early twentieth-century Japan, though clearly a significant aspect of modern social organization, has been little researched in either Japanese or English. Edward Norbeck lamented in 1967 that "we lack essential information on many aspects of rural and, particularly, urban associations, including their internal structure, their procedures of operation, and their roles in local and national politics." Norbeck, "Associations and Democracy in Japan," in *Aspects of Social Change in Modern Japan*, ed. R. P. Dore (Princeton, NJ: Princeton University Press, 1967), 185. Hashizume Shin'ya looks at the architectural and design elements of the clubhouse in Japan from the Meiji period in *Kurabu to Nihonjin: Hito ga atsumaru kūkan no bunkashi* (Kyoto: Gakugei Shuppansha, 1989). Edward Norbeck is the most prolific scholar in English on the subject of voluntary associations in Japan, in particular their relationship to the emergence of democracy in the countryside during the early postwar period. See especially Norbeck, "Associations and Democracy in Japan," and "Common

Interest Associations in Rural Japan," in *Japanese Culture: Its Development and Characteristics*, ed. Robert J. Smith and Richard K. Beardsley (Chicago: Aldine, 1963). Donald Roden explores the vitality of *bu-seikatsu* (club life) among male students at elite higher schools, preparatory schools for Japanese imperial universities, in the early twentieth century in *School Days in Imperial Japan: A Study in the Culture of a Student Elite* (Berkeley: University of California Press, 1980), 113–122. Darryl Flaherty looks at the role of voluntary lawyers' associations in the formation of Japanese political parties in "Organizing for Influence: Lawyers' Associations and Japanese Politics, 1868–1945" (PhD diss., Columbia University, 2001). Japanese press clubs have also been the object of inquiry. See, for example, Laurie Anne Freeman, *Closing the Shop: Information Cartels and Japan's Mass Media* (Princeton, NJ: Princeton University Press, 2000); and William de Lange, *A History of Japanese Journalism: Japan's Press Club as the Last Obstacle to a Mature Press* (Richmond, Surrey, UK: Japan Library, 1998). Despite these studies, research on recreational clubs is still scant.

7. Hashizume, *Kurabu to Nihonjin*, 42–46.

8. This Nihon Shashin Kai is not the same as the later, artistic association of the same name that Fukuhara Shinzō founded in 1924 and is still active today. An earlier and less formal gathering seems to have begun in the mid-1870s under the auspices of Samuel Cocking. Gartlan, "Samuel Cocking," 160–161.

9. Kaneko, "Japanese Photography," first page of nonpaginated text. See also Ozawa Takeshi, *Nihon no shashin shi: Bakumatsu no denpa kara Meiji-ki made* (Nikkor Club, 1986), 142–147.

10. The following brief biographical sketch of Burton and the outline of the history of the Nihon Shashin Kai come from Ozawa, *Nihon no shashin shi*, 142–145.

11. In 1901 Ozaki, along with other leading art and literary figures, founded the Tokyo Shayū Kai, a photography club, under the auspices of the esteemed literary society Kenyūsha. Iizawa, *"Geijutsu shashin,"* 221n1.

12. This debate is thoroughly covered in two pieces by Iizawa, "Nihon no 'Geijutsu shashin' ga hajimatta," 48–53, and "'Geijutsu-ha' to 'Kikaiteki shabutsu-ha,'" in *"Geijutsu shashin,"* 24–33.

13. Kaneko, "Japanese Photography," second page of nonpaginated text.

14. For example, Kyoto Shashin Kyōkai (1902); Kobe Shayū Kai (1902); Kitagoe Shashin Kurabu (Niigata prefecture, 1902); Nihon Kamera Kurabu (Osaka, 1904); Kajima Kōga Kai (Ibaragi, 1905); Nagasaki Kōga Kyōkai (1906); Matsue Shayū Kai (Shimane, 1906); Tokyo Shashin Kenkyū Kai (1907); Naniwa Shashin Kurabu (Osaka, 1907); and Aiyu Shashin Kurabu (Nagoya, 1912). For a more complete listing of clubs established during this period, see the chart "Zenkoku shashin dantai ichiran (Meiji chūki-Taishō shonen)," in Iizawa, *"Geijutsu shashin,"* 39–42.

15. Unlike the members of the Meiji generation of clubs, photographers of this generation no longer needed to prove that photography was an art.

16. Takayama-sei (pseudonym), "Mudai-roku," *Shashin geppō* 18, no. 12 (December 1913): 50.

17. The English translation of the associations' names was provided in the bylaws of the Zen Kansai Shashin Renmei published in "Zappō," *Shashin geppō* 31, no. 1 (January 1926): 80.

18. Personal communication with Kaneko Ryūichi, 15 May 2002.

19. For more on the popularization of art photography and the aesthetic trends promoted in early popular camera clubs, see Ross, "'Little Works of Art,'" 425–457.

20. A year after its release, the company changed the name of the camera from Minimamu *Aideya* Kamera to the slightly altered Minimamu *Aidea* Kamera. For example, see ad in *Shashin geppō* 19, no. 9 (September 1914): prefatory page 15.

21. Sakai Shūichi, *Raika to sono jidai: M3 made no kiseki* (Asahi Shinbunsha, 1997), 156.

22. Shūkan Asahi, *Nedan-shi nenpyō*, 107.

23. *Shashin geppō* 18, no. 1 (January 1913): supplemental middle page 19.

24. "Minimamu Shashin Kai Kaiin Boshū," *Shashin geppō* 18, no. 9 (September 1913): supplementary prefatory page 21.

25. Ibid.

26. Konishi Roku, *Shashin to tomo ni*, 321. The company had already established a pattern for a single production facility with its factory for light-sensitive materials in 1902. The move from subcontracted production of cameras to a unified production facility in 1919 set the stage for the mass production of cameras on a scale never before achieved in Japan (248–249).

27. *Pāretto no tsukaikata* is the first volume of Arusu's *Kamera tsukaikata zenshū*, a ten-volume series that devotes one volume each to ten different models of cameras.

28. In the 1928 listing of photography clubs mentioned previously, 2,178 people had officially registered with the Pearlette Shashin Renmei. Tokyo Asahi Shinbunsha, *Nihon shashin nenkan*, 20.

29. Another opportunity was the chance to have one's work published in Konishi Roku's journal *Pāretto gashū*.

30. *Shumi no tomo* could also be translated as "friends of like taste."

31. Suzuki Hachirō, "Atarashiku umarekawaru *Kamera kurabu*," *Kamera kurabu* 2, no. 9 (September 1936), n.p.

32. Ibid. According to Suzuki there were more than twenty thousand subscribers.

33. Hashizume briefly discusses the way that Japanese companies address consumers of their particular products and services as "members" in the introduction to *Kurabu to Nihonjin*, 10–11.

34. "Zappō," *Shashin geppō* 32, no. 11 (November 1927): 830.

35. Kondō Suga, "Fujin-bu sōritsu tōji no omoide," in "Shashin josei-gun," 54.

36. The following summary of the Lady's Camera Club comes from the preface of Shibuya Kuritsu Shōtō Bijutsukan, ed., *Tokubetsu chinretsu: Nojima Yasuzō to Redeisu Kamera Kurabu* (Shibuya Kuritsu Shōtō Bijutsukan, 1993).

37. "Zappō," *Shashin geppō* 40, no. 8 (August 1935): 805.

38. Images of people attending the exhibition are highlighted in "Zappō," *Shashin geppō* 40 no. 6 (June 1935): 805.

39. "Zappō," *Shashin geppō* 37, no. 7 (June 1935): 784.

40. The terms *kisoku, kiyaku,* and *kaisoku* are used interchangeably to refer to "bylaws" throughout the documents.

41. Ikegami, *Bonds of Civility,* 32–33.

42. Norbeck, "Associations and Democracy in Japan," 192–193.

43. For example, see Katō Shinichi, *Shashin-jutsu kaitei* (1904; repr., Konishi Honten, 1912): appendix, unpaginated; Anonymous, "Atarashii yōsai chitai," *Kamera* 1, no. 5 (1922): 113–114; Takakuwa Katsuo, *Fuirumu shashin jutsu* (1920; repr., Arusu, 1922): appendix, 17–20.

44. "Zappō," *Shashin geppō* 26 no. 12 (December 1921): 60.

45. "Zappō," *Shashin geppō* 20, no. 8 (August 1915): 78.

46. "Zappō," *Shashin geppō* 23, no. 3 (March 1921): 75.

47. "Zappō," *Shashin geppō* 23, no. 11 (November 1918): 56.

48. "Zappō," *Shashin geppō* 23, no. 9 (September 1919): 54.

49. "Zappō," *Shashin geppō* 27, no. 5 (May 1922): 63.

50. "Zappō," *Shashin geppō* 27, no. 2 (February 1922): 62–63.

51. "Zappō," *Shashin geppō* 25, no. 9 (September 1920): 73. The list reads somewhat like the typical table of contents for a beginner's how-to book on photographic technique.

52. "Zappō," *Shashin geppō* 25, no. 11 (November 1920): 82.

53. "Zappō," *Shashin geppō* 34, no. 8 (August 1929): 718.

54. Howard Chudacoff, *The Age of the Bachelor: Creating an American Subculture,* (Princeton, NJ: Princeton University Press, 1999), 153.

55. "Zappō," *Shashin geppō* 26, no. 9 (September 1921): 50.

56. "Zappō," *Shashin geppō* 27, no. 2 (February 1922): 62.

57. "Zappō," *Shashin geppō* 26, no. 3 (March 1921): 88.

58. "Zappō," *Shashin geppō* 39, no. 7 (July 1934): 773–774.

59. Ibid., 773.

60. Ibid., 774.

61. Ibid.

62. Robert Anderson, "Associations in History," *American Anthropologist* 73, no. 1 (1971): 209–222. Though the study of Japanese voluntary associations is still somewhat scant, the study of voluntary associations in North America and Western Europe has produced an enormous amount of historical and sociological scholarship. The formation of voluntary associations in large metropolitan centers of North America and Western Europe have long been recognized by sociologists and historians as an adaptive mechanism that helped urban immigrants transition into their new and often very alienating surroundings after they migrated from the country to the city during the nineteenth and early twentieth centuries. See, for example, Orvoell R. Gallagher, "Volunteer Associations in France," *Social Forces* 36, no. 2 (December 1957): 153–160; and Lynn Abrams, *Workers' Culture in Imperial Germany: Leisure and Recreation in Rhineland and Westphalia* (London: Routledge, 1992).

63. Abrams, *Workers' Culture in Imperial Germany,* 116.

64. Gallagher, "Volunteer Associations in France," 153.

65. "Zappō," *Shashin geppō* 18, no. 11 (November 1913): 62–80.

66. Anderson, "Associations in History," 216.

67. Abrams, *Workers' Culture in Imperial Germany*, 116. In addition to recognizing the role of urban voluntary associations as mediating the uncertainty of migration from country to city, scholars have further explained the evolution of club organization in the context of the development of democratic political institutions. Numerous studies have looked at the development of voluntary associations as closely associated with the development of civic participation. See, for example, Gerald Gamm and Robert Putnam, "The Growth of Voluntary Associations in America, 1840–1940," *Journal of Interdisciplinary History* 29, no. 4 (1999): 511–557; Theda Skocpol, *Diminished Democracy: From Membership to Management in American Civic Life* (Norman: University of Oklahoma Press, 2003); Matthew Baggetta, "Civic Opportunities in Associations: Interpersonal Interaction, Governance Experience and Institutional Relationships," *Social Forces* 88, no. 1 (2009): 175–199. Along with this increased modernization of the club in terms of its activities and organizational structure, another element of the modern club is its commitment to ideals of democratic process and transparency. Gamm and Putnam, "The Growth of Voluntary Associations," 511. Alexis de Tocqueville observed in the early nineteenth century that voluntary associations in America acted as "free schools" to train citizens in the art of democracy. Baggetta, "Civic Opportunities in Associations," 175.

68. Anderson, "Associations in History," 215.

69. Ibid.

70. "Zappō," *Shashin geppō* 34, no. 8 (August 1929): 718.

71. "Zappō," *Shashin geppō* 25, no. 10 (October 1920): 51.

72. "Zappō," *Shashin geppō* 25, no. 9 (September 1920): 74.

73. Anderson, "Associations in History," 215.

74. "Zappō," *Shashin geppō* 27, no. 5 (May 1922): 64.

75. Abrams, *Workers' Culture in Imperial Germany*, 116.

76. Ibid.

77. Ibid.

78. Sheldon Garon, *Molding Japanese Minds: The State in Everyday Life* (Princeton, NJ: Princeton University Press, 1997), 119.

79. Garon, *Molding Japanese Minds*, 118–119.

80. "Zappō," *Shashin geppō* 37, no. 6 (June 1932): 596.

Chapter 5

1. Fukuhara Shinzō, "Shashin-dō," *Asahi kamera zōkan: Nihon no shashin shi ni nani ga atta ka? 'Asahi kamera' hanseiki no ayumi* (April 1978): 63. Originally published in *Asahi kamera* 1, no. 1 (April 1926): 30–31.

2. For a brief discussion of the relationship between painting and photography in the late Meiji and Taishō periods, see Iizawa, "Nihon no 'Geijutsu shashin' ga hajimatta." A fuller presentation of the range of debates during this period is presented in his book *"Geijutsu shashin" to sono jidai*.

3. Fukuhara, "Shashin-dō," 63.

4. Ibid.

5. Saitō Tazunori, *Geijutsu shashin no tsukurikata* (Genkōsha, 1932), 6. Throughout the twentieth century, *geijutsu shashin* has often been translated as "pictorial photography" or "pictorialism," which in some cases is appropriate. But, as I argue throughout this chapter, *geijutsu shashin*, especially as it is used by the early 1930s, is a much more inclusive term than the English phrase connotes. Throughout the chapter, I use the Japanese term *geijutsu shashin* to avoid conflation with the common connotation of the English phrase. In English, "pictorialism" after 1910 refers to photographic work that "values soft-focus effects and hand-manipulated imagery. Pictorialists promoted the study of the established arts and continued to proclaim the self-expressive possibilities of photography. . . . Beauty for its own sake was widely worshipped by traditional pictorialists." Christian Peterson, *After the Photo-Secession: American Pictorial Photography, 1910–1955* (New York: Minneapolis Institute of Fine Arts and W. W. Norton, 1997), 18–19. According to Jones in the *Encyclopedia of Photography* of 1911, pictorial composition is the "outcome of a kind of instinct, a natural feeling for what is harmonious, tasteful, and pleasing. Whether that instinct can be created is very doubtful; but it can certainly be fostered and cultivated by careful study of Nature, and of graphic representations of Nature produced by others who have themselves studied and observed" (137).

6. The work of photographers like Alfred Stieglitz (American, 1864–1946), Emil Otto Hoppé (British, 1878–1972), and Adolf Fassbender (American, 1884–1980), as well as Japan's Fukuhara Shinzō and Nojima Yasuzō's early work, is typically labeled "pictorialist."

7. Saitō, *Geijutsu shashin*, 34.

8. Ibid., 33.

9. Ibid., 35–36.

10. Ibid.; on individualism, see pages 22–23; on motivation, see pages 16–18. The motivation to capture beauty is characterized by a desire to move beyond simply seeing (*nagameru*) to deeply looking (*fukaku miru*) and observing (*kansatsu*).

11. Ibid., 31–32.

12. Ibid., 31.

13. Ibid., 37.

14. Murayama Tomoyoshi, "Shashin no atarashii kinō," *Asahi kamera* 1, no. 1 (May 1926): 24–27. Reprinted in a special issue of *Asahi kamera* (April 1978): 64. On Mavo, see Weisenfeld, *Mavo*.

15. Murayama, "Shashin no atarashii kinō," 64.

16. Ibid.

17. Ina Nobuo, "Shashin ni kaere," *Kōga* 1, no.1 (May 1932): 3.

18. Ibid.

19. "Inshō shugiteki kaiga wo mohō suru koto wo mokuteki to shita." Ibid.

20. Ibid.

21. Ibid.

22. *Dō* is the Chinese reading for the character *michi* or "way."

23. Saitō, *Geijutsu shashin*, 12.

24. Ibid.

25. "Shinkyō kara kanjō no gekihatsu to kōfun." Ibid., 27.

26. Ibid., 26.

27. Ibid., 26–27.

28. *Shashin shinpō* sponsored the "Getsurei dia-ichi/dai-ni bu ōbo" (Monthly Call for First and Second Division Photographs); *Shashin geppō*, the "Getsurei kenshō shashin boshū" (Monthly Call for Prize Photographs); *Kamera*, the "Maitsuki kenshō shashin boshū" (Monthly Call for Prize Photographs) from 1921; and *Fuototaimusu*, the "Fuototaimusu Sha getsurei shashin boshū" (Phototimes Company Monthly Call for Photographs) from 1924.

29. *Gekkan Raika* (which became *Kogata kamera* in 1936) sponsored the "Getsurei kenshō sakuhin boshū" (Monthly Call for Prize Work) from 1934. Submissions had to be taken with a Leica camera, though there were no restrictions on paper, printing materials, subject matter, or size of submissions. Editors also published commentary on winning submissions. *Shashin saron* held its monthly contest "Getsurei kenshō shashin boshū" and provided editorial commentary on winning submissions from 1933.

30. There were no restrictions on the kinds of photographs submitted or on the materials contestants used. Interestingly, the staff at *Kōga* offered to return all submissions with comments if the contestant sent return postage. Though other magazines published commentary on *winning* submissions in the pages of their magazine, *Kōga* is the only journal I have encountered that offered such personalized attention, even for those who did not win.

31. *Asahi kamera* 26, no. 3 (September 1938): 554.

32. Throughout the period 1926–1941, the number of divisions changes occasionally from three to four or five.

33. The following brief biography is a collation of information taken from Iizawa, *Nihon shashin shi wo aruku*, 160–170; and Fuku, *Shinzo and Roso Fukuhara*, 8–10. When Fukuhara returned to Tokyo in 1913, he became an active member of the Minimum Photography Club and won third place for his submission, "Senba" (Washing a Horse), which was published in the October 1913 issue of *Shashin geppō*.

34. He held this position except for a brief period in 1944–1945 during World War II, when the government disbanded the society. Fuku, *Shinzo and Roso Fukuhara*, 9.

35. Suzuki was relatively successful in the very new field of commercial photography. In 1924, he and several other photographers, including how-to writer Saitō Tazunori, started Hyōgensha, a publishing company with two divisions: Geijutsu Shashin Kenkyū Bu (Art Photography Research Division) and Shōgyō Shashin Bu (Commercial Photography Division). He teamed up with Kanemaru Shigene in 1927 to establish Kinreisha, one of Japan's earliest studios devoted entirely to commercial photography. Iizawa, *Geijutsu shashin*, 101–103.

36. The subscription included all ten volumes; each volume cost one yen forty sen, plus fourteen sen for postage. The ten volumes are *Kamera no chishiki to erabikata* (Knowledge of the Camera and How to Choose One, 1); *Kamera wo tsukaikonasu kotsu* (Mastering the Camera, 2); *Tadashii roshutsu*

no kimekata (How to Decide on the Proper Exposure, 3); *Fuirumu to fuirutā hayawakari* (A Quick Guide to Film and Filters, 4); *Utsushikata no dai-ippō* (The First Steps to Taking Pictures, 5); *Utsushikata no dai-nihō* (The Second Step to Taking Pictures, 6); *Dare ni mo dekiru genzō no yōryō* (Guidelines to Developing: Anyone Can Do It, 7); *Yakitsuke kara hikinobashi made* (From Printing Out to Enlargement, 8); *Shiki no shashin jutsu* (Photographic Technique for the Four Seasons, 9); and *Watakushi no shashin jutsu* (My Photographic Technique, 10).

37. In the monthly column "Sengai inga hyō: Doko ga warui ka" (Comments on Prints Not Selected: What Went Wrong?), Fujiki Kennosuke included several example photographs and offered his comments on submissions *not* chosen. In the first of this series, Fujiki promises to be fair, to give only constructive criticism, and to use the losing photographs anonymously. Fujiki Kennosuke, "Sengai inga hyō: Doko ga warui ka," *Kamera* 2, no. 7 (July 1936): 52.

38. *Kamera kurabu*, 2, no.7 (July 1936): 56.

39. Pamphlet, n.d. I found this pamphlet inside the cover of a used copy of Suzuki's *Arusu taishū shashin kōza, 9 kan: Shiki no shashin jutsu* (Arusu, 1938).

40. Steven Gelber recounts the similar popularity of contests in the model airplane and flying hobby: "The use of airplanes in World War I and Lindbergh's 1927 trans-Atlantic flight fueled a veritable craze for model airplanes. At the dawn of the Great Depression, model airplanes had become a multimillion-dollar business with about two thousand manufacturers. . . . For the most part, however, non-flying display kits took a back seat to flying models. By the mid-1930s 2 million flying model airplanes were being built each year, about a quarter of them powered by tiny internal combustion engines pioneered in the United States. Throughout the 1930s model builders joined clubs and competed in contests under the auspices of a variety of private and public sponsors." Gelber, *Hobbies*, 231–232.

41. *Kamera* (November 1925).

42. "Geijutsu shashin seikō no ippan wa shashinka jishin no ginō ni yoru koto wa ihe, naokatsu ippan wa shiyō zairyō no sentaku ika ni yoru." *Kamera* (November 1925).

43. "Bromide paper is a pure photographic paper coated with a sensitive emulsion, composed principally of bromide of silver and white gelatin and similar to that of the ordinary dry plate or film only of much less rapidity, permitting manipulation by a stronger light than would be safe for plates or films." *How to Make Good Photographs* (Kodak, ca. 1917), 130.

44. Gelber cites the important marketing role of celebrities in endorsing hobby activities. Throughout the 1930s, the Playground and Recreation Association of America sponsored regional model plane flying competitions and "featured aeronautics luminaries like Orville Wright and Charles Lindbergh, who assured model builders that they were developing practical skills." Gelber, *Hobbies*, 232.

45. Even when the names of the judges were not listed separately, many announcements claimed that a panel of experts from the world of photography

would judge the contest. For example, a contest that required the use of the Kurosu Filter and domestically produced film advertised in the September 1938 issue of *Asahi kamera* did not name specific judges but assured contestants that the judging would be "entrusted to eminent experts" (Chomei senmonka ni izoku [*sic*] su).

46. *Asahi kamera* 26, no. 3 (March 1938).

47. The law, Yushutsunyū Hintō Rinji Sochi Hō, was enacted in September 1937. Nihon Shashin Kyōkai, *Nihon shashin-shi nenpyō*, 186.

48. *Mitsukoshi* 12, no. 3 (March 1922): 32.

49. *Yukata* are light cotton or linen kimono worn during the summer season.

50. "Iwayuru shumi-teki geijutsu shashin no zōge no tō wo dete, shashin jitsuyō-ka." *Asahi kamera* 9, no. 3 (March 1930).

51. *Asahi kamera* 21, no. 4 (April 1936): n.p.

52. Peterson, *After the Photo-Secession*, 32.

53. Ibid.

54. For example, the following best sellers each included several chapters on the bromoil process: Takakuwa Katsuo's *Fuirumu shashin jutsu* (1920), Miyake Kokki's *Shumi no shashin jutsu* (1923), and Narita Ryūkichi's *Shashin inga no tehodoki* (An Introduction to Photography, 1929).

55. Kenten is the shortened name for the Tokyo Shashin Kenkyū Kai, an annual photography exhibition that began in 1910 and continues to this day.

56. Iizawa includes a useful chart on the popularity of various photographic techniques in *"Geijutsu shashin,"* 46.

57. Nor can they be explained by escapism or trendy fashion, as Iizawa argues. Ibid., 162.

58. John Brinckerhoff Jackson, "Craftsman Style and Technostyle," in *Discovering the Vernacular Landscape* (New Haven, CT: Yale University Press, 1984), 117.

59. Ibid., 116–117.

60. Gelber, *Hobbies*, 30.

61. Peterson, *After the Photo-Secession*, 109.

62. Ibid., 28. Fassbender quotations cited from Adolf Fassbender, "Understand the Amateur versus the Artist," manuscript (Fassbender Foundation, n.d., unpaginated).

63. In Chapter 3, I argued that one of the appeals of hobby photography was its implicit connection with the modern world of production and industrialization. Hobby photography and the home darkroom brought ideologies of the workplace and the research and development lab into the home.

64. Takakuwa Katsuo, "Zōkan ni nozomite," *Kamera* 1, no. 1 (April 1921): 1. In much of his writing he uses *shumi shashinka* and *kōzu shashinka* interchangeably to refer to the amateur photographer.

65. "Shin no ryōhin naraba ōi ni fuichō shiyō." Takakuwa, "Zōkan ni nozomite," 1. The idea that a magazine would act as a mouthpiece for particular camera companies and their products was a jab at the prevailing popular photography magazines of the day, such as *Shashin geppō*, sponsored by Konishi Roku, and *Shashin shinpō*, sponsored by Asanuma Shōkai. Though these

magazines published articles on many "neutral" topics, such as technique and aesthetics, they also regularly featured extended articles on their own products and on imported products sold in their shops.

66. The term *bijutsu shashin* (literally, "art photography") is not to be confused with *geijutsu shashin* as I have been discussing it in this chapter. The *bijutsu shashin* practitioner is a well-established photographer, one who submits his work to the various imperial exhibitions and whose work is known as "art."

67. Takakuwa, "Shashin-shi Ichikawa-kun ni," 667.

68. Ibid., 668.

69. Fuchigami's photograph has been published in several volumes, including Takeba Jō and Miura Noriko, eds., *Ikyō no modanizumu: Fuchigami Hakuyō to Manshū Shashin Sakka Kyōkai* (Nagoya: Nagoya-shi Bijutsukan, 1994); Ansel Adams Center, ed., *Modern Photography in Japan, 1915–1940* (San Francisco: The Friends of Photography, 2001); and Tucker et al., *The History of Japanese Photography*.

70. Ina Nobuo, "Shashin ni kaere."

Epilogue

1. *Shashin geppō* 30, no. 1 (January 1925): prefatory page 10. The advertisement in which this goal was stated was for the Idea No. 1 and the Pearl No. 2 cameras. It announced: "The Highest Quality and the Best Prices. It is the sacrificial (*gisei-teki*) effort of this company to try as much as possible to bring about the democratization of photography [*shashin minshū-ka*]. Just as every home possesses a wall clock or a table clock, in today's world, the camera should be seen as one of the most essential possessions for every home."

2. The summary of Konishi Roku's wartime production activities comes from Konishi Roku, *Shashin to tomo ni*.

3. "Yushutsunyū Hintō Rinji Sochi Hō." The data on the consumption of photographic products during wartime comes from *Nihon shashin-shi nenpyō*.

4. Tsūshin Sangyō Daijin Kanbō Chōsa Tōkei-bu, ed., *Kikai tōkei nenpō, Shōwa 27–nen* (Nihon Kikai Kōgyō Kai, 1948), 139.

5. Ina Nobuo, "Japan's Photographic Industry," *Japan Quarterly* 5, no. 4 (October/December 1958): 511.

6. Tsūshin Sangyō Daijin Kanbō Chōsa Tōkei-bu, ed., *Kōgyō tōkei 50 nen-shi, Shiryō hen 1* (Ōkurashō Insatsu Kyoku, 1961), 512.

7. Nihon Shashin Kyōkai, *Nihon shashin-shi nenpyō*, 207. Other magazines that began publishing again after the war include *Kōga gekkan* (January 1947); *Asahi kamera* (October 1949); *Shashin saron* (June 1951); and *Kamera kurabu*, which restarted as *Shashin no kyōshitsu* in 1949. Mari Shirayama et al., "JCII Raiburarī 10 shūnen kinen-ten: Shashin zasshi no kiseki" (JCII Raiburarī, 2001), 4–11.

8. Nihon Shashin Kyōkai, *Nihon shashin-shi nenpyō*, 210.

9. Ibid., 207.

10. Tanabe Yoshio, *Mitchaku no jitsugi* (Genkōsha, 1954), 9.

BIBLIOGRAPHY

Note: Place of publication for Japanese titles is Tokyo unless otherwise noted.

Photography Magazines

Asahi kamera (Asahi Shinbunsha, 1926–1941, 1949–current)
Fuototaimusu (Fuototaimususha, 1924–1941)
Geijutsu shashin (Arusu, 1922–1940)
Gekkan Raika (Leica) (Arusu, 1934–1940; *Gekkan kogata kamera* from 1936)
Kamera (Arusu, 1921–1956)
Kamera kurabu (Arusu, 1936–1940)
Kōga (Shurakusha, 1932–1933)
Shashin geppō (Konishi Shōten, 1894–1940)
Shashin saron (Genkōsha, 1933–1940, 1951–1961)
Shashin shinpō (Chōyōsha, 1882–1940)

Published Works

Abrams, Lynn. *Workers' Culture in Imperial Germany: Leisure and Recreation in Rhineland and Westphalia.* London: Routledge, 1992.

Akiyama Tetsusuke. "Nihon ni okeru shashin no enkaku." *Shashin geppō* 30, no. 12 (December 1925): 865–876.

"Amachua wo kataru: Zairyōya-san no zadankai." *Asahi kamera* 21, no. 4 (April 1936): 636–645.

Ambaras, David. "Social Knowledge, Cultural Capital, and the New Middle Class in Japan, 1895–1912. *Journal of Japanese Studies* 24, no. 1 (Winter 1998): 1–33.

Anderson, Robert. "Associations in History." *American Anthropologist* 73, no. 1 (February 1971): 209–222.

Ansel Adams Center, ed., *Modern Photography in Japan, 1915–1940.* San Francisco: The Friends of Photography, 2001.

Appadurai, Arjun. "Introduction: Commodities and the Politics of Value." In *The Social Life of Things*, edited by Arjun Appadurai, 3–63. Cambridge: Cambridge University Press, 1986.

"*Asahi gurafu* shusai shashin hyakunen-sai." *Shashin geppō* 30, no. 12 (December 1925): 926–951.

Asahi Shinbunsha, ed. *Asahi gurafu* Henshūbu. *Shashin hatsumei hyakunen-sai kinen kōen shū.* Asahi Shinbunsha, 1926.

———. *Shashin hatsumei hyakunen-sai kinen kōen shū.* Asahi Shinbunsha, 1926.

Asanuma Shōkai. *Asanuma shōkai hyakunen-shi.* Asanuma Shōkai, 1971.

Ashiya Shiritsu Bijutsu Hakubutsukan. *Ashiya no bijutsu wo saguru: Ashiya Kamera Kurabu, 1930–1942.* Ashiya: Ashiya Shiritsu Bijutsu Hakubutsukan, 1998.

Auyeung, Pak K. "A Comparative Study of Accounting Adaptation: China and Japan during the Nineteenth Century." *Accounting History Journal* 29, no. 2 (December 2002): 1–30.

Baggetta, Matthew. "Civic Opportunities in Associations: Interpersonal Interaction, Governance Experience and Institutional Relationships." *Social Forces* 88, no. 1 (2009): 175–199.

Barclay, Paul D. "Peddling Postcards and Selling Empire: Image-Making in Taiwan under Japanese Colonial Rule." *Japanese Studies* 30, no. 1 (2010): 81–110.

Bardsley, Jan, and Hiroko Hirakawa. "Branded: Bad Girls Go Shopping." In *Bad Girls of Japan*, edited by Laura Miller and Jan Bardsley, 111–125. New York: Palgrave Macmillan, 2005.

Benson, Susan Porter. *Counter Cultures: Saleswomen, Managers, and Customers in American Department Stores 1890–1940.* Urbana: University of Illinois Press, 1986.

Bourdieu, Pierre. *Photography: A Middle-Brow Art.* Translated by Shaun Whiteside. Stanford, CA: Stanford University Press, 1990.

Brandt, Kim. *Kingdom of Beauty: Mingei and the Politics of Folk Art in Imperial Japan.* Durham, NC: Duke University Press, 2007.

Brayer, Elizabeth. *George Eastman: A Biography.* Baltimore: Johns Hopkins University Press, 1996.

Breward, Christopher. *The Hidden Consumer: Masculinities, Fashion and City Life, 1860–1914.* Manchester, UK: Manchester University Press, 1999.

Charrier, Philip. "Nojima Yasuzō's Primitivist Eye: 'Nude' and 'Natural' in Early Japanese Art Photography." *Japanese Studies* 26, no. 1 (2006): 47–68.

Chiba Noriko. "Utsusareru kata no okeshō to kitsuke." *Asahi kamera* 9, no. 1 (January 1930): 50–51.

Chizu Shiryō Hensan Kai. *Chiseki daichō, chiseki chizu "Tokyo."* Vols. 1 and 2. Kashiwa Shobō, 1989.

Chudacoff, Howard P. *The Age of the Bachelor: Creating an American Subculture.* Princeton, NJ: Princeton University Press, 1999.

Condax, Philip L. *The Evolution of the Japanese Camera.* Rochester, NY: International Museum of Photography, 1984.

Croissant, Doris. "In Quest of the Real: Portrayal and Photography in Japanese Painting Theory." In *Challenging Past and Present: The Metamorphosis of*

Nineteenth-Century Japanese Art, edited by Ellen Conant, 153–176. Honolulu: University of Hawai'i Press, 2006.

Crossick, Geoffrey, and Serge Jaumain, eds. *Cathedrals of Consumption: The European Department Store, 1850–1939*. Aldershot, UK: Ashgate, 1999.

Curtis, James E., Douglas E. Baer, and Edward G. Grabb. "Nations of Joiners: Explaining Voluntary Association Membership in Democratic Societies." *American Sociological Review* 66, no. 6 (December 2001): 783–805.

Cwiertka, Katarzyna. "How Cooking Became a Hobby: Changes in Attitude toward Cooking in Early Twentieth-Century Japan." In *The Culture of Japan as Seen through Its Leisure*, edited by Sepp Linhart and Sabine Frühstück, 41–58. Albany: State University of New York Press, 1998.

de Lange, William. *A History of Japanese Journalism: Japan's Press Club as the Last Obstacle to a Mature Press*. Richmond, Surrey, UK: Japan Library, 1998.

Dore, R. P. *City Life in Japan: A Study of a Tokyo Ward*. Berkeley: University of California Press, 1958.

Dower, John. "Ways of Seeing, Ways of Remembering: The Photography of Prewar Japan." In *A Century of Japanese Photography*, edited by Japan Photographers Association, 1–20. New York: Pantheon Books, 1980.

Fedman, David. "Triangulating Chōsen: Maps, Mapmaking, and the Land Survey in Colonial Korea." *Cross-Currents: East Asian History and Culture Review* 1, no. 1 (2012): 205–234.

Flaherty, Darryl. "Organizing for Influence: Lawyers' Associations and Japanese Politics, 1868–1945." PhD diss., Columbia University, 2001.

Francks, Penelope. *The Japanese Consumer: An Alternate Economic History of Modern Japan*. Cambridge: Cambridge University Press, 2009.

Freedman, Alisa, Laura Miller, and Christine Yano, eds. *Modern Girls on the Go: Gender Mobility and Labor in Japan*. Stanford, CA: Stanford University Press, 2013.

Freeman, Laurie Anne. *Closing the Shop: Information Cartels and Japan's Mass Media*. Princeton, NJ: Princeton University Press, 2000.

Führer, Karl Christian. "A Medium of Modernity? Broadcasting in Weimar Germany, 1923–1932." *Journal of Modern History* 69, no. 4 (December 1997): 722–753.

Fujiki Kennosuke. "Sengai inga hyō: Doko ga warui ka." *Kamera kurabu* 2, no.7 (July 1936): 52–53.

Fujimori Terunobu, Hatsuda Tōru, and Fujioka Hiroyasu, eds. *Shashinshū: Genkei no Tokyo: Taishō, Shōwa no machi to sumai*. Kashiwa Shobō, 1998.

Fuku, Noriko. *Shinzo and Roso Fukuhara: Photographs by Ginza Modern Boys, 1913–1941*. SEPIA International Incorporated, 2000.

Fukuhara Shinzō. "Shashin-dō." *Asahi kamera zōkan: Nihon no shashin shi ni nani ga atta ka? 'Asahi kamera' hanseiki no ayumi* (April 1978): 63. Originally published in *Asahi kamera* 1, no. 1 (March 1926): 30–31.

———. "Shashin geijutsu ni tsuite." In *Shashin hatsumei hyakunen-sai kinen kōen shū*, edited by Asahi Shinbunsha *Asahi gurafu* Henshūbu. Asahi Shinbunsha, 1926.

————. "Shashin no shin-shimei, shosen." In *Tokyo-to Shashin Bijutsu-kan sōsho: Sairoku: Shashin-ron 1921–1965*, edited by Ōshima Hiroshi. Tankōsha, 1999. First published in *Geijutsu shashin* (September 1923).

————. *Shashin wo kataru.* Musashi Shobō, 1933.

Gallagher, Orvoell R. "Volunteer Associations in France." *Social Forces* 36, no. 2 (December 1957): 153–160.

Gamm, Gerald, and Robert Putnam. "The Growth of Voluntary Associations in America, 1840–1940." *Journal of Interdisciplinary History* 29, no. 4 (1999): 511–557.

Garon, Sheldon. "From Meiji to Heisei: The State and Civil Society in Japan." In *The State of Civil Society in Japan*, edited by Frank Schwartz and Susan Pharr, 42–62. Cambridge: Cambridge University Press, 2003.

————. *Molding Japanese Minds: The State in Everyday Life.* Princeton, NJ: Princeton University Press, 1997.

Gartlan, Luke. 2009. "Samuel Cocking and the Rise of Japanese Photography." *History of Photography* 33, no. 2 (2009): 145–164.

Gelber, Steven. *Hobbies: Leisure and the Culture of Work in America.* New York: Columbia University Press, 1999.

————. "A Job You Can't Lose: Work and Hobbies in the Great Depression." *Journal of Social History* 24, no. 2 (1991): 741–766.

Gordon, Andrew. "Consumption, Leisure and the Middle Class in Transwar Japan." *Social Science Japan Journal* 10, no. 1 (2007): 1–21.

Hane, Mikiso. *Reflections on the Way to the Gallows: Voices of Japanese Rebel Women.* Berkeley: University of California Press, 1988.

Hasegawa Akira. "'Hōdō shashin' no yukue." In *Nihon kindai shashin no seiritsu: Kantō dai-shinsai kara Shinju-wan made, 1923–1941–nen*, edited by Kashiwagi Hiroshi, Kaneko Ryūichi, and Itō Shunji, 161–189. Seikyūsha, 1987.

Hashimoto Takehiko and Kuriyama Shigehisa, eds. *Chikoku no tanjō: Kindai Nihon ni okeru jikan ishiki no keisei.* Sangensha, 2002.

Hashizume Shin'ya. *Kurabu to Nihonjin: Hito ga atsumaru kūkan no bunkashi.* Kyoto: Gakugei Shuppansha, 1989.

Hatsuda Tōru. *Hyakkaten no tanjō.* Sanseidō, 1993.

Hayami Kimiko. "Utsusare jōzu: Kore dake no kokorogake ga taisetsu." *Asahi kamera* 9, no. 1 (January 1930): 48–49.

Hight, Eleanor M. *Picturing Modernism: Moholy-Nagy and Photography.* Cambridge, MA: MIT Press, 1995.

Hirayama, Mikiko. "'Elegance' and 'Discipline': The Significance of Sino-Japanese Aesthetic Concepts in the Critical Terminology of Japanese Photography, 1903–1923." In *Reflecting Truth: Japanese Photography in the Nineteenth Century*, edited by Nicole Coolidge Rousmaniere and Mikiko Hirayama, 100–108. Amsterdam: Hotei Publishing, 2004.

Hirsohima-shi Shakai Ka. "Kyūryō seikatsusha seikatsu jōtai." In *Rōdōsha seikatsu chōsa shiryō shūsei: Kindai Nihon no rōdōsha zō 1920–1930*, vol. 2, *Kyūryō rōdōsha*, edited by Nakagawa Kiyoshi, 1–71. Seishisha, 1994.

Horowitz, Roger, and Arwen Mohun. "Introduction." In *His and Hers:*

Gender, Consumption, and Technology, ed. Roger Horowitz and Arwen Mohun, 1–6. Charlottesville: University of Virginia Press, 1998.

Hotta Shinpei. "*Asahi gurafu* shusai kinen shaten wo miru." *Shashin geppō* 30, no. 12 (December 1925): 902–910.

How to Make Good Pictures: A Book for the Amateur Photographer. Rochester, NY: Eastman Kodak Company, ca. 1917.

Huizinga, Johan. *Homo Ludens: A Study of the Play Element in Culture*. Boston: Beacon Press, 1955.

Huyssen, Andreas. *After the Great Divide: Modernism, Mass Culture, Postmodernism*. Bloomington: Indiana University Press, 1986.

"Ichi-jikan shashin no kaishi." *Mitsukoshi* 1, no. 6 (1911): 6.

Iizawa, Kōtarō. "The Evolution of Postwar Photography." In *The History of Japanese Photography*, edited by Anne Tucker, Dana Friis-Hansen, Kaneko Ryūichi, and Takeba Jō, 211–212. New Haven, CT: Yale University Press, 2003.

———. "*Geijutsu shashin*" to sono jidai. Chikuma Shobō, 1986.

———. "Jinrui-gakusha no kamera ai: Torii Ryūzō." In *Nihon-shashinshi o aruku*. Shinchōsha, 1992.

———. "Nihon no 'Geijutsu shashin' ga hajimatta." In *Kamera omoshiro monogatari*, edited by Asahi Shinbunsha. Asahi Shinbunsha, 1988.

———. *Nihon shashin-shi wo aruku*. Shinchōsha, 1992.

———. *Sengo shashin nōto: Shashin wa nani wo hyōgen shite kita ka*. Chūkō Shinsho, 1993.

———. *Shashin ni kaere: "Kōga" no jidai*. Heibonsha, 1988.

———. *Toshi no shisen: Nihon no shashin, 1920–1930 nendai*. Sōgensha, 1989.

Iizawa Kōtarō and Kaneko Ryūchi, eds. *Nihon no shashin-shi no shihō, bekkan: Kōga no kessakushū*. Kokusho Kankōkai, 2005.

Iizawa Kōtarō, Kinoshita Naoyuki, and Nagano Shūichi, eds. *Nihon no shashinka bekkan: Nihon shashinshi gaisetsu*. Iwanami Shoten, 1999.

Ikegami, Eiko. *Bonds of Civility: Aesthetic Networks and the Political Origins of Japanese Culture*. Cambridge: Cambridge University Press, 2005.

Iketani Kentarō, ed. *Pāretto gashū*, no. 5 (1936).

Ina, Nobuo. "Japan's Photographic Industry." *Japan Quarterly* 5, no. 4 (October/December 1958): 507–514.

———. "Shashin ni kaere." *Kōga* 1, no. 1 (May 1932): 1–13.

———. *Shashin: Shōwa 50-nen shi*. Asahi Shinbunsha, 1978.

Inoue Sadatoshi. "Kyūryō seikatsusha no tsūkin jikan oyobi kyūjitsu." In *Kyūryō seikatsusha mondai: Dai 2 kai shakai seisaku kaigi hōkokusho*, edited by Shakai Rippō Kyōkai, 73–103. Shakai Rippō Kyōkai, 1933.

Ishii Kendō. *Shōnen kōgei bunko: Shashin no maki*. 1902. Reprint, Hakubunkan, 1918.

"Īsutoman-shi kangeikai." *Shashin geppō* 25, no. 5 (May 1920): 351–354.

Itagaki Takaho. "Kikai to geijutsu to no kōryū." In *Kikai no metoroporisu*, vol. 6, *Modan toshi bungaku*, edited by Uno Hiroshi, 451–471. Heibonsha, 1990. First published in *Shisō* (September 1929).

Itō Hidetoshi. "Shashin minshūka ni taisuru ikkōan." *Shashin geppō* 28, no. 1 (January 1923): 49–55.

Jackson, John Brinkerhoff. *Discovering the Vernacular Landscape.* New Haven, CT: Yale University Press, 1984.

Jenkins, Reese V. *Images and Enterprise: Technology and the American Photographic Industry, 1839 to 1925.* Baltimore: Johns Hopkins University Press, 1975.

Jinno Yuki. *Shumi no tanjō: Hyakkaten ga tsukutta teisuto.* Keisō Shobō, 1994.

Jones, Bernard E., ed. *Encyclopedia of Photography.* 1911. Reprint, New York: Arno Press, 1974.

Jones, Mark. *Children as Treasures: Childhood and the Middle Class in Early Twentieth Century Japan.* Cambridge, MA: Harvard University Press, 2010.

Kamei Takeshi. *Tokyo-to Shashin Bijutsukan sōsho: Nihon shashin-shi e no shōgen (Gekan).* Tankōsha, 1997.

———. *Tokyo-to Shashin Bijutsukan sōsho: Nihon shashin-shi e no shōgen (Jōkan).* Tankōsha, 1997.

Kanagawa Kenritsu Kindai Bijutsukan. *"Nihon no shashin 1930 nendai" ten zuroku.* Kanagawa: Kanagawa Kenritsu Kindai Bijutsukan, 1988.

Kanehara Sanshō. "Fuaindū wa dō nozoku no ga tadashii ka." In *Shotō shashinjutsu hyakkō,* edited by Asahi Kamera. Asahi Shinbunsha, 1939.

Kaneko, Ryūichi. "Japanese Photography in the Early Twentieth Century." In *Modern Photography in Japan, 1915–1940,* edited by the Ansel Adams Center, n.p. San Francisco: The Friends of Photography, 2001.

———. "Nihon pikutoriarizumu shashin to sono shūhen: Kakō sareta kindai." In *Nihon kindai shashin no seiritsu: Kantō dai-shinsai kara Shinju-wan made, 1923–1941–nen,* edited by Kashiwagi Hiroshi, Kaneko Ryūichi, and Itō Shunji, 9–38. Seikyūsha, 1987.

———. "The Origins and Development of Japanese Art Photography." In *The History of Japanese Photography,* ed. Anne Tucker, Dana Friis-Hansen, Kaneko Ryūichi, and Takeba Jō, 104–113. New Haven, CT: Yale University Press, 2003.

Kashiwagi Hiroshi. *Shōzō no naka no kenryoku: Kindai Nihon no gurafuizumu wo yomu.* Heibonsha, 1987.

Kashiwagi Hiroshi, Kaneko Ryūichi, and Itō Shunji, eds. *Nihon kindai shashin no seiritsu: Kantō dai-shinsai kara Shinju-wan made, 1923–1941–nen.* Seikyūsha, 1987.

Katō Shinichi. *Shashin-jutsu kaitei.* 1904. Reprint, Konishi Honten, 1912.

Kawahigashi Yoshiyuki. "Misezō no fukyū to 'Zō no machi' no seiritsu." In *Kenchiku-shi no mawari butai: Kindai no dezain wo kataru,* edited by Nishi Kazuo, 129–143. Shokokusha, 1999.

Kim, Gyewon. "Unpacking the Archive: Ichthyology, Photography, and the Archival Record in Japan and Korea." *positions* 18, no.1 (Spring 2010): 51–87.

Kimura Shizuko. "Shashin no tanoshimi." In "Shashin josei-gun kōshinkyoku." *Asahi Kamera* 19, no. 1 (January 1935): 49–50.

Kinmonth, Earl. *The Self-Made Man in Meiji Japanese Thought*. Berkeley: University of California Press, 1981.

Kisha [staff reporter]. "Atarashii yōsai chitai." *Kamera* 1, no. 5 (1922): 113–114.

Kishi Gi'ichi. *Kamera tsukaikata zenshu*. Vol. 1, *Pāretto no tsukaikata*. Arusu, 1937.

Kitano Kunio. *Hyakuman nin no shashin jutsu*. Kōgasō, 1940.

Kitaoka Juitsu. "Kyūryō seikatsusha mondai gaikan." In *Kyūryō seikatsusha mondai*, edited by Shakai Rippō Kyōkai. Shakai Rippō Kyōkai, 1933.

Kiyanon-shi Henshū I'in Kai. *Kiyanon-shi: Gijutsu to seihin no 50–nen*. Kiyanon Kabushiki Kaisha, 1987.

Kobayashi Hidejirō. "Shashin mōyō, sono satsuei hō." *Asahi kamera* 9, no. 3 (March 1930): 276–283.

Koizumi, Shirō. "Oshō-san ga kamera ni korimashita." *Asahi kamera* 22, no. 6 (December 1936): 970.

"Kokusan shōkan ō-kenshō shashin bōshū." *Shashin geppō* 30, no. 1 (January 1925): prefatory advertising section.

Kondō Suga. "Fujin-bu sōritsu tōji no omoide." In "Shashin josei-gun kōshin-kyoku." *Asahi kamera* 19, no. 1 (January 1935): 54.

Konica Minolta. "Corporate Information: More about History." Konica Minolta, 2011–2015. Available at http://www.konicaminolta.com/about/corporate/history_timeline_3.html.

"Konishi Honten no shinchiku rakusei." *Shashin geppō* 21, no. 6 (June 1916): 56–59.

Konishi Roku Shashin Kōgyō Kabushiki Kaisha Shashi Hensan-shitsu, ed. *Shashin to tomo ni hyakunen*. Konishi Roku Shashin Kōgyō Kabushiki Kaisha, 1973.

Levine, Lawrence L. *Highbrow/Lowbrow: The Emergence of Cultural Hierarchy in America*. Cambridge, MA: Harvard University Press, 1988.

Linhart, Sepp, and Sabine Frühstück, eds. *The Culture of Japan as Seen through Its Leisure*. Albany: State University of New York Press, 1998.

Lubar, Steven. "Men/Women/Production/Consumption." In *His and Hers: Gender, Consumption, and Technology*, edited by Roger Horowitz and Arwen Mohun, 7–37. Charlottesville: University of Virginia Press, 1998.

Maeda Hajime. *Sarariman monogatari*. Tōyō Keizai Shuppanbu, 1928.

Mashiko Zenroku. "Tesei kamera no gisei." *Asahi kamera* 22, no. 3 (September 1936): 970.

McKenzie, D. F. *Bibliography and the Sociology of Texts*. London: British Library, 1986.

McKinnon, Jill. "The Historical and Social Context of the Introduction of Double-Entry Bookkeeping to Japan." *Accounting Business and Financial History* 4, no. 1 (1994): 181–201.

Mills, C. Wright. *White Collar: The American Middle Classes*. 1951. Reprint, Oxford: Oxford University Press, 2002.

Minimamu Shashin Kai Kaiin Boshū. *Shashin Geppō*, 18, no. 9 (September 1913): prefatory page 21.

Minami Hiroshi, ed. *Kindai shomin seikatsushi, daigokan: Fukushoku, biyō, girei.* San'ichi Shobō, 1986.

———. *Nihon modanizumu no kenkyū: Shisō, seikatsu, bunka.* Burēn Shuppan, 1982.

Minami Hiroshi and Shakai Shinri Kenkyū-jō, eds. *Shōwa bunka, 1925–1945.* Keisō Shobō, 1987.

———. *Taishō bunka, 1905–1927.* Keisō Shobō, 1988.

Miyake Kokki. *Shashin no utsushikata.* Arusu, 1920.

———. *Shumi no shashin jutsu.* 86th ed. 1919. Reprint, Arusu, 1923.

Miyano Rikiya. *Etoki hyakkaten "Bunka shi."* Nihon Keizai Shinbunsha, 2002.

Moeran, Brian. "The Birth of the Japanese Department Store." In *Asian Department Stores*, edited by Kerrie L. Macpherson, 141–176. University of Hawai'i Press, 1998.

Morris-Suzuki, Tessa. *The Technological Transformation of Japan: From the Seventeenth to the Twenty-First Century.* Cambridge: Cambridge University Press, 1994.

Murayama Tomoyoshi. "Shashin no atarashii kinō." *Asahi kamera* 1, no. 1 (May 1926): 24–27.

Nagai Saburō. *Arusu shashin bunkō: Katei anshitsu no tsukurikata.* Arusu, 1939.

Nagamine Shigetoshi. *Zasshi to dokusha no kindai.* Nihon Edeitā Sukūru Shuppanbu, 1997.

Naikaku Tōkei Kyoku. *Kakei chōsa hōkoku, dai-nikan: Kyūryō seikatsusha, rōdōsha no bujō 1926–27.* Naikaku Tōkei Kyoku, 1927.

Nakano Susumu. *Nihonbashi Honchō.* Tokyo Yakubō Kyōkai, 1974.

Narita Ryūkichi. *Shashin inga no tehodoki.* Hakubunkan, 1929.

Narusawa Reisen, ed. *"Asahi gurafu" shashin hyakunen-sai kinen-gō.* Asahi Shinbunsha, 1925.

Natori Yōnosuke, Ishikawa Yasumasa, and Nihon Shashinka Kyōkai. *Hōdō shashin no seishun jidai: Natori Yōnosuke to nakamatachi.* Kōdansha, 1991.

Nihon Kamera Hakubutsukan Un'ei I'in Kai. *Nihon no kamera tanjō kara konnichi made.* Nihon Kamera Hakubutsukan, 1989.

Nihon Shashin Kyōkai. *Nihon shashin-shi nenpyō.* Kōdansha, 1976.

Norbeck, Edward. "Associations and Democracy in Japan." In *Aspects of Social Change in Modern Japan*, edited by R. P. Dore, 185–200. Princeton, NJ: Princeton University Press, 1967.

———. "Common Interest Associations in Rural Japan." In *Japanese Culture: Its Development and Characteristics*, edited by Robert J. Smith and Richard K. Beardsley, 73–85. Chicago: Aldine, 1963.

O'Connell, Sean. *The Car and British Society: Class, Gender, and Motoring, 1896–1939.* Manchester, UK: Manchester University Press, 1998.

Ogi Shinzō, Haga Tōru, and Maeda Ai, eds. *Tokyo kūkan, 1868–1930.* Vol. 1, *Tokyo jidai.* Chikuma Shobō, 1978.

———. *Tokyo kūkan, 1868–1930.* Vol. 2, *Teito Tokyo.* Chikuma Shobō, 1978.

———. *Tokyo kūkan, 1868–1930*. Vol. 3, *Modan Tokyo*. Chikuma Shobō, 1978.

Oldenziel, Ruth. "Man the Maker, Woman the Consumer: The Consumption Junction Revisited." In *Feminism in Twentieth-Century Science, Technology and Medicine*, edited by Angela N. H. Creager, Elizabeth Lunbeck, and Londa Schiebinger, 128–148. Chicago: University of Chicago Press, 2001.

Orientaru Shashin Kōgyō Kabushiki Kaisha. *Orientaru Shashin Kōgyō Kabushiki Kaisha 30-nen shi*. Orientaru Shashin Kōgyō Kabushiki Kaisha, 1950.

Ōshima Hiroshi. *Tokyo-to Shashin Bijutsukan sōsho: Sairoku: Shashin-ron 1921–1965*. Tankōsha, 1999.

Ozawa Takeshi, ed. *Nihon no shashin shi: Bakumatsu no denpa kara Meiji-ki made*. Nikkor Club, 1986.

———. *Nihon shashin senshū*. Vol. 2, *Geijutsu shashin no keifu*. Shogakukan, 1986.

Peterson, Christian. *After the Photo-Secession: American Pictorial Photography, 1910–1955*. New York: Minneapolis Institute of Fine Arts and W. W. Norton, 1997.

Roden, Donald. *School Days in Imperial Japan: A Study in the Culture of a Student Elite*. Berkeley: University of California Press, 1980.

Rojek, Chris. "Leisure and 'The Ruins of the Bourgeois World.'" In *Leisure for Leisure*, edited by Chris Rojek, 94–112. London: Macmillan Press, 1989.

Rokugawa Jun. *Roshutsu no hiketsu: Kamera yomihon*. 4th ed. Kyōbunsha, 1937.

———. *Roshutsu shōkai: Shashin jutsu 12 kagetsu*. Kyōbunsha, 1936.

Ross, Kerry. "Between Art and Industry: Hobby Photography and Middle-Class Life in Early Twentieth-Century Japan." PhD diss., Columbia University, 2006.

———. "'Little Works of Art': Photography, Camera Clubs and Democratizing Everyday Life in Early Twentieth-Century Japan." *Japan Forum* 25, no. 4 (December 2013): 425–457.

———. "Returning to Photography: Ina Nobuo and Real Photography in 1930s Japan." Master's thesis, Columbia University, 1997.

Rubin, Joan Shelly. *The Making of Middlebrow Culture*. Chapel Hill: University of North Carolina Press, 1992.

Saitō Tazunori. *Geijutsu shashin no tsukurikata*. Genkōsha, 1932.

Sakai Shūichi. *Raika to sono jidai: M3 made no kiseki*. Asahi Shinbunsha, 1997.

———. *Shōwa 10–40 nen kōkoku ni miru kokusan kamera no rekishi*. Asahi Kamera Henshūbu, 1994.

Sakamoto Fujiyoshi. *Nihon koyō shi*. Chūō Keizaisha, 1977.

Sand, Jordan. "At Home in the Meiji Period: Inventing Japanese Domesticity." In *Mirror of Modernity: Invented Traditions of Modern Japan*, edited by Stephen Vlastos, 191–207. Berkeley: University of California Press, 1998.

———. "The Cultured Life as Contested Space: Dwelling and Discourse in the 1920s." In *Being Modern in Japan: Culture and Society from the 1910s to*

the 1930s, edited by Elsie Tipton and John Clark, 99–118. Honolulu: University of Hawai'i Press, 2000.

———. *House and Home in Modern Japan: Architecture, Domestic Space, and Bourgeois Culture, 1880–1930.* Cambridge, MA: Harvard University Asia Center, 2005.

Sato, Barbara. *The New Japanese Woman: Modernity, Media, and Women in Interwar Japan.* Durham, NC: Duke University Press, 2003.

Satō Kenji. "Ehagaki no naka no jinruigaku." In *Kankō jinruigaku*, edited by Yamashita Shinji, 45–53. Shin'yōsha, 1996.

———. *Fūkei no seisan, fūkei no kaihō.* Kōdansha, 1994.

———. "Postcards in Japan: A Historical Sociology of a Forgotten Culture." *International Journal of Japanese Sociology*, no. 11 (November 2002): 35–55.

Sawa Kurō. *Amachua shashin kōza.* Vol. 9, *Kogata kamera shashin jutsu.* Arusu, 1937.

"Shashin hyakunen-sai, Tokyo *Asahi Shinbun* ronsetsu." *Shashin geppō* 30, no. 12 (December 1925): 910–913.

Shibuya Kuritsu Shōtō Bijutsukan. *Tokubetsu chinretsu: Nojima Yasuzō to Redeisu Kamera Kurabu.* Shibuya Kuritsu Shōtō Bijutsukan, 1993.

Shiraishi Takeshi. *Nihonbashi machinami shōgyō-shi.* Keiō Gijuku Daigaku Shuppan Kai, 1999.

Shirayama Mari. *JCII Raiburarī 10 shūnen kinen-ten: Shashin zasshi no kiseki.* JCII Raiburarī, 2001.

Shūkan Asahi, ed. *Nedan-shi nenpyō: Meiji, Taishō, Shōwa.* Asahi Shinbunsha, 1996.

Silverberg, Miriam. "After the Grand Tour: The Modern Girl, the New Woman, and the Colonial Maiden." In *The Modern Girl around the World: Consumption, Modernity, and Globalization*, edited by The Modern Girl around the World Research Group, 354–361. Durham, NC: Duke University Press, 2008.

———. "The Café Waitress Serving Modern Japan." In *Mirror of Modernity: Invented Traditions of Modern Japan*, edited by Stephen Vlastos, 208–225. Berkeley: University of California Press, 1998.

———. "Constructing the Japanese Ethnography of Modernity." *Journal of Asian Studies* 51, no. 1 (February 1992): 30–54.

———. *Erotic Grotesque Nonsense: The Mass Culture of Japanese Modern Times.* Berkeley: University of California Press, 2007.

———. "The Modern Girl as Militant." In *Recreating Japanese Women, 1600–1945*, edited by Gail Lee Bernstein, 239–266. Berkeley: University of California Press, 1991.

———. "Remembering Pearl Harbor, Forgetting Charlie Chaplin, and the Case of the Disappearing Western Woman: A Picture Story." *positions* 1, no. 1 (Spring 1993): 24–76.

Skocpol, Theda. *Diminished Democracy: From Membership to Management in American Civic Life.* Norman: University of Oklahoma Press, 2003.

Slater, Don. "Marketing the Medium: An Anti-marketing Report." In *The*

Camera Work Essays, edited by Jessica Evans, 172–187. London: Rivers Oram Press, 1997.

Stebbins, Robert. *Amateurs, Professionals, and Serious Leisure*. Montreal: McGill-Queen's University Press, 1992.

Sternberger, Paul Spencer. *Between Amateur and Aesthete: The Legitimization of Photography in America, 1880–1900*. Albuquerque: University of New Mexico Press, 2001.

Sugiwara Kiyoko. "Fujin to shashin." In "Shashin josei-gun kōshinkyoku." *Asahi kamera* 19, no. 1 (January 1935): 49.

Suzuki Hachirō. *Arusu saishin shashin dai kōza*. Vol. 10, *Hikinobashi inga hō*. Arusu, 1935.

———. *Arusu saishin shashin dai kōza*. Vol. 18, *Hikinobashi shashin no okugi*. Arusu, 1936.

———. *Arusu taishū shashin kōza*. Vol. 1, *Kamera no chishiki to erabikata*. Arusu, 1937.

———. *Arusu taishū shashin kōza*. Vol. 9, *Shiki no shashin jutsu*. Arusu, 1938.

———. "Atarashiku umarekawaru *Kamera Kurabu*." *Kamera kurabu* 2, no. 9 (September 1936): n.p.

———. *Shashin shippai to sono gen'in*. Arusu, 1926.

Tagg, John. *The Burden of Representation: Essays on Photographies and Histories*. Minneapolis: University of Minnesota Press, 1988.

———. "Practicing Theories: An Interview with Joanne Lukitsch." In *Grounds of Dispute: Art History, Cultural Politics and the Discursive Field*, 62–96. Minneapolis: University of Minnesota Press, 1992.

Takahashi Junjirō. *Mitsukoshi 300–nen no kei'ei senryaku: Sono toki kei'eisha wa nani wo ketsudan shita ka*. Sankei Shinbunsha, 1972.

Takakuwa Katsuo. *Fuimuru shashin jutsu*. Arusu, 1920.

———. "Shashin-shi Ichikawa-kun ni kotaete shumi shashin no tachiba wo akiraka ni suru." *Shashin geppō* 25, no. 10 (October 1920): 665–676.

———. "Zōkan ni nozomite." *Kamera* 1, no. 1 (April 1921): 1.

Takakuwa Katsuo and Nakajima Kenkichi, eds. *Arusu shashin nenkan, 1926 nenpan*. Arusu, 1926.

Takayama-sei [pseudonym]. "Mudai-roku." *Shashin geppō* 18, no. 11 (November 1913): 50–56.

Takayanagi Mika. *Shōuindō monogatari*. Keisō Shobō, 1994.

Takeba Jō and Miura Noriko, eds. *Ikyō no modanizumu: Fuchigami Hakuyō to Manshū Shashin Sakka Kyōkai*. Nagoya: Nagoya-shi Bijutsukan, 1994.

Tanabe Yoshio. *Mitchaku no jitsugi*. Genkōsha, 1954.

Thomas, Julia. "Power Made Visible: Photography and Postwar Japan's Elusive Reality." *Journal of Asian Studies* 67, no. 2 (May 2008): 365–394.

Tipton, Elsie, and John Clark, eds. *Being Modern in Japan: Culture and Society from the 1910s to the 1930s*. Honolulu: University of Hawai'i Press, 2000.

Tokyo Asahi Shinbunsha. *Nihon shashin nenkan*. Asahi Shinbunsha, 1925.

Tokyo-to Chūō Kuritsu Kyōbashi Toshokan. *Chūō-ku enkaku zushō: Nihon-bashi-hen*. Tokyo-to Chūō Kuritsu Kyōbashi Toshokan, 1994.

Tokyo-to Shashin Bijutsukan. *Nihon kindai shashin no seiritsu to tenkai.* Tokyo Shashin Bijutsukan, 1995.

Trentmann, Frank. "Beyond Consumerism: New Historical Perspectives on Consumption." *Journal of Contemporary History* 39, no. 3 (July 2004): 386–387.

Tsurudono Teruko. "Shashin no tanka." In "Shashin josei-gun kōshinkyoku." *Asahi kamera* 19, no. 1 (January 1935): 52–53.

Tsūshin Sangyō Daijin Kanbō Chōsa Tōkei-bu. *Kikai tōkei nenpō, Shōwa 27-nen.* Nihon Kikai Kōgyō Kai, 1948.

———. *Kōgyō tōkei 50 nenshi, Shiryō hen 1.* Ōkurashō Insatsu Kyoku, 1961.

Tucker, Anne, Dana Friis-Hansen, Kaneko Ryūichi, and Takeba Jō, eds. *The History of Japanese Photography.* New Haven, CT: Yale University Press, 2003.

Uchida Roan. "Shashin no shinku." In *Tokyo-to Shashin Bijutsukan sōsho: Sairoku: Shashin-ron 1921–1965,* edited by Ōshima Hiroshi, 8–13. Tankōsha, 1999. First published in *Yomiuri shinbun* (27 February 1921).

"Vesuto kenshō shashin tenrankai." *Mitsukoshi* 12, no. 3 (March 1922): 33.

Weisenfeld, Gennifer. "'From Baby's First Bath': Kaō Soap and Modern Japanese Commercial Design. "*Art Bulletin* 86, no. 3 (2004): 573–598.

———. "Japanese Modernism and Consumerism: Forging the New Artistic Field of 'Shōgyō Bijutsu' (Commercial Art)." In *Being Modern in Japan: Culture and Society from the 1910s to the 1930s,* edited by Elsie Tipton and John Clark, 75–98. Honolulu: University of Hawai'i Press, 2000.

———. *Mavo: Japanese Artists and the Avant-Garde, 1905–1931.* Berkeley: University of California Press, 2002.

———. "Selling Shiseido: Cosmetics Advertising & Design in Early 20th-Century Japan." MIT *Visualizing Cultures,* 2010. Available at http://ocw .mit.edu/ans7870/21f/21f.027/shiseido_01/sh_essay01.html.

West, Nancy Martha. *Kodak and the Lens of Nostalgia.* Charlottesville: University of Virginia Press, 2000.

Williams, Raymond. *The Politics of Modernism: Against the New Conformists.* Edited and introduced by Tony Pinkney. London: Verso, 1989.

Williamson, Judith. "Family, Education, Photography." In *Culture/Power/History: A Reader in Contemporary Social Theory,* edited by Nicholas Dirks, Geoff Eley, and Sherry B. Ortner, 236–244. Princeton, NJ: Princeton University Press, 1994.

Wong, Ka F. "Entanglements of Ethnographic Images: Torii Ryūzō's Photographic Record of Taiwan Aborigines (1896–1900)." *Japanese Studies* 24, no. 3 (2004): 283–299.

Yamada Yaeko. "Shashin to ikuji." In "Shashin josei-gun kōshinkyoku." *Asahi kamera* 19, no. 1 (January 1935): 50–51.

Yamamoto Taketoshi and Nishizawa Tamotsu, eds. *Hyakkaten no bunkashi: Nihon no shōhi kakumei.* Kyoto: Sekai Shisōsha, 1999.

Yanagi Yōko. "Kaidai: Fukushoku." In *Kindai shomin seikatsu-shi, daigokan: Fukushoku, biyō, girei,* edited by Minami Hiroshi. San'ichi Shobō, 1986.

Yanagita Yoshiko. "Haha to shite mita shashin." In "Shashin josei-gun kōshinkyoku." *Asahi kamera* 19, no. 1 (January 1935): 52–53.

Yasukōchi Ji'ichirō. "Kantan na anshitsu wo tsukuru ni wa." In *Shotō shashin jutsu hyakkō,* edited by Matsuno Shigeno. Asahi Shinbunsha, 1939.

———. *Yasashii shashin no utsushikata.* Arusu, 1937.

Yomiuri Shinbunsha, ed. *Eiga hyaku monogatari: Nihon eiga hen 1921–1995.* Yomiuri Shinbunsha, 1995.

Yomiuri Shinbunsha Benri-bu, ed. *Shōhin yomihon.* Chikara no Nihonsha, 1937.

Yoshida Mitsukuni. "Meiji shashin kō: Sono imi to kinō." In *Shikaku no jūkyū seiki: Ningen, gijutsu, bunmei,* edited by Yokoyama Toshio, 155–182. Kyoto: Shibunkaku Shuppan, 1992.

Yoshikawa Hayao. "Tesei kamera ga kataru 30 nen mae no amachua shashin jutsu." *Asahi kamera* 40, no. 9 (September 1935): 349–352.

Yoshimi Shun'ya. *Toshi no doramatourugii: Tokyo, Sakariba no shakai-shi.* Genbundō, 1987.

Yoshioka Kenkichi. *Shashin jutsu no ABC.* Seikōkan, 1933.

Young, Louise. "Marketing the Modern: Department Stores, Consumer Culture, and the New Middle Class in Interwar Japan." *International Labor and Working-Class History* 55 (Spring 1999): 52–70.

INDEX